ART THEFT

ART THEFT

and the Case of the Stolen Turners

SANDY NAIRNE

REAKTION BOOKS

Published by
Reaktion Books Ltd
33 Great Sutton Street
London ECIV ODX, UK

www.reaktionbooks.co.uk

First published 2011

Printed and bound in Great Britain
by MPG Books Group

British Library Cataloguing in Publication Data
Nairne, Sandy.
Art theft and the case of the stolen Turners.
1. Art thefts. 2. Art thefts – Case studies. 3. Art thefts – Investigation –
Case studies. 4. Turner, J.M.W. (Joseph Mallord William), 1775–1851.
Shade and darkness. 5. Turner, J.M.W. (Joseph Mallord William),
1775–1851. Light and colour.
I. Title
364.1'6287-DC22

ISBN 978 1 86189 851 7

Contents

Introduction

Two paintings by the great 19th century English artist J.M.W. Turner insured for £12 million each have been stolen from a German gallery while on loan from the Tate. Loss adjusters offered a six-figure reward for information leading to the safe return of the works as an international search was launched.

 – *Guardian*, Saturday, 30 July 1994

That what we have we prize not to the worth whiles we enjoy it; but being lack'd and lost, why then we rack the value, then we find the virtue that possession would not show us while it was ours.[1]

 – Friar Francis, *Much Ado About Nothing*

Turner Bequest: Numbers 531 and 532

I never expected to write this book. Nor could I have imagined that the theft of two paintings would so disrupt my work at one of the world's leading art museums. Or that the theft and its aftermath would extend for nearly a decade. The starting point for this book is the story of two highly esteemed late paintings by J.M.W. Turner, part of the Turner Bequest within the Tate collection, stolen on 28 July 1994 while on loan to an exhibition in Frankfurt. The theft is the start of the narrative, but the attempted recovery of the paintings – their determined pursuit by several investigators, the cross-border and European collaboration with government agencies and police forces, and the payment of funds for information – make it a tale with much wider ramifications. I was centrally involved as the Tate's Director of Programmes and my account is as much about the

delicacy of negotiating for the recovery of the paintings as about their theft. And there was the additional factor that the original crime spawned 'piggy-back' deception and fraud. Works of international importance were eventually put back in place on the gallery's walls – recovered from a shadowy criminal underworld – brought back literally into the light.

The first part of the book is a personal story, a memoir, while the second part is an analysis of the questions surrounding art theft. The recovery of the Turner paintings is linked to a discussion of comparative cases and an exploration of critical issues. I have drawn on my diaries and on subsequent interviews, as well as on published accounts of previous art thefts. Given that the display of art offers opportunities for art to be stolen, the book examines how it attracts criminal interest and discusses how, despite the ethical complications, long-term negotiations can produce successful results, restoring works to the public domain. The book is about the constraints on negotiation and acceptable exchange, while also delineating institutional parameters, risks and opportunities, secrecy and exposure.

Sadly, the number of cases since the 1980s demonstrates that high-risk theft of high-value art is a continuing threat. The greater prominence of art combined with hugely increasing values for fine art in the post-war period has created the motivation for thieves to become ever bolder in their attacks. While the myths around art theft, fuelled by descriptions in the media and depictions in film and television, make it appear to be the romantic material of thrillers, the actual business is undertaken for financial gain by hard-nosed criminals, often linked to underworld trading in drugs. Art thefts should not be seen as if each were an isolated incident, nor should the myths of an Arthur Raffles or a Thomas Crown hold sway in the public mind over the grubby reality of criminal gangsters. This divergence between the mythology and the everyday reality is considerable, and yet the myths cannot simply be dismantled given their power over the popular imagination. Nevertheless, there are and can be better processes to deter art thieves and help prevent thefts from public galleries and museums. Understanding the issues is crucial in exploring how, collectively, we can care for art more effectively, and perhaps more completely.

Stealing Art

More art gets lost than stolen. Of the many works produced in any year only a small number will survive. Most such 'losses' are not caused by wilful damage but because the great majority of art is not acquired by private collectors or added to the holdings of a museum. Art is graded through comparative judgements, and much of it will be discarded. Even when art is taken into a museum there can be occasional damage, deterioration, loss or de-accessioning.[2] And of the works that are selected – that endure by being highly regarded – only a very small proportion will ever attain the status of being considered as 'masterpieces'. There is a presumption in Western society that these unique and much-valued works, admired for the skill and intellectual force with which they are created, are then part of a collective heritage, to be conserved and displayed as part of the national patrimony. They should be looked after for everyone – and forever.

Theft in all its forms is a challenge, but the theft of important paintings – especially those in public ownership – produces complex reactions. It startles and disturbs, whether because of a brazen disregard for commonly held values, because of the violence with which it is enacted or because, like banks, museums are expected to be burglary-proof. But it also intrigues. Despite a heightened awareness of the risk and extensive improvements in security within museums and public galleries, art robberies have increased over the past half-century.[3] Art theft has become big business. The international crime agency, Interpol, will not give statistics, but some estimate that the international market for stolen art and antiquities is worth as much as $5 billion annually and, in terms of impact and extent, this places it among the top international crimes, after drugs, money-laundering and the sale of illegal weapons.[4]

Fact or Fantasy

Art theft focuses attention on which works of art are worth stealing and, by implication, which are not. What should be pursued, and – with luck and determination – recovered? But through the reporting of art theft, the media often increase public expectations

about the myth-laden figures of the art thief, the art detective or the idea of the 'hidden' collector.

For example, in the Stockholm theft of December 2000, three masked men walked into the National Museum of Fine Art just before closing time on a late weekday afternoon.[5] One man brandished an automatic weapon and ordered the guards to the floor, while the others stormed upstairs. They left the building with an exquisite 10 × 20-cm (4 × 8-in.) self-portrait painted on copper by Rembrandt, even then worth $36 million, and two paintings by Renoir, *Conversation* and *A Young Parisian*. A journalist commented:

> There is . . . no national outcry in Sweden about the theft, only a fascination as to how it was so smoothly executed . . . Before they made their escape by speedboat they threw a net full of spikes on the road in front of the museum to immobilize police cars. They also detonated two car bombs in the area to confuse the police emergency switchboard . . . Nobody was hurt in the raid, which thus falls into the romantic mould of fictional art theft as an apparently cultured and victimless crime. As a result public anger in Sweden is not so much directed at the thieves as at the museum management.[6]

A British specialist detective commented that 'It bore all the hallmarks of an organized crime operation – professional criminals who left nothing to chance. But when stealing art the mark of the true professional is his ability to dispose of the stolen works.'[7] Within a month a ransom was demanded, though the Swedish police were not prepared to enter such a negotiation. Following a failed attempt to ransom the paintings, arrests were made in January 2001. *Conversation* was recovered later that year, found through routine investigation of a drug-dealing network.[8] After years of complex detective work by the Swedish police, working closely with the FBI, the second Renoir was recovered in September 2005 in the possession of an organized crime group in Los Angeles. The Rembrandt was finally obtained by Robert Wittman, Head of the FBI's Rapid Deployment Art Crime Team, in a sting set up in Stockholm the same month.[9] The film-like elements,

the mix of drama and violence, and the links to the drugs trade, make this a classic high-value, high-risk theft and recovery.

Theft of really valuable art has strongly romantic connotations, enhanced in literature and film. The narrative builds on the nineteenth-century tradition of the gentleman thief, such as Adam Worth, and on accounts of well-known losses – whether the *Mona Lisa* from the Louvre in 1911, the Goya from the National Gallery in 1961 (fifty years later to the day), the Vermeer from Kenwood in 1973 or the loss of the Rembrandt from Dulwich Picture Gallery, stolen four times between 1966 and 1983 (the most stolen work of art in the world). The invention of mysterious, avaricious collectors such as H. G. Wells's Captain Nemo or world-threatening criminals like Ian Fleming's Dr No feeds into the immediacy with which film conveys the thrill of a brilliantly orchestrated theft, whether *Topkapi* or *The Thomas Crown Affair*. This is the context for some audacious thefts of recent years, in which the loss of the two late Turner paintings in Frankfurt in 1994 appears as part of a sequence that includes the attack on the Isabella Stewart Gardner Museum in Boston in 1990, the thefts of versions of *The Scream* in Oslo in 1994 and 2004, the loss of Cellini's *Saliera* in Vienna in 2003 and the theft of works by Matisse, Picasso and others from the Musée d'Art Moderne in Paris in May 2010.

Art crime replays its own myths. Many film viewers would admire as a creative challenge the ability to overcome complex security systems, whether in a bank, military facility or a modern museum, and similarly public condemnation of criminal behaviour is reduced if a thief is clever or ingenious. The 'art' of art theft is extensively explored within the genre of detective fiction, and the activity of actual art theft may, in a self-conscious sense, be 'performed' in order to gain kudos in the criminal fraternity. In addition to the physical and logistical battle to prevent unauthorized entry to well-protected properties, combating high-level art theft is a struggle with mythology itself.

In fiction, the shadowy character of the hidden collector is in the background, and the determined and ruthless detective, male or female, is in the foreground – pursuing the criminal perpetrators and the precious art. There are many well-known detective and forensic

heroes and heroines of all periods from Georges Simenon's Inspector Maigret to Patricia Cornwell's Kay Scarpetta, DCI Jane Tennison of *Prime Suspect* and Stieg Larsson's Lisbeth Salander. Much of what appears in the newspapers seems, at times, like an account from fiction, and vice versa. But fiction offers a rose-tinted view of serious theft: as exciting, daring and part perhaps of a heroic struggle between good and evil, where the criminal or detective, like an artist, can be portrayed as an 'outsider'. The actual world of organized crime, with its brutal connections to the distribution of hard drugs, prostitution, racketeering, extortion and the sale of illegal weapons, offers a different image that is the truer picture. A common denominator for many high-value art thefts in the past ten to fifteen years has been the potential for stolen works to be used as collateral linked to drug deals. And drug deals invariably relate to extortion, misery and violence.

Motives

The experienced art investigator Peter Watson commented in 2003: 'In fact, truly professional art thieves steal jewellery, which can be re-cut, or they deal in illegally excavated and smuggled antiquities which have never been photographed before they come to auction and therefore can't be identified and reclaimed. And the clever thief deals in second-rate paintings.'[10]

Given the considerable risk of being caught, or not being able to pass on stolen paintings with obvious recognition value, like the Turners, there is a genuine puzzle as to why this type of crime is undertaken at all. Making money, combined with a certain level of bravado, is the simplest answer. Because after a successful theft each stolen work of art acquires a new 'value' in the underworld: perhaps only 10 per cent of its commercial value, but still potentially a large sum. This is value that can be utilized as collateral in criminal deals. Such motivation for thieves has significantly increased as the values at the top end of the fine art market have shown stupendous growth.

Specialist criminologist Professor John Conklin analyses this financial desire of the 'motivated offender' through the Routine Activities Theory, which breaks theft down into five subcategories.[11] First, there are those who steal art in the hope of selling on to a

dealer, either directly or through a middleman or fence – although this does not generally relate to high-value works, which by definition cannot simply be sold on. Secondly, there are those who are paid to carry it out, who steal on commission. Thirdly, thieves may steal with the intention of ransoming the work to the owner, seeking a buy-back from an insurance company or doing a deal of some indirect kind. And, fourthly, those who steal to keep the work for themselves. Occasional symbolic or political acts constitute a fifth category, such as Kempton Bunton's theft in 1961 of Goya's portrait of the Duke of Wellington from the National Gallery (as a protest against the cost of television licences for pensioners), discussed in chapter Eight and the theft of 1974 at Russborough House near Dublin, described in chapter Seven. The fourth and fifth categories are very rare and seen only occasionally in recent times. It is clearly financial considerations that are uppermost in the minds of most criminals, sometimes with an added element of competition, certainly pronounced in the blustering claims of a Myles Connor or equally in the assertivenenss of an art dealer like Michel van Rijn.[12]

The third category is the principal focus of this book, although it may overlap with commissioned stealing in the second. Conklin himself quotes from a thief, Daniel Golden: 'The biggest thing about stealing a painting is having someone to sell it to. Unless you have it sold ahead of time, it's useless.'[13]

It is a clichéd notion about modern art that a work is originally reviled and only recognized as exceptional at a later date – its greatness secured by admission to a noted collection or by high monetary valuation. But it is this high value, in terms both of market valuation and the celebrated position of a well-known artist, which attracts the interest of criminals. Very high values boost public fascination when criminals overcome the defences constructed by museums, removing works from under the noses of those supposedly keeping them safe. Somehow, through the act of theft, while the museum may be very embarrassed, the stature of a work is confirmed in this unexpected way: the theft of a work adding notoriety, and translating to a changed perception of its significance and perhaps even its market value.[14]

High recognition value may restrict thieves from immediately re-selling works, but high monetary value raises the stakes for those

in pursuit of the works and the criminals. Daring art thefts are somewhat removed from the everyday thieving of garden statuary, small items of jewellery, art and antiques from historic houses or churches. These are either stolen opportunistically or while preying on the security weakness of domestic or public buildings. For fine art objects – with the value confirmed in the signature of the highly regarded artist who made it – there have been perennial cries of 'crisis' at the number and severity of high-value art crimes as far back as the 1960s, some commentators seeing the very act of fine art theft as a symptom of a misguided art world, turning away from the 'spiritual' and overtaken by over-promoted exhibitions and high society interests.[15] In response, special squads have been set up to counter art crimes, and an increasing effort made to prevent thefts taking place and to recover stolen works.[16]

The theft and criminal exchange of famous works of art has been made less viable by using the Internet to distribute – rapidly and widely – information on, and images of, stolen works. But at the same time art theft has been downgraded as a lower police priority compared to terrorism and national security. Police resources are always overstretched, and the complicated recovery of stolen art is not the highest priority. On the one hand, therefore, art theft is seen as a 'luxury' crime, of lower significance compared to the abuse or abduction of children, or murder, or when set against organized terrorist activity. On the other hand, while richly mythicized, it has a prominence in the wider world as an aberration, as something preventable. More work is therefore needed to share knowledge across museums, cultural institutions and agencies, to create clearer policy guidelines for recovery, to develop a more comprehensive database of stolen art and to reinforce the work of specialist art crime squads. Greater combined effort is required not only to stop skilled criminals from stealing works of great cultural value, whether in public or private ownership, but also to explore the ethical questions and unravel the fiction-derived assumptions that surround so many stories of art theft.

Part One

one

Loss

July 1994

On Friday, 29 July 1994, I was woken early. A call came from Nicholas Serota, Director of the Tate, to tell me that two important late Turner paintings had been stolen while on exhibition in Germany. Sabine Schulze, curator at the Schirn Kunsthalle in Frankfurt, had rung in the night, in a distraught state, trying to contact someone. She got through to the 24-hour security office at Millbank, and a call was made to a Turner curator, David Blayney Brown, who in considerable shock had then passed on the dreadful news to Nick.

'Bring your passport with you', was Nick's instruction to me. I was one of his two deputies appointed at the start of that year to boost the Tate's senior team, since the planning for creating Tate Modern was stepping up a gear. I was now in charge of all the exhibitions and programmes, but had also worked with Nick twenty years previously at the Museum of Modern Art in Oxford. We trusted each other completely, and I suppose I was in line for unusual requests.

An early meeting in Nick's office – facing the Thames above the front of the Gallery at Millbank – led quickly to decisions about a draft response for the press, and who to call: the Department of National Heritage, the Foreign Office and the British Consulate in Frankfurt. It was clear that because this was such a serious loss, I should take the next flight to Frankfurt. With the help of the Tate's senior paintings conservators, Alexander Dunluce and Roy Perry, I hastily assembled a Turner catalogue, an envelope of black-and-white photographs, conservation reports (crucial material for the identification of paintings),

contact numbers – and my passport. The two stolen paintings were *Shade and Darkness – The Evening of the Deluge* and *Light and Colour (Goethe's Theory) – The Morning after the Deluge – Moses Writing the Book of Genesis*, numbers 531 and 532. They might have the superficial appearance of strange, semi-abstract swirls of paint, but the loan file revealed that they were valued at £24 million, and because they were on loan to an exhibition organized by the Schirn Kunsthalle, they were fully insured with a reputable insurance company.

In mid-flight the shock of the theft began to sink in. I tried to think ahead – I knew little about art theft, but I wondered whether this might be a political move. Could the paintings have been taken as a form of kidnap to support some protest or cause? Why would two Turner paintings, however valuable, be a specific target? And of course the obvious question circled in my mind as to how there could have been such an appalling lapse in security. I was familiar with Frankfurt as a city to visit for viewing exhibitions of contemporary art, but now it felt very different – more than a little hostile. The process of preparing to ask so many difficult questions was strangely numbing.

At the Schirn Kunsthalle I was greeted by the head of security, with obvious embarrassment. 'I am so sorry' was well meant but somewhat inadequate. I learned that a small painting by Caspar David Friedrich lent by the Hamburg Kunsthalle had also been taken. I toured the main part of the building – a rather plain late modern piece of architecture tucked into the historic centre of Frankfurt – before seeing the special exhibition area in which the exhibition, *Goethe and the Visual Arts*, was hung and to which the Tate's two Turner paintings had been lent. We started with the front entrance door of the Kunsthalle, locked by the night security guard at 10.10 p.m. the previous night after the last of the evening visitors had departed. We followed the route by which the guard, after seeing out the public and dispatching the fourteen gallery security staff – all employed by Eufinger, a Frankfurt security firm – had picked up the cash from the ticket desk till and gone upstairs to lock it away. I saw the onward route taken by the guard, surrounded, so it appeared to me, with places where thieves might hide after closing time – the back stairs? Behind partitions on the mezzanine? An

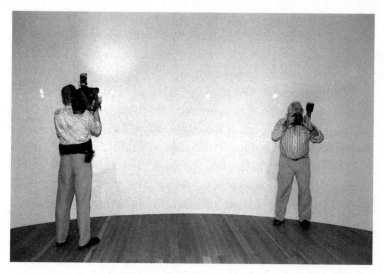

Schirn Kunsthalle, Frankfurt, 29 July 1994.

entry point from the sister institution, the Music School? Any of these seemed workable as places from which to launch an internal attack. It was already clear that this theft was of the kind known as a 'stay-behind'.

We viewed the place where the guard was actually attacked and held, near the entrance to the exhibition, tied up in a cleaning cupboard. Walking into the top-floor exhibition space itself, there ahead of me was the empty end wall with a poignant pair of blank spaces. Nearby was a smaller space from which Caspar David Friedrich's *Nebelschwaden* had been stolen. These areas of wall looked very bare, like exclamation marks, stark and shockingly blank, giving nothing away about who had been there and why. It is an image that has not faded in my mind.

The thieves had entered the gallery towards the end of the day, staying behind after hours and overcoming the night guard. But how did they get out again? It seemed by using the guard's keys, unlocking the back entrance area and opening the big doors, so gaining access to the goods lift and from there to the loading bay. This might have been fairly straightforward, but, crucially, it was possible only with knowledge of the security system and the internal layout to execute the operation swiftly. While removing the paintings, the

three men (two thieves and the waiting driver as it later emerged) would have been listening to the guard's radio, connected to Eufinger's headquarters. This was their way of knowing whether any suspicions had been aroused.

Did the thieves have a more ambitious plan? Had they been commissioned to take more works? Did they also intend to take a painting by Jacques-Louis David or a Claude Lorrain, or even the large and hefty – and hugely valuable – Raphael painting hanging only 15 feet away? Had they in fact been surprised? Was the gallery more vulnerable during evening hours? And how did they actually get away from the building? The exit route within the Kunsthalle building was clear: down and out through the goods lift and straight into a van alongside the loading bay. Such a city-bound building has no perimeter fence, no contained defensible space and no specific physical barrier surrounding it. Looking at it on that Friday afternoon either the security system or the personnel, or both, were compromised. Though highly risky, a theft was quite possible – just unbelievably bold.

Later, I was given the timing by the Frankfurt police – the minutes and seconds of what was discovered at the start of the police investigation – 22.10 the front doors were locked; 22.51 an alert was raised at Eufinger's head office; 22.55 the police had been called, who then contacted the gallery staff; 23.15 Dr Schulze, the Kunsthalle's curator, arrived with the acting director, Helmut Szeemann, and his head of security. When they realized which works were missing, a call was made to the Tate in London. There was undoubtedly a delay while Tate security staff tried to make sense of a confused-sounding woman from Germany saying that two Turner paintings had been stolen.

I questioned the Schirn Kunsthalle staff, all of whom were overwrought and quietly apologetic – how could they make excuses for 'letting' a £24 million theft take place? – but they had very little information. Then I was taken to the office of chief investigator Herr Bernd Paul at the nearby Frankfurt police headquarters, accompanied by Szeemann, a woman from the city cultural department (which owns and runs the Kunsthalle) and Michael Hall, the British consul. Sitting in a sweleringly hot office, the stolid Herr Paul set out what he had done so far, and what he was about to do: 'We will be

accumulating every possible piece of evidence of what happened last night in and near the Kunsthalle. And we will be pursuing the many contacts we have in the Frankfurt underworld, to find out who may have planned this.' It emerged that he was a specialist in blackmail and ransom work, and turning calmly to me he said: 'Your pictures have been taken hostage.' I guessed that he was probably right, but I had no experience against which to compare it.

His proposition implied that it was a spontaneous theft, and unlikely to have been commissioned by a 'hidden' collector of the kind so often imagined in the media, or undertaken by political extremists trying to embarrass or pressurize the German government. Herr Paul elaborated on the work to come: sifting information from cameras at the nearby underground car parks in central Frankfurt; trying to contact anyone visiting the Kunsthalle and arts complex that evening and interviewing all of Eufinger's present and past staff. I was trying hard – in the oppressive heat – to think of the main questions, and trying to convey fully to this calm, polite man that these were precious, national treasures. I wanted to explore whether he thought that they had already been shifted to an international black market (remembering occasional half-read Sunday supplement articles about stolen art). How could I convey a sense of urgency, that the very best efforts of his staff needed to be redoubled to find the paintings before they disappeared beyond the reach of police investigators? 'These are two of the most important works by Britain's single most important artist', I said. 'They are literally irreplaceable and priceless.' The consul backed me up politely, but I was not sure that Herr Paul took in his importance. It all seemed curiously out of time, as if we were setting in train an investigation to be carried out by a classic sleuth from the pre-war period, a Hercule Poirot.

After registering my contact details with the police, the Consulate and the Schirn Kunsthalle, there was no more to be done and I flew back to London that evening feeling very pessimistic. I rang Nick from Terminal 3 at Heathrow and gave him a quick update. We spoke again on Saturday. Having known Nick for so many years, I was able to speak frankly about the difficulties that the Tate faced: 'We are in the hands of police and investigators who appear to see the importance of this, but who may not be able to marshal sufficient

resources.' The theft might be highly embarrassing for the city of Frankfurt, but losing two outstanding Turner paintings was a major loss for the Tate, and for Britain, never mind that it was not directly the Gallery's own fault. At least Nick was used to dealing with information that was unexpected or unwelcome.

I telephoned Helmut Szeemann over the weekend, to get an account of the visit of Mark Dalrymple, the loss adjuster from Tyler & Co., employed by the insurance syndicate from Lloyd's. Dalrymple had spent the whole of Saturday in Frankfurt and had gone over everything in great detail. Szeemann offered me further details about what might have taken place, which were subsequently confirmed by Dalrymple:

> We think there was an interruption during the process of the theft. The third man, the driver, seems to have been holding the guard while the other two unscrewed the paintings from the wall of the exhibition room. I wondered if there was a connection with the poster for the *Goethe* exhibition. The chosen image was one of the two paintings by Turner.[1]

He told me that on Monday evening the police were planning a reconstruction. Perhaps this would provide more information and uncover some witnesses, although it was not clear that anyone had actually seen anything happening that was out of the ordinary that Thursday evening. As I mused on what we knew – on the use of inside information, the apparent planning of the operation – it brought me no nearer to who might have been this determined. But maybe the motive was simple: to make money out of taking very high-value paintings, whether by ransom, or as collateral. How could we find out?

On the Saturday morning I gave an interview to Radio 5 over the phone from home. Eric Shanes, then President of the Turner Society, was in the studio. Luckily, he was quite low-key about questions of responsibility and the vetting of venues taking loans from national collections. I said my piece about the tragic loss and tried to convey an emphasis on the criminal act. But even as he and I discussed the theft it was apparent that an essentially romantic narrative was all-pervasive: distorting information and absorbing some of the shock

of such a large-scale loss. I soon learned how easy it was for even well-informed readers to get a buzz from learning about the 'difficulty' of the break-in (or out, as in this case), from the possible 'outsider' position of the thieves, from the general sense of excitement surrounding the idea of an investigation, the thrill of the chase and the contrast between the large art institution and the bravery of an intrepid individual thief. Not that six minutes on Radio 5 Live could really explore this territory; nor could it convey anything of the real importance of Turner or these two specific paintings.

J.M.W. Turner and his Legacy

Introduced today to the man who beyond all doubt is the greatest of the age; greatest in every faculty of the imagination, in every branch of scenic knowledge; at once the painter and poet of the day, J.M.W. Turner. Everybody had described him to me as coarse, boorish, unintellectual, vulgar. This I knew to be impossible. I found in him a somewhat eccentric, keen-mannered, matter-of-fact, English-minded-gentleman: good-natured evidently, bad-tempered evidently, hating humbug of all sorts, shrewd, perhaps a little selfish, highly intellectual, the powers of his mind not brought out with any delight in their manifestation, or intention of display, but flashing out occasionally in a word or a look.[2]

– John Ruskin, June 1840

The two paintings stolen that Thursday night in Frankfurt, *Shade and Darkness – The Evening of the Deluge* and *Light and Colour (Goethe's Theory) – The Morning after the Deluge – Moses Writing the Book of Genesis*, are critically important paintings by Turner. The influential art critic Ruskin would have recognized them as part of the defining experimental character of his genius. They sit within the later phase in Turner's work, creating canvases highly regarded subsequently for their semi-abstract and proto-modern effects.

Although throughout his career there had been ambivalence about Turner's more innovative work when it was first exhibited, his reputation was still immense. On the day after his large-scale funeral in St Paul's Cathedral in 1852, *The Times* surmised:

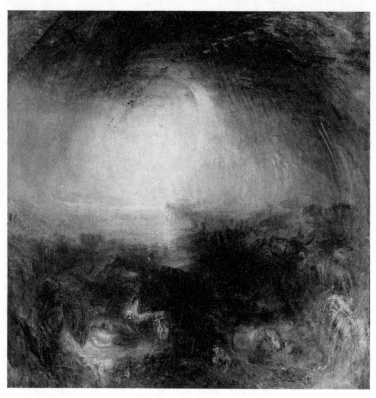

J.M.W. Turner, *Shade and Darkness – The Evening of the Deluge*, oil on canvas, 78.7 x 78.1 cm, exhibited 1843. Tate Collection.

Long ere his death he had the felicity of knowing that his name and his works were regarded with that reverential respect and estimation which is given to other artists by posterity alone . . . Even those who could only sneer and smile at the erratic blaze of his colour . . . lingered minute after minute before the last incomprehensible 'Turner' that gleamed on the walls of the Academy.[3]

Turner's exceptional status as a British artist involved in the nineteenth-century European Romanticism movement, who also reinvented landscape painting, made the theft of these paintings a calamity not only for the Tate. It was also a massive loss to the nation and arguably to art worldwide. The fact that these two paintings were part of the Turner Bequest – those works he regarded as his most

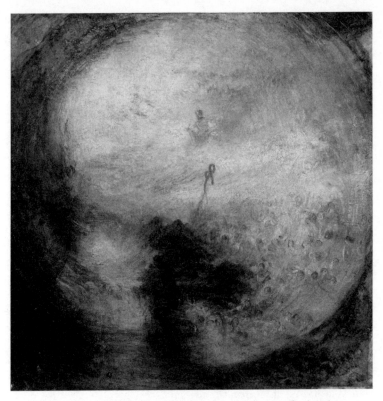

J.M.W. Turner, *Light and Colour (Goethe's Theory) – The Morning after the Deluge –
Moses Writing the Book of Genesis*, oil on canvas, 78.7 x 78.7 cm, exhibited 1843.
Tate Collection.

important paintings that he retained or re-purchased in order to
assemble the most significant gift by any artist to the nation – added
further significance to the loss.[4]

However abstracted to twenty-first-century eyes, the paintings
were intended as depictions of biblical events and as a riposte to
the ideas of the writer Johann Wolfgang von Goethe as Turner
understood them through his reading (and annotation) of a recent
translation of the *Theory of Colours*. When exhibited at the Royal
Academy in 1843, and viewed by the young critic John Ruskin, the
two paintings were regarded as both controversial and visionary.
They allude to ideas of cataclysm and renewal represented by the
biblical event of the Flood and the morning after, and are rich with
symbolic connotations. They refer to those who are saved and those

drowned; the idea of Moses writing the account of the birth of man; and the position of the serpent as the embodiment of evil but containing the medical power of healing. Such allusions are magnified by Turner's addition of his own poetry to the works when first exhibited, extracted from his poetic compendium *The Fallacies of Hope*. The idea of painting being linked to poetic lines was not unusual. With *Shade and Darkness* were the lines:

> The moon put forth her sign of woe unheeded;
> But disobedience slept; the dark'ning Deluge closed around,
> And the last token came: the giant framework floated,
> The roused birds forsook their nightly shelters screaming
> And the beasts waded to the ark.

And with *Light and Colour*:

> The ark stood firm on Ararat; th'returning sun
> Exhaled earth's humid bubbles, and emulous of light,
> Reflected her lost forms, each in prismatic guise
> Hope's harbinger, ephemeral as the summer fly
> Which rises, flits, expands, and dies.

They are complex paintings in which a sense of loss and desperation is emphasized, from the image in *Shade and Darkness* of the sheltering figures under a 'brooding black and purplish-grey cloud', representing those parts of humanity not allowed to be saved, and in *Light and Colour* the lost, drowned figures (some of whose heads are enclosed in shining bubbles) against which the serpent rises up to challenge the figure of Moses.[5] In this second painting, which is perhaps more positive and hopeful, Turner seems to see life as 'ephemeral as the summer fly which rises, flits, expands and dies'.

The critical reaction to the works when first exhibited at the Royal Academy in 1843 was (bar John Ruskin) universally negative and uncomprehending. On 11 May the art critic of *The Times* referred to *Shade and Darkness* as 'this ridiculous daub', and *Light and Colour* as a 'wretched mixture of trumpery and conceits'.[6] The writer for the *Morning Chronicle* of 9 May referred to them as 'perfectly indescribable, and seem to

consist of atoms casually together hurl'd', while the critic for the *Athenaeum* for 17 June regretted 'Mr Turner's flagrant abuse of his genius'.[7] Whatever the view of the critics, Turner himself was careful to include this pair of paintings with those he bequeathed to the nation at his death eight years later in December 1851.[8] 'The Turner Bequest' of 1856 emerged from a will made hugely complicated by various codicils, so that it took more than three years to resolve in the Chancery Court. It was examined subsequently by a Select Committee of the House of Lords in 1861. At issue was an estate valued at some £140,000, equivalent to at least £4 million today and showing him more wealthy than any other British painter of his generation.[9] The competing interests in the will included his family (although he was not married and had no acknowledged children as direct heirs), his own desire to make a scheme for the 'relief of aged and distressed artists' and his wish to keep the oil paintings together as a 'collection of his works', to be known as Turner's Gallery.[10] Two cherished and important works were transferred to the National Gallery in the year after his death, 1852, to hang as companions to a pair of Claude paintings, but the remaining terms of the will were complex and demanding.

There has been a long-running dispute as to whether Turner's wishes have been complied with. A retired solicitor, Nicholas Powell, an expert on the Turner Bequest, concludes that Turner was not motivated by any 'craving for public applause' – he had already received plenty – but rather by an understandable desire,

> to be understood . . . He loved his art and thought nobly of it. His works were himself at his best; and it was by those that he wished to be remembered . . . It was therefore the most natural thing in the world for him to wish his bequest to be kept together 'as a collection of his works' and to have them made readily accessible in their entirety.[11]

Turner had created his own small gallery in his house in the West End of London, and took control there of how works were displayed. So when in 1987 after various vicissitudes the Tate was able to open the purpose-built Clore Gallery designed by Sir James Stirling to house the Bequest, 136 years after Turner's death, it was

a huge step towards meeting Turner's own wishes. Today, the display of the Turner Bequest paintings (and the archival housing of the huge collection of works on paper) at Tate Britain remains the most prominent national presentation of any one single artist. It is a collection from which any loss would undoubtedly be a double blow – as works in their own right and to the integrity of the Bequest.

Turner and Goethe

The two paintings also embody specific references to 'Goethe's Theory'. The German writer, Johann Wolfgang von Goethe, although he died in 1832, was a crucial figure for intellectual life in the post-Romantic period of the middle years of the nineteenth century. Thomas Carlyle had translated some of his novels and poems in the 1830s, and in 1840 Sir Charles Eastlake, artist and later director of the National Gallery, had translated *Zur Fahrbenlehre*, of which Turner owned a copy. Turner's annotations in the margin give specific clues to his argument with Goethe's thinking. The particular references, as Martin Butlin and Evelyn Joll put it, are to Goethe's 'theory of a colour circle divided into "plus" and "minus" colours: the reds, yellows and greens (the plus colours), associated by Goethe with gaiety, warmth and happiness, with the blues, blue-greens and purples (the minus colours) seen as productive of "restless, susceptible, anxious impressions"'.[12] This division, and the implication that colour resulted from the combination of darkness and light, ran counter for Turner to the clarity of Isaac Newton's theory that all colour comes out of light, and is derived from it.

Turner therefore created an opportunity with these two paintings to make a proposition about the interdependence of light and darkness, while also demonstrating that ultimately, in Gerald Finlay's words, he was convinced that 'light, which is positive, holds dominion over darkness, which is negative'.[13] The Newtonian connection is emphasized further in *Light and Colour*, where the rainbow that acts in the biblical story of the Flood as a symbol of the agreement between God and man is transformed into a large rainbow-hued bubble that contains the whole composition.

When selecting works by various artists for the loan exhibition *Goethe and the Visual Arts* for the Schirn Kunsthalle for May 1994,

Sabine Schulze had seen these two Turner paintings as vital to the exploration of Goethe's ideas and to an understanding of the effects across Europe of the writer's poems and ideas on art. They were hung with Renaissance masterpieces that Goethe had admired and with those such as Friedrich who exemplified his Romantic thinking. The Tate agreed to the loan of the works because curators recognized the importance of the exhibition and, as Schulze later put it, 'You don't understand the work of William Turner without these two paintings. Without them, art history really has a gap.'[14]

Responses to the Theft

The initial investigation by the Frankfurt police was intended to cast the widest possible net in pursuit of the thieves and the paintings. Mark Dalrymple was employed by the insurers to track the operation. The insurers would potentially have to pay out on the £24 million claim to be made by the Tate, and if the paintings were found quickly then they could avoid making that payout. Talkative and dapper, Dalrymple is one of the most experienced of specialist loss adjusters in the insurance field. He has, on many occasions, organized complex negotiations for the return of valuable materials, while at the same time linking closely to police investigations. He also travelled to Frankfurt on the day after the theft.

> I had a telephone call at about 9.30 in the morning. Charlie Schramm of Hiscox Syndicates rang and said – he is quite laconic – a little like me sometimes. 'Mark, what are you doing at the moment? We have had a loss'. 'Yes'. 'Quite a big one. Can you get to Germany?'. 'When do you want me to get there?' 'Now'. 'OK. What is it?' The story briefly unfolded, and I said, 'Oh Shit'. Shit because (a) the value, and (b) it was two important Turners. And I felt sorry for the Tate, for them as the guardians. I also felt slightly sorry for the underwriters, taking a hit on £24m. So I was immediately thinking we have got to get them back. That was all I was thinking about – we have got to get them back.

So literally I drove back to London, booked a flight and was in Frankfurt on that Friday night.

When I got there I found it very disconcerting that everyone seemed to know about things that they should not have known about . . . Just general information which seemed to have been going around, about who may have been involved, who was there, what they were doing. The first meeting we had was at 10.30 a.m. on the Saturday morning with the acting director. There was another loss adjuster there, who had an interest in the stolen Friedrich . . . [but] . . . there wasn't one policeman at the meeting which surprised me as well . . . I did not meet Herr Paul. With help from the Consul I eased my way into the Praesidium and had a rather formal meeting at which the police said 'We are not going to tell you anything'. I did feel like saying, 'You do realise that these are British pictures; they are highly important' . . . That is how I felt. This is our culture. There is a lot of money involved, but that was not the point – more, how can we help you? And the answer seemed to be – you can't.[15]

Dalrymple as the loss adjuster appointed by Robert Hiscox, lead insurance underwriter from Lloyd's, soon had the mandate to offer a $250,000 reward on behalf of the insurers (for information leading to the recovery of the paintings – under the 'usual conditions'). But his role was also to link with the police and to try to find leads as to whether the paintings could be recovered. After an art theft there are complementary responses: the museum that simply wants its paintings back; the insurers who do not want to have to pay out the insured sum; and the police who want to catch the criminals involved. They need to work together, while recognizing their different motivations.

Paintings when they hang in national collections are not commercially insured.[16] Each national museum manages and conserves them, and repairs any damage if it occasionally occurs. It is only when works go out on loan, and are then the responsibility of another institution, that insurance or indemnity is required. Paying the premium is a cost for the borrowing institution – in this case the

Schirn Kunsthalle. Before going out on loan, the insurance value of each work is checked to make sure that the level of insurance to be taken out is correct. The two Turner paintings had only recently been re-valued by Andrew Wilton, Keeper of the British Collection and the most senior Turner scholar at the Tate. In a routine reassessment of the value of the two Turners (assessed by him at £12 million each, based on comparative market information for Turner or artists of similar stature), he established a crucial matter, both in terms of publicity and the complexity of the negotiations that would emerge over the years ahead. Back at the Tate we positioned a special label on the wall of the gallery in the Clore extension at Millbank. The label simply described what had happened, and indicated that the Tate was keen to gather any information leading to the return of the paintings.

There were initial shock reports in the press, but these soon passed. The London-based art critic Brian Sewell wrote an article about four weeks after the theft pondering whether there was a 'collector-thief' who might have undertaken this particular crime (also implying links between possessive behaviour in relation to high-value works of art and male sexual conquest). He went on to question whether pursuit was really required, regretting that in European museums in particular there are insufficient examples of the best British art:

> My not entirely mischievous thought is that for the sake of Turner's reputation the Tate should make no effort to recover them, but be happy to let them shine among the nineteenth-century pictures in the German national collections, for shine they will, making Caspar David Friedrich and his ilk look very dull indeed.[17]

Even in Sewell's fantasy, it would be impossible that if the works unexpectedly surfaced in Germany they would be transferred to a public collection. Nicholas Serota was much more direct in his view on the absolute priority of pursuing these two stolen works:

> First, they are highly important works in Turner's oeuvre. Their absence from the Turner Bequest, in terms of both

their aesthetic and intellectual importance – for an under-standing of what Turner was doing in the 1840s and his relationship with advanced colour theory and with one of the principal writers of the Romantic era – was the para-mount reason. Secondly, of course, they are part of the origi-nal Bequest to the nation from Turner. He had not sold them in his lifetime, and clearly saw them as very significant. It was crucial to him they were a pair, and to get them both back, and intact, was vital. Finally, it is not good for art museums to feel that if works are lost they will never be recovered; i.e. it gives succour to thieves if the institutions that own these important cultural objects do not really care enough to make every effort to recover them.

The insurance money can never be full compensation for something that is part of the fabric of this collection.[18]

Alex Beard (then Director of Finance and Administration, now Deputy Director) put additional emphasis on the external determinants:

The Tate is the 'trustee' of the Turner Bequest which is its jewel: the most important group of paintings, by Britain's most important artist . . . When the paintings were stolen we had a moral obligation to ensure their recovery, to restore them to the Bequest, and to ensure their enjoyment by future viewers.[19]

The Tate had a clear incentive to do everything in its power to pursue the missing works, but I was left with much less clarity about the original motivation of the criminals. What *kind* of art theft was this? Who was the theft *for*? Why did the criminals take such *risks* to obtain these well-known paintings? What comparisons could be made with other high-value thefts in recent years? And an additional question emerged: who else might try to profit from the theft?

Diversion

On 1 August 1994, the Monday following the theft in Frankfurt, a call came through to the Information Desk at the Tate at Millbank. It was about 10 a.m., just as the Gallery was opening. The caller wanted to know who was in charge. Redirected to the Director's office, the caller spoke to Lynn Murfitt, who told him the Director was away on holiday. He said that he needed to speak to someone about the stolen paintings, 'someone who was in charge'. She told him to ring back in an hour. When asked, he said his name was Mr Rothstein.

On that Monday I was desperate for news of some kind, although I probably didn't expect it to emerge quite so soon. What was actually in my mind was a clear week with Nick away, in which to catch up with large piles of material on my desk and have some mental space to develop work on various current issues: completing a submission to the Secretary of State on museums' policy; the next stages of thinking about the question of acquiring non-Western art; ordering matters relating to the Tate's collection of works on paper; planning the next stages of work towards the major Tate Gallery of Modern Art project – which had really started to move forward that spring. These were all necessary matters for a summer period with fewer meetings and a little more time.

I called Mark Trodd, the Tate's Head of Security, and asked his advice in case the man called back. 'Make sure that you have a pad of paper with you, and ask him to repeat things, so that you keep him talking. You will need to build up trust.' This was new to me, because I had never had occasion to talk directly with anyone connected with a major crime. In the meantime Mark tried calling the National Security Adviser, but he had no luck. He went on to the Art and Antiques Squad at Scotland Yard. They said they would come over to the Tate, and bring a suitable tape recorder. While we waited, and tried to do other work, Detective Inspector Jill McTigue rang to say that her team might take a little time, and gave me precise instructions should he call back: 'Firstly, keep him talking; secondly, take him seriously; thirdly, repeat back to him what he was saying; and fourthly, if necessary, invent an excuse for him to have to call back.'

But it was a while before Mr Rothstein make another call and by then the Metropolitan Police team were in the Tate with all the bustle and unspoken 'excuse me' of police officers working out how and where to arrange things. They switched the telephone line we should use from a spare in the assistants' office to the line in Nick's office next to his desk. A wise decision as it turned out. The team wired in a tape recorder to this line and quickly drilled Lynn in how to take the next call, and then to ask the caller to ring back on this specific and separate number.

It is hard to think back to my early exchanges with Mr Rothstein. The dark, muffled voice. Was it Arab? Or West Indian? The quirky pauses and interruptions – he would break off and resume – were all disturbing. And there were sudden flares of annoyance. We started with establishing the basic story. He said that he had 'access' to the two pictures, and he wanted £30,000 if he was to let the Tate have them back: 'I haven't stolen them myself. You must understand this. This is very important.' The two Turner paintings had been brought to London after the theft and he was in charge of guarding them. At the end of the week they would be 'auctioned' by the thieves who had brought them from Frankfurt. 'If you can get authorisation to pay me £30,000 then I will be able to arrange for the release of the paintings? It will be difficult, but I can do it.'

I explained that this could be possible, but it would take a little time. (Jill McTigue had already said that I should use reference to higher authority, a director or chairman, as a way of stalling him.) I also started asking about how I was to believe him. 'How do I know that what you have told me is true? How can I know that this is a serious offer?' I then asked him to call me back later. When the third call came I rushed upstairs to Nick's office. My heart thumped and my body felt cold as I took the receiver. I knew I had to invent the next bit of dialogue in order to discover what he actually had (the paintings? information about them? access to them?) and to make offers that I was unable to back up (the money? some of the money? a ploy for the money in the form of a briefcase?).

At some point that morning it emerged that Detective Inspector Jill McTigue had a BBC film crew with her (actually an independent company, Touch Productions, working for the BBC), making a 'fly-on-

the-wall' documentary about the Art and Antiques Squad. The sound man and camera simply emerged in the Director's office and started filming. So all the main briefing session with the police in the late morning was filmed, including our having to re-run bits of me telling Jill what had happened on the telephone, what information had been exchanged. Rothstein was due to ring back at 4.30 p.m., and Jill arrived with another senior officer from the Art and Antiques Squad, Dick Ellis (and the film crew), to wait for the call and talk through the next stage. Nothing happened. And still nothing. By this time we had another number to use, if and when Rothstein called again. We were given an additional British Telecom line on which we were instructed to tell someone called 'Tony' when a call came in on the special Tate number. Ringing this extra number was a constant part of activity over the next few days, with the oddity that sometimes nobody answered or appeared indifferent when I got through. Meanwhile, I was practising writing notes on only one pad of paper, firmly instructed that this must not be

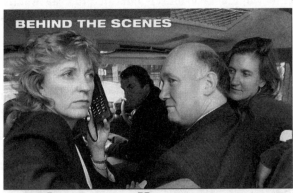

BEHIND THE SCENES

Stakeout: Producer Carrie Britton (right) poised for action with the Art Squad team (from left) DI Jill McTigue, DS Tony Russell and DS Dick Ellis. Below left: Tony and Jill with one of the stolen paintings

the Tate's director in case it all turns dangerous. As both sides approach the meeting the suspect begins to smell a rat and races off in his car.

The squad and crew set off in hot pursuit, with Paul desperately trying to get the best footage.

'I've done a lot of filming in the back of police cars at speed and it's very difficult,' he says. 'You're fighting for space and trying to stay steady so the picture doesn't wobble. At the same time, you're trying to make sense of what's happening outside.

'Then, at the moment of arrest, the adrenalin is flowing and you're always wondering whether the suspect will get away.'

Suddenly the two cars – plus police vehicles appearing from nowhere – screech to a halt and surround the suspect's car.

Carrie races alongside Paul as he films the action, handing him reels of film, each of which only lasts 10 minutes. 'It's so nerveracking,' she gasps, 'I'm

'What really scares us is running out of film'

Inside Story BBC1 Thurs

They could face arch criminals or armed robbers but for the undercover camera crew there's only one true worry...

● Documentary
● TV joins the art detectives
● TVTimes FIVE-STAR RATING ★ ★ ★ ★

producer Carrie Britton. 'He knows police procedure and the officers too, which helps to smooth our way.'

and Antiques Squad, is told of the massive theft – but has no leads to follow up with her small full-time

squeeze into the back of his unmarked car. 'The buzz comes when you grab the suspects,

Jill McTigue and Dick Ellis with TV producer Carrie Britton, *TV Times* (17–23 June 1995).

used for anything else, that is, must not have any other indentations on it or over it, and in due course would be signed and dated by me on every page.

We waited, but Rothstein did not call back. Maybe he had given up, although this did not seem likely because part of his last call had started to get more complicated. 'You are to contact your director, Mr Serota, and ask him what the names Alan and Michael mean to him. Ask him that.' I couldn't get more out of Rothstein as to what he meant by this or what he was really after. 'Just ask him about the names', Rothstein said with great emphasis. This might also help us to know whether Rothstein was serious, and later in the week I did ask Nick if these names registered in any way. They didn't. The nearest thing was either the names of Alan Yentob and Michael Jackson, Heads of BBC1 and BBC2 respectively, or Alan Bowness and Michael Compton, previous Director and Head of Exhibitions at the Tate. The connections had been in my mind, but it didn't signify in any useful way. At 6 o'clock we gave up and agreed to meet again the next morning. Jill had already indicated that she wanted an undercover plainclothes specialist to join me as my 'curator'. He would need to be given an introduction to Turner, and an induction in handling paintings.

Jill had tried to call that night at home, as had Nick before he left for a holiday in France, but irritatingly our home landline went on the blink. Jill wanted me to brief 'Peter' (I never knew any other name for this undercover officer). At home, I went over everything with my partner, an art historian, describing to her the strangeness of these unpredictable conversations and the nervousness I felt about dealing with someone who might actually connect to the stolen works.

The next morning started with Jill and the film crew together. Peter was to become the Gallery's new expert curator (and my associate in responding to Rothstein). So I had to give Peter a beginner's introduction to Turner (on camera), which felt faintly ludicrous. Thirty minutes later and he was meant to be able to act like one of the Tate's Turner experts, although there was an assumption that the thieves would themselves know so little that it would not matter. It either said a lot for his acting skills or something about the

ease of imitating the manners and behavioural characteristics of curators. Peter was intriguing: a youthful-looking 30-year-old, good-looking and clean-cut. He appeared more like a youngish business leader, confident and supremely clear about what had to be done next. He certainly helped keep my nerves under control.

We then agreed that if Peter *was* to be a top expert he had better have a name and an identity. This had to be Andrew Wilton, Head of the British Collection and senior Turner expert. We had already organized for Alexander Dunluce, Tate's Head of Conservation, to take Peter to the stores to learn how to pick up and examine a painting – so Alexander, who was officially Nick's deputy in this period, had already been given the basic information about the situation following the theft. Otherwise, Scotland Yard insisted on the idea that they were 'not there'. If anybody asked, then the Tate had to say that it was dealing with the Frankfurt police. But Jill had also made it quite clear that I was to speak with no one (neither Frankfurt nor Tyler & Co., the loss adjusters) without going to her first.

Reinventing Peter as Andrew Wilton involved bringing Andrew into the very small circle of those informed about Rothstein. Andrew was, conveniently, away from the Gallery, having just had a minor operation. In a parallel conversation I realized that we should brief the secretaries in the office of the Chairman of the Trustees in case anyone tried to get to him or send him a ransom note following the theft. (We had already worked with the Gallery's Information staff so they were prepared for calls coming through to the Information Desk, or for odd letters or further strange phone calls – a ransom note that followed on from a theft at Sotheby's had apparently been calmly handed in at the front desk by one of the criminals.) I explained it all over the telephone to Andrew on his convalescent bed. He agreed, and told me where in his office we would find his business cards: the essential modern item of identity.

At this point I called a halt to the filming, politely pointing out to Jill that it was difficult enough to deal with the current situation, but doing it on camera was impossible. She agreed to the immediate withdrawal of the filming team. We had already run into the problem of the crew wanting access to the store in order to follow Peter, which was forbidden under the Tate's general security rules.

Footage of the stores is never allowed. Suzanne, Nick's assistant, Lynn and Laura, my assistant, had found it very difficult having the camera around. They did not know what was expected of them either in shot or out. It was unfair and unhelpful. I also spoke with Carrie Britton, the producer/director, and she was apologetic about how the crew had arrived so abruptly at the Tate the day before. She also offered Nick and myself viewing and editing rights at the rough-cut stage, if the Rothstein story stayed in the overall coverage of the Squad.

Rothstein called again and picked up the thread on Tuesday by demanding to know why I had talked to the police. I bluffed and said that I had had no contact except with the Frankfurt police, on the Friday immediately after the theft. I kept repeating that I had no interest other than to get the paintings safely back to the Tate. In this call he explained that they were safe and well protected. 'I know how valuable they are', he emphasized. (Why then was he only asking for £30,000 to get them back? I couldn't quite ask him this directly.) He repeated an earlier threat that the paintings would be 'auctioned' on Friday and he was simply offering them at the starting price for the black market bidding – his role was to guard them and he could only just afford to let us have them by slipping them out from under the watchful eye of colleagues. He then asked that I speak with him later, and happily – given how much work had to be done – I agreed to an afternoon time.

Just as I was trying to get on with other pressing bits of work, I was interrupted by a question on the phone to do with the arrangements for the television crew to join me for the next telephone call from Rothstein. This was very odd since I had specifically said that no more filming was allowed. When I rang Jill, she and Carrie knew nothing of any call. Who had called this time? I wondered later if Rothstein might have been invented by the Art and Antiques Squad as a way of getting more coverage for their work through dramatic sequences appearing in a BBC documentary, perhaps to counter the threat of being disbanded and merged with other parts of 'special operations'. Or perhaps Rothstein had simply invented himself?

Tuesday afternoon involved parleying towards a meeting – an exchange – and agreeing the terms under which it could take place.

Where and when, and with exactly what? In mid-afternoon Roth-stein rang back unexpectedly (most of the exchanges followed agreement as to when to talk next) and demanded that I speak only on a mobile phone. 'You must bring the money in a briefcase of the size that I say. Its size must be no less than 6.5 cm, and no wider than 7.5 cm.' 'Deeper', I corrected. 'No, wider', he said. I tried again, and then he said: 'Look, it must be a case, a slim-line briefcase, to contain the money, and no more than 7.5 cm off the ground, if laid down.' 'OK', I said. I think I finally got it. Or we both did.

Actually, I had already discussed a briefcase, Jill having spotted Nick's empty case sitting by his desk. I mentioned it in one of my brief conversations with him in France and he had said it was fine. Later, he had asked us to use another. The first had great sentimen-tal value – it had been his mother's. Jill was asked to come up with a briefcase to match the specification. She also had to come up with the £30,000. I had been reassured that, since the loss adjusters knew nothing of this operation, it was Scotland Yard that might have to come up with the money if it were needed to facilitate a meeting. Infinitely alarming was the thought of losing the money without gaining the painting.

Wednesday morning started with Peter at my side as I was on the phone, while he kept in touch with Jill at the control room at Scotland Yard. By the end of Tuesday I had started to question Rothstein hard as to how I could know that he really did have access to the paintings. He had already rejected providing a photograph of them with a copy of the *Evening Standard* propped up in front (indeed, I had thought this idea was far too corny but had been told that it was still common prac-tice in hostage or ransom cases). He said: 'I don't have that access. The paintings are guarded by others as well. I am one of several guards and there is no way that I can take photographs without it seeming sus-picious. You know they are very secure.'

Rothstein phoned later than agreed that morning, but I had transferred on to the mobile, assured him that I had the briefcase ready, and I also stopped and started quite a bit, claiming that the connection had broken or that I couldn't hear him. Getting him to redial seemed to help the police a lot. Presumably, they were trying to locate him or to track the account that he was using. Some of this

took place with me rather absurdly mimicking a crackling or non-working line. It was hard to believe that he would believe it. But he did. He needed me as much as I needed him.

Wednesday was filled with negotiations about the exchange: where and how it should take place. I was given continuous guidance from Peter as to what we would or would not accept. Rothstein started with a whole proposition about meeting in the evening, which was the only time when the 'paintings could be moved'; otherwise, I have 'six pairs of eyes upon me all the time'. 'But', I responded, 'the evening is quite unacceptable to us. I cannot endanger myself or my curator by walking about London carrying thirty thousand pounds. Never mind the question of carrying the paintings in the dark.' There was a lot of stuff from him about the countdown, day-by-day, to the 'auction': only limited time was left for us to obtain the paintings. He reiterated that the paintings were safe, including a line about how 'he too knew the true value of these things'. We were being offered an incredibly cheap deal (and obviously my mind was on the real value of the two paintings), and we shouldn't mess him about, etc. Every now and then he would get angry, and increasingly, with Peter's encouragement, I would get tough back, explaining that we had had other enquiries (which we hadn't) and still had no proof from him that he actually had access to the paintings. All the time, although I got tougher, I was aware of not wanting to push him too far, either because he might actually have the stolen Turner paintings and get worried that I was working with the police, or that he did not have them and we would lose the chance to eliminate him from the full investigation of where they were. But who was trying to catch whom? He wanted to lure me into a meeting and for me to bring the money (I kept thinking about why he would do this? and how it was that he thought that he wouldn't get caught?); and I wanted to lure him into a meeting either to get the paintings, or for the police to arrest him and take him out of the equation. Both of us were using false pretensions simultaneously. Or at least I knew I was. Maybe he wasn't.

Peter and I had by now the almost continuous use of Nick's office at the front of the Tate, overlooking the Thames at Millbank. Cups of tea and coffee came frequently, and Jill McTigue and Dick Ellis would either drop in or ring Peter on one of the lines in Lynn's

and Suzanne's outer office. Peter's crucial expression was whether Rothstein could show us that he was 'real'. Since I had a more and more fragile hold on reality as the week progressed (and the worst cold that I had had for more than eighteen months), this phrase became more and more poignant. 'Get him to show that he is *real*' was Peter's insistent instruction, although wonderfully ironic given that I never knew who Peter actually was. I was trying as best I could, but had to translate this back into my own vocabulary. Peter's working manner with me was exemplary, but he was used to going underground and speaking the language of the 'other side'. Rothstein asked me what proof I wanted. I explained: 'If you can't take a photograph, you have to tell me what is on the back of the paintings: what can you actually see? Describe in detail what is visible.' Some description of the stretcher, with the canvas tacked to it, the reference numbers or any transit labels would clarify whether he was or was not with the actual paintings.

This caused a gap in the middle of the day and also a renegotiation on timing. Our latest time had been 4 p.m. and his earliest 7 p.m. I had said again and again that it had to be a straight exchange of the paintings for the money; and we had to know for certain that these were the paintings. I and my expert curator would need to see the paintings, would have to examine them and check that they were genuine, and then and only then would we hand over the money in the briefcase. At a later point I agreed that we would do 'a show' (open the briefcase to reveal the money) to demonstrate that *we* were 'real'! After lunch, when Rothstein was meant to have checked the back of the paintings, he pitched very aggressively about a change of plan and how only he could set the terms of an exchange, not me. 'There has been a change in the programme', he asserted; and this became a frequent mantra from his barking voice. But when I challenged him about the identification, he bluffed and said nothing, went off the line, produced confusion, came back and then off the line again, and suddenly I was speaking to someone else. 'Who is that?', I said. 'Mark Silverman', he replied. 'Oh, and who are you?', I said. 'I am not at liberty to disclose that, sir', he answered politely. He had an American accent. Anyway, he broke off, saying that they would ring back soon.

Rothstein rang again: 'I cannot see the back of the paintings because they are wrapped; they are covered in tape. Tape runs over a wooden backing. That is all that I can see.' I pressed him, but he said that it was impossible to see more, and he could not take the packing tape off or this would seem far too suspicious to his fellow guards. But, he said, he had looked at the front and he could make out a monogram, or so he thought. 'It has the letters, J M W T'. I did not counter this but let it ride. And he agreed to an earlier meeting, at 5 p.m. He then produced a whole elaborate spiel about couriers, about us being met and taken to where the pictures were, 'when they have been brought into central London. Only at this point will I be allowed to have the key to the safe house where the paintings will be deposited.' Then there would be an exchange, as we wanted.

The police simply expected to use a hotel of their choice in central London, that is, one that they could cover with discreet plain-clothes officers. At one point Rothstein said he would not want to meet in a hotel because 'that is where the police operate'. He was right, of course. We could not agree and the conversation ended with him asserting that I was to come to the Paddington area during the late afternoon, and that he would phone me from there. He had already asked me to make sure that I had spare batteries for the mobile, although the police immediately invented an excuse so that there would be a limit to me wandering about different parts of London or beyond. I did not quite say that I would be there, but hadn't said that I wouldn't. But we didn't go. We switched the mobile off and arranged things so that we would not take any more calls.

On Thursday morning Peter declared that he and Jill no longer thought it credible that Rothstein had the paintings or access to them. But they wanted me to play along so that they could arrest him for deception or extortion. On the Wednesday Peter had said that from listening to the tapes he thought that the caller might be African. I had explained my confusion from the beginning as to whether the voice was Middle Eastern or West Indian or even occasionally middle European; it seemed to oscillate. His view now was that 'Mr Rothstein' could be Nigerian, not least because, as Peter put it, some Nigerians 'have a tremendous gift of the gab, they like telling stories and are famous as con men'. It sounded plausible, but not what I wanted to hear.

I wanted Rothstein to be telling the truth. I desperately wanted him to have the paintings. I was willing him to have given a true account of the wooden backboards and the packing tape (his account had been relatively convincing because when museum paintings go on loan they often have a backboard screwed on to protect the canvas from accidental damage in transit). Quite separately, we had given the police in London and Frankfurt the true identifying marks for the paintings, on the stretchers and on the backboards; these had also gone to the Hamburg Kunstverein and to Mark Dalrymple at Tylers, the loss adjusters. This was precious information, since it could be used to construct a false ransom scenario. Each day I had become more certain that Rothstein would read about the actual $250,000 reward that had now been offered for 'information'. We had wanted as much publicity for this as possible, but it was evident that either way it would make Rothstein's own demand look very paltry. It was increasingly clear that his demand had been at the wrong level, and his story was almost certainly invented.

Peter invented an excuse for me to use as to why I had failed to show up 'in the Paddington area' the night before. I had been called unexpectedly by Nicholas Serota, who had demanded to know where I was going. I had explained the terms of the planned meeting with Rothstein, and, although I would still have come, Serota had vetoed the idea that I and my curator should be out, with the money, in the evening. Serota – I would explain to Rothstein – cared passionately about the paintings, but he cared more about human life. He had therefore ordered me to go home and made clear that he would ring me there to make sure that I wasn't in Paddington in defiance of his views. (The supposed rift between Nick and me was constructed to make Rothstein and myself conspiratorial allies – I added a whole piece about calling me only on the mobile number, and not being able to talk to anyone else at the Tate about what was happening.)

Since the Wednesday afternoon, I had, of course, checked with Andrew Wilton about Turner signatures. He was explicit about the almost complete lack of signatures except on works that Turner had sold (like those to Lord Egremont at Petworth) and *never* a monogram or initials. A few lines written in paint on a late painting now in an American collection was the nearest. But interestingly Andrew

suggested that frequently people 'saw' signatures or monograms in a painting even though they were not there: they so desperately wanted the letters to demonstrate that their painting *was* 'a Turner'.

Rothstein swallowed the Nick story, but now laid more and more emphasis on the lack of time, and on wanting to proceed to a meeting. I said that I would get the money out of the bank. And we had a 'gap' in the conversation while supposedly I did this. Peter, of course, turned to me and asked 'where does the Tate bank?' I had no idea. But luckily the answer was Coutts in the Strand, and it seemed perfectly appropriate in terms of timing and accessibility. So I pretended that we had obtained the money and we went back into a debate about what sort of meeting and where. I had already suggested (as the choice of the police) the Landmark Hotel at Marylebone Station. Pure Monopoly, I thought. We were far from agreeing amicably because Rothstein made it clear that he could not 'expose' himself. But we finally came to an agreement – with Peter making signs and scribbling me wonderful notes of guidance while Rothstein was on the line. Rothstein said that he would send a signal with a courier and it was agreed that there would be a password. He came up with the phrase 'on tour'. 'As in a rock band', he said. It had all taken hours of arguing and counter-arguing, but at the end I said that my 'expert' and I were simply going to the Landmark Hotel and he was to meet us there and discuss the arrangements for the exchange. We would bring the money in the briefcase.

Peter had already indicated that Rothstein might have the Tate watched – because there was no way of knowing how many accomplices he had – and certainly could be expected to have the hotel covered. I was relieved that we were taking a briefcase but not, now, the actual money. But I was more nervous when I overheard some sharp words from Peter (spoken via walkie-talkie with a hidden mike to Jill at the Scotland Yard HQ) about what we might actually be walking into. I was less anxious without the money because although notionally we were tempting Rothstein (or his courier, who might actually *be* Rothstein pretending to be a courier) with a 'show', I had from the beginning of the week had a nightmare scenario in mind: handing over £30,000 of real money (belonging to the police) to Rothstein or his people for what seemed to be the paintings, and

then finding afterwards that they were fakes. This nightmare was fuelled by Andrew saying earlier in the week, in a very quiet but forceful voice: 'How, Sandy, will this plain-clothes police person pretending to be me actually know if they are the paintings?' 'It'll be obvious', I had replied. 'Will it?' said Andrew insistently, 'It might be quite difficult.'

We left the Tate for the hotel at about 1.45 p.m. I knew that Peter was wired by radio to Jill, and had a minute tape recorder strapped to his back in order to tape conversations. I also knew that trying to catch an extortionist was complex because there was almost no hard evidence: we had to pin down every conceivable fact and connection in order to have something that would stick in court. Even if Rothstein and any accomplices were caught, it would be an intricate business actually to get a conviction. For the moment the chaos it was causing in my life was all too apparent.

Peter revealed the size of the operation, with a surveillance team all over the hotel and an 'arrest' team, and us, all connected through the Scotland Yard HQ. It should not have been a surprise that a special radio cab, identical to an ordinary black cab, glided up John Islip Street and met us precisely as we left the rear of the Tate site. All it had needed was for Peter to mouth into his chest 'we are now leaving the staff entrance, and walking across the car park' for this magic to work. As we travelled to Marylebone Station, there was intermittent conversation between Peter and the driver, and not the usual taxi-cab banter.

The hotel was filled with groups of men sitting at small tables, in close conversation or smoking. All of them seemed to have mobile phones set out on the table. Any of them could have been Rothstein. Except there was clearly no one sitting on his own. No one seemed to be just waiting. So we found a table, with Peter sitting close so that his mike would pick me up in any conversation. And as we entered he had looked around to check the balconies and the overlooking corridors and access areas. It was hard to see any police cover, except one or two people who glanced in our direction. The briefcase was placed fairly prominently beside the table. And we waited – for some time, and then for more time, and finally a call came on the mobile. It was Rothstein.

He claimed to be coming, and would arrive in a red car. Peter went to the loo to confer with the other teams. They now had the front of the hotel covered. And after some time the signal came through that a red car was pulling in. So we got ready. But for nothing, because the car didn't stop and no one climbed out. No Rothstein. In the next call I said: 'What are you playing at? You said you were coming to talk. The two of us are sitting here and waiting. Why should we do this – we have the briefcase. We will not wait much longer.' He was almost apologetic – he concocted a new story about how he couldn't get away from his duties in relation to the paintings. Was the red car his? Hard to know; he may have been trying to check whether we were there or whether the police were there as well.

After further argument and debate – I went on about the danger, and wasting my time and that of my curator – we agreed that it had to happen the next day. It had to be on Friday. This was the last possible time within the schedule he had set. So we agreed that it would still be in the Paddington area, and that in the morning we would agree on a new meeting place, and then we would go straight on to an exchange. It sounded so simple – but the police wanted further delays so that they could get a better track on his mobile. This was the same scenario of breaking off the call, making it sound as if there were an interruption. All the while I was thinking more and more about where the paintings really were. Who had them? What was happening in Germany? Were the police making any headway in finding those responsible for the theft? Rothstein was intriguing, but perhaps absolutely irrelevant. That night my partner asked what I thought I was walking into the next day, but it was hard to know. The worry was obvious: that Rothstein and his colleague might be armed, or might think that they could succeed only through violence. She was not happy, making me promise that I wouldn't put myself at risk. I agreed, but knew it might be more dangerous than I wanted to admit, armed only with a briefcase.

Early on Friday Jill and Peter made it clear that I would not be going to the meeting. Peter would go, but I would stay at the Tate. Jill would not countenance the risk of having me in the middle of something that might get out of control. I was disappointed, but this was not up for debate. We discussed how they could find a substitute

for me, together with the false expert curator! So Peter and I invented the idea that I would not actually be there, but would pretend to go along to make the exchange. I would continue on the telephone and would convince Rothstein through my voice – offering the critical degree of continuity – that it was me in the flesh. This would need a bit of coordination but was worth the risk. Since Rothstein had never seen me, it was a much lower risk than having someone pretend to be me on the phone through imitating my voice.

Given that Rothstein had now agreed to a morning meeting, we would propose the main concourse at Paddington Station. Then – and only notionally, because an undercover officer would actually be in my place – he would lead me to where the paintings were. To get a firm conviction for extortion, Rothstein needed to be seen in contact with what he thought was the money while pretending to be about to exchange something that he did not have (supposedly the paintings) – as opposed to what he wanted, which was to convince us that we would give him real money because we believed that he would give us back the two valuable paintings that had definitively been stolen. That was what it came down to.

Endless further conversations were required to establish timing and location, Peter giving me more and more encouragement to get tough with him, to try to call the shots. Paddington Station was finally agreed on for noon: on the main concourse, but just me, and no 'expert' with me. And then the final escapade started. I rang him to say 'OK, I am leaving the office at the Tate, and about to walk out from the Gallery. I'll call again when I am in transit.' In my mind I walked out of the back of the Tate, through the staff entrance and towards John Islip Street to pick up a cab. I counted out the time to get into the cab and head up towards Hyde Park Corner, allow a little time for traffic and a bit more (as the police called back to slow me down) and then I rang him 'from Park Lane' – 'I'm just travelling up towards Marble Arch, but the cab's run into some traffic. But I'm on my way' – with my head out of Nick's office window to give the impression of traffic noise around me. And then another delay 'on the Bayswater Road' – 'I am getting there, I will be about seven to ten minutes'. It sounded OK. Amazingly, he didn't seem to doubt that it was actually happening. And then the arrival at the station.

I timed it to the minute, and this was now the point at which Scotland Yard had someone walk into Paddington holding a briefcase and ready for a meeting, with a mobile phone connected to the central control office.

But my substitute reported that no one was there. And I rang Rothstein, shouting: 'Where are you; I can't see you at all – are you here? Where the hell are you?' A pause – and then he said: 'There has been a change of plan – it is necessary.' And I started really shouting: 'This is unacceptable – I am completely exposed. I'm standing in the middle of Paddington Station [actually I was now in the upper part of the Tate Library, where the balcony surrounds the entrance rotunda and the sounds of school kids and general visitors come floating up through the space and create a compelling hubbub of public sound], with £30,000 in my hands. I am not prepared to be put at risk like this.' 'There is no choice', said Rothstein sternly. 'Take the Hammersmith Line to Westbourne Park. That is where the meeting will be.' With nods from Peter, I had to agree – and then I told him I would ring when I was on the Tube train itself (because the line is above ground at that point). And then I had to stall, since the police needed time to move the surveillance operation and get into new positions.

The next part of the story is mixed in my mind between what actually happened and the re-telling of it through the BBC documentary. At the time I had no idea that the TV crew was still following this part of the case. Indeed, I think they had stopped telling me anything because they knew that I did not want them around. But the images of the action are theirs. I had no 'sight' at this point, sequestered in the Tate at Millbank, only hearing back from Peter what was happening on the ground. So I 'paced' very slowly – in my imagination – across Paddington Station to the Metropolitan and Hammersmith Line platforms, and stood – in my mind – on the edge of the platform waiting for a train; and at this stage it had to be made more realistic. So I rang and said: 'I have just missed a train – another westbound is just coming. The phone may cut off when I am in the carriage.' The police fed back the timing of the actual trains, to the point at which I would have been boarding, being then about seven minutes away from Westbourne Park. And so I told this to Rothstein and then cut him off. And waited the seven minutes, before imagining that I was

now at Westbourne Park and ringing him instantly to say: 'Where are you? I cannot see you – where the hell are you?', to which he replied: 'I am here on the other side of the station – where are *you*? What are you wearing?', at which I stalled, and stumbled through an interruption on the line, turning to Peter to say: 'What the hell *am* I wearing?' After calling Jill at the control room he came back with the answer: 'You are wearing a polo neck and slacks.' 'I would never wear that' was my unhelpful thought. But I rang Rothstein back to tell him and said: 'I am walking over the bridge, to your side of the tracks.' I heard him say: 'I'm at the end of the platform', but breaking off and saying 'Hey, what's going on? What's happening?', and I knew it had to be the end.

The BBC footage shows this shadowy figure at one end of the eastbound platform of Westbourne Park, with, unbelievably, a dustbin liner over his head running along next to the fencing, which had vertical metal stanchions. The metal uprights are closely spaced. This explained the obsession with the width of the briefcase and how Rothstein had planned to snatch the briefcase, push it through the railings, to an accomplice standing in the bushes below, and escape in a car parked nearby. At least that bit had been well thought out. But both of them were arrested, taken away and charged. This I knew later from what was relayed over the phone from the police control room and from what was recorded on the TV footage.

There was no great celebration. We still did not have the paintings. Rothstein had been caught and it was the end of a false trail. It emerged that he was a young Nigerian, named Nwanosike, aged 24, with a record in deception and petty crime, with an accomplice, St Louis, who was even younger. Both were determined to obtain money in very unusual ways. At some point, when the police got back to the Tate, I handed over all my notes from the many telephone calls and signed off a statement for the police. It had been an exhausting day at the end of a bizarre week.

I was not asked to appear as a witness, neither at the Magistrates' Court in Horseferry Road, nor in the full hearing (Wells Street) that took place on 2 February 1995. Rothstein, Nwanosike, was given a sentence of eight months, and his accomplice, St Louis, a conditional discharge, having no previous 'form'. But nothing had moved forward

in relation to the stolen Turner paintings. They had created a strange diversion from the story that I wanted to unfold. Later that year, on the night of 5 August 1995, I was woken by the phone in the middle of the night, perhaps at about 2 or 3 o'clock. I woke from deep sleep, to hear a male voice say: 'I've rung about the meeting'. 'What meeting?' – 'You know, the meeting. The one which has been planned' – 'Sorry. What meeting?' – 'Listen, you know what I am talking about. The meeting in Moscow Square.' I couldn't handle this. I had nothing to say. I put the phone down and then thought to ring the police and Mark Dalrymple to see if this was part of any current investigation. But I was too spooked to do anything, and it was the middle of the night. It was impossible to sleep.

The next day I found nothing. There was no news on the investigation. That was it, until I realized that the previous day was the anniversary of Rothstein's arrest. And he had been out of jail for at least three or four months. So he had not forgotten me, or how he had been caught. Every 5 August for several years I switched the phone to a recorder at night and unplugged the other extensions, in case he phoned again – perhaps wishing to honour the anniversary. But nothing came through. The diversion was complete.

Pursuit

August 1994

After the shock of the theft itself – and the diversion in the following week – I felt an immense sense of loss, both personal and collective. The feeling was pervasive and hard to suppress. I felt anxious. With effort, I could summon up some sense of hope, knowing that a considerable reward had been offered for the two Turner paintings and the German police were pursuing their investigations. I imagined rather vaguely that the Interpol system of information exchange across Europe would yield a few leads. But equally a huge unknown space opened up after the theft and the Rothstein distraction. If these criminals had any sense – audacious Frankfurt gangsters, or whoever they actually were – they would keep their heads down and hide the paintings well. Why would they go to any risk now if they could store them away for a number of years and then realize some value from them in the future?

Mark Dalrymple, the loss adjuster, recalled the summer of 1994, and some of the leads that surfaced:

> Within a month we started to get information that seemed to relate to the Turners. It was quite difficult to be clear about the origin of that information, because quite a number of people were involved beyond those who actually perpetrated the theft: the two thieves, the van driver and the handler . . . At the end of the day, we were not interested in the thieves, we were interested in what the thieves had done with the paintings. Very rarely do thieves hold on to these things. They do these jobs for money.[1]

The recovery of stolen art involves a twin-track approach and different priorities. The police are determined to find those involved with the theft and will also hope to find the stolen art. And the loss adjusters (working closely with the police, but employed by the insurers) want to find the stolen paintings, and help to ensure that all the relevant criminals get caught in the process.

Mark Dalrymple had organized for the reward of 'up to $250,000, subject to specific conditions' to be published. The reward notice referred rather blandly to 'Two highly important paintings by J.M.W. Turner and another by C. D. Friedrich', and asked for information to be forwarded to Detective Inspector J. McTigue, New Scotland Yard, or to Mark Dalrymple, Tyler & Co., Chartered Loss Adjusters. The notice, published in the *Antique Trade Gazette*, *Trace* and the French, German and Italian editions of the *Art Newspaper*, gave a German contact address.

Under UK jurisdiction it is illegal to publish a reward without any strings attached.[2] The 'specific conditions' are crucial to ensure that a reward is not used to give benefit to a criminal involved in a theft. The conditions must be tested, and therefore a reward cannot be paid without specific approval from the police. In the days immediately after the theft, and after returning from Germany, I noted down:

> A clear distinction must be drawn between offering a reward for information leading to recovery and arrest, and paying a ransom demand for the return of the works. The Tate, DNH [Department of National Heritage] and Lloyd's will obviously all be clear on this issue. Herr Paul believes the former, if the timing is right, could be very effective.
>
> This may not be the place or time for speculation on the state of security at foreign or British galleries, but such a theft brings into sharp focus the ease with which a well-planned robbery can be accomplished, and the fact that some will try it. There was only a single guard in a complex and seemingly easy-to-hide-in building, with several one-way fire exit doors which could provide exits or elicit entry. The guard was linked to a security system, but although this worked, it was

too slow to prevent the theft of the paintings. There was a full and sophisticated alarm system but with a gap in time before it was set.

The Kunsthalle is a complex building with the offices of the Music School within it, and it has no secure space around it. Rather, the very presence of the Cathedral, housing and cafés close to hand must have made it easy for a van to drive up and away without causing any particular attention.[3]

I reported on the security issues to the Tate Trustees at their next full meeting, but my mind was mostly taken up with questions of pursuit. Instead of coherent reports from the investigation, what emerged was random and partial intelligence. Over the first two months Mark Dalrymple picked up stories about the paintings being taken to France and then Spain, seemingly to be offered to other criminals, and with no chance for the police to intervene. I remained uneasy.

The initial investigation was being conducted by the Frankfurt-am-Main Organized Crime Squad. After setting up a reconstruction, collecting evidence from the Schirn Kunsthalle staff and from witnesses that evening, the Squad eventually got to the point of being able to make arrests. Over a period of time they arrested nine suspects, only some of whom they could actually connect with the emerging evidence. Looking back to this period, Rocky (Jurek Rokoszynski), working then as a Metropolitan Police undercover officer, recalled:

I first heard about the theft while I was doing a job in Germany with the BKA [German Federal Criminal Police]. The thieves and the handler were arrested soon afterwards. Two characters, Turk and Weiss, were arrested dozens of times. Apparently they had an alibi for the actual time of the robbery. They said they were in a disco or a nightclub in the red light district, and they could prove it. But the clock was hours out of time, and only years afterwards, when the clock was checked against the actual time of the theft, did the truth emerge.

The police had their thumb prints or partial prints right from the start, because they had left them at the Schirn. There was also a third person, a 'handler'. He was the one that the

BKA put an undercover agent onto, to try and obtain the paintings, but each time he was arrested he would keep his mouth shut and would have to be released again.[4]

Rocky was to become central to the pursuit of the paintings and his background made him an ideal investigator for this case. He was born in the British sector of occupied Berlin, to Polish parents who re-located to England at the end of the Second World War. He was brought up to challenge authority but also to respect it. Rocky was physically tall and strong, with jet-black hair and broad shoulders, and the police force seemed to offer a suitable career since it gave him the chance to play sport, rugby in particular. After he had qualified for investigative detective work, being fluent in German and Polish, he was able to employ his language skills in European undercover work for the Met. Certainly, by the time I met him he had a distinguished track record of dealing with drug gangs, smuggling rings and violent criminals: he knew exactly how to mix with those on the 'other side' and to track and outwit dangerous criminals. Rocky remembered:

After the theft, there were a lot of lawyers getting in touch with the Met, with Dalrymple, and certainly with the BKA, saying that they had clients who, allegedly, had got the paintings and were seeking the reward. Certainly a Spanish 'buyer' was involved. And allegedly the 'buyer' had been involved in putting up money for the theft . . . in this case they were asking for DM100m, and they were insisting that they wanted DM1m up front which the BKA was not prepared to offer.

In the red light district of Frankfurt, Serbs who were part of the criminal underworld kept very much to themselves. They all knew each other over many, many years; trusted each other. Once the police had the partial prints from the theft, the investigation was centred there and with people close by. The van that was used was linked to a driving licence itself linked to one of the red light district establishments, run by Serbs. But in a police interview, if they don't have to say anything, they just don't say a thing.

I concluded that the actual thieves, once they understood what the paintings were worth from the media coverage – how much they were insured for – might have changed their strategy. It was a couple of doctors, coming back from the opera, who spotted a van with paintings being taken out from the Kunsthalle and took the number, and tried to call the police, but their mobile battery went dead . . . and only got through to the police, hours later . . . Subsequent intelligence indicated the thieves had compiled a portfolio with details of all the paintings in the exhibition that were worth a lot of money.

September 1994

At their meeting on 21 September, the Tate Trustees, led by Dennis Stevenson, debated whether, in the light of the Frankfurt theft, loans to foreign museums should be curtailed. I reminded them how, set against the many movements of valuable works of art, thefts could be regarded as rare. The Frankfurt theft was the first occasion that any Tate work had been stolen since the loss of a small 1952 Lucian Freud portrait of Francis Bacon – snatched during opening hours from the Neue Nationalgalerie in Berlin in May 1988. Everyone worked very hard to prevent theft or damage of any kind. In addition to the facilities reports sent by borrowing venues, independent security reports were provided to the Tate by the National Security Adviser. Assessment of a museum's general security and a view of its management and trustworthiness were carefully taken into account when loan requests were discussed at the Tate Loans Committee (which I chaired).

If an exhibition was important (either in the consideration of a particular artist or the examination of a particular theme or period of interest) then the Tate would try to lend – and particularly to museums that owned works that might be requested by the Tate at some point in the future. This last factor had not come into play for the Schirn Kunsthalle in Frankfurt because it does not have a collection of its own. Tate loans out were formally approved by the Director under delegated authority from the Trustees, and if I was

worried about a venue or a particular exhibition, I certainly discussed it with Nick. In the case of the Schirn Kunsthalle, no questions had been raised and the Tate had no way of knowing that there might be weaknesses in the management of the security system. It had taken a shocking theft to demonstrate this.

The Trustees' conclusion was that foreign loans should continue, but that staff should review the procedures for checking venues. Trustees recognized the de facto duty the Tate held to promote the work of British artists abroad, and the Tate was itself running an ambitious exhibitions programme that inevitably depended on the generosity of other public collections. For the Tate to start cutting back its loans might be self-defeating, but more security checks could help avoid future losses.

Whatever was happening in Germany with the initial police investigation was not conveyed to me in London. But I thought about the missing canvases often, sometimes imagining damage or even total destruction. Given that the theft had been fairly sophisticated, the thieves or whoever was now holding the Turners would know their value from the newspaper reports. The reward was attracting attention from other criminals, but was it of interest to those who were now holding *Shade and Darkness* and *Light and Colour*, who might already no longer be the original thieves?

1994–6

Persistent police work in Frankfurt led to the questioning and eventual conviction of those who had raided the Schirn. Of nine people arrested, only three were in due course convicted: Yusef Turk (born 2 April 1969 in Çorum, Turkey), later sentenced to eight years imprisonment; Stephen Peter Weiss (born 28 September 1967 in Frankfurt-am-Main), given eleven years for the theft; and Stefan Harald Hoffler (born 4 December 1965 in Alzenau, Germany), later given two years and six months for handling. There were conflicting reports as to whether a fourth accomplice had also taken part in the robbery.

Weiss came from a broken home and had an unstable, drifting existence in the 1990s around the central station area of Frankfurt.

His criminal record was extensive, with convictions for reckless driving under the influence of alcohol, possession of narcotics (hashish) and attempted robbery with extortion, including a breach of the German Weapons Act for carrying a handgun.[5] Yusef Turk had been fined previously for carrying an offensive weapon, while Harald Hoffler, the oldest of the three, had no previous convictions.

The Frankfurt police report confirms that it was Hoffler who in September 1994 was apparently offering the paintings (on behalf of someone named Stevo Vuksanovi) to a Spanish buyer, and who travelled to Marbella in early 1995. Nothing came of this. The Frankfurt police report (in translation here) then details the cat-and-mouse game played by the BKA undercover investigator, posing as a buyer:

In autumn 1995 the police made contact with H [Hoffler] through an undercover investigator from the Federal Criminal Police Office. A first meeting between H and the undercover investigator took place on 28.11.1995 at the motorway services near Bruchsal. H stated to be acting on behalf of clients. The paintings were undamaged regarding the frames and expertly stored. He offered both the 'Turner' paintings for sale – the 'Caspar David Friedrich' wouldn't be available anymore – for a price of 10 million US dollars. H wanted to sell the paintings and to divide the proceeds between himself and the persons involved in the robbery of the paintings. Probably H assumed the undercover investigator was a buyer instructed by the insurer of the paintings.

The handing over of the paintings was to occur on 06.12 and on 07.12.1995 in exchange for a payment of 5 million US dollars each . . . [Various arrangements for the potential inspection and exchange of paintings and monies were then negotiated] . . . As agreed a further meeting between H and the undercover investigator took place on 05.12.1995. Both went to a car rental company in Frankfurt where the undercover investigator hired a van and handed it over to H. In the course of that day a repeated meeting took place at around 13.00 between the undercover investigator and H at Frankfurt Airport. Both went on from there to the motorway

services near Medenbach. There another undercover invest-
igator was waiting with a suitcase with 1 million DM. This
money was inspected by H and a further meeting was agreed
upon for 06.12 at about 13.00 at Frankfurt Airport.

In this meeting H informed the undercover investigator
that his clients had changed the conditions for the handing
over. Both paintings were only to be sold together in one sin-
gle move and the buyer had to put down an advance payment
of 2.5 million DM one hour before the delivery of the paint-
ings. The undercover investigator rejected these conditions.
Then a further meeting materialized at around 15.00, during
which H stated that his clients would stick to the advance
payment, which the undercover investigator rejected repeat-
edly. He called upon H to get the hired van and to return it.
H replied that his clients were holding on to the keys and
that in the vehicle there still were the paintings which had to
be carried back at first. It was then agreed upon that H had
to return the vehicle at 18.00.

On the way back from the airport to Frankfurt, H was
being observed and was arrested at around 17.40 in Eulen-
gasse in Frankfurt. He had just got out of a vehicle, a BMW.
The keeper of this vehicle is the fiancée of the defendant T
[Turk]. Also in Eulengasse the hired van was found empty
and was confiscated. The BMW drove off after H had got out
and was found without passengers by the police at around
18.17 in Rotlintstrasse in Frankfurt. The flat of the defendant
W [Weiss] was in a house in Rotlintstrasse. W and T were
arrested there at around 19.30. The fiancée of the defendant
T was living opposite in another house.

W had a semi-automatic gun of the brand Glock, calibre
9 mm, individual number ARA 331, in full working order, in
his possession without gun licence, directly next to his place
to sleep in the room in which he was arrested, together with
2 magazines and 6 rounds of ammunition.[6]

It is not clear whether Turk, Weiss and Hoffler still had access
to the actual Turner paintings at this stage. It is quite possible that

they were simply trying to extort monies on the basis of *appearing* to possess them. The German police, both in Frankfurt and the Federal force, continued to pursue their investigations, but were unable to make any link from the thieves to the actual whereabouts of the canvases. The likelihood is that the thieves were paid a fee to burgle the Schirn Kunsthalle, and having passed the paintings to those who commissioned them, would not have known their subsequent location. Dick Ellis, having become Head of the Art and Antiques Squad, and Charley Hill, a senior and experienced art crime investigator at the Met, were both still hopeful that the paintings would re-emerge. But when and how?

Between 6 November 1995 and 4 January 1998 at least thirteen approaches were made, each of which needed investigation, though some were in effect sequential attempts by the same criminals to extort monies from the underwriters or their agents. Mark Dalrymple, as the loss adjuster, tried not to take a jaundiced view as he assessed each offer of information, often arriving with a demand for an initial fee to 'unlock' a network of promised connections that would allegedly lead to the paintings. Most were from fraudsters and confidence tricksters – chancers simply trying to get some of the reward. They often approached through a German lawyer, who would then contact Tyler & Co., as the company that had posted the reward.

The laborious unravelling of these offers, sometimes involving the lead underwriter Robert Hiscox and Lloyd's of London, was a distraction from the critical matter of catching those who had planned the theft or those who now held the paintings. So it was essential to convince informants to produce actual evidence. Mark briefed me only on the most convincing of these offers. But of course – over the years – I desperately wanted each new approach to be real. Fragmentary information came to Mark about complexities within the German police forces. Intelligence seemed to go around in circles in Frankfurt, and criminality appeared to breed more criminality as others attempted to profit from the theft.

Mark was convinced that the criminals who had organized the theft had now passed the paintings on. He commented later on how they were controlled:

The paintings were held by a completely different group . . . They were east European criminals of the type that stick together, very closely indeed . . . The sanctions against people moving outside that arena are rapid and total. In other words they will kill you. The east European criminals seem to take one step further in brutality, by killing the family as well. And they do.

The only way to sort the wheat from the chaff was to have 'proof of life' as we call it. That was the key issue. From summer of 1994 until right up until the summer of 1999, there were still offers coming through, even up to the Antwerp case later in 2000. The difference here was the preponderance of lawyers, which is innate to German culture and their legal system. People rush off to a lawyer to make any kind of a statement.[7]

In the mid-1990s Rocky was working with a senior colleague from the Metropolitan Police, Mick Lawrence – an experienced senior detective known for his work in solving murder cases – on a case on the Czech border, helping to investigate art and antiques going missing in the wake of the collapse of the Communist state. In the light of these contacts, and the potential for links to those who might be holding the Turners, an alias was constructed for Rocky as 'Jan Koval', an insurance investigator invented as if an employee of Tyler & Co. Rocky found a natural position in undercover work, where his larger-than-life personality, language skills and outstanding ability to assess risks and opportunities could be put to good effect in exploring criminal networks. He was accurately described once as 'Looking more like a criminal than most criminals . . . [with] an ability to mix with all layers of society'.[8]

1997

In April 1997, as all efforts by the Frankfurt-am-Main police to recover the paintings had failed, the national criminal force, the Bundeskriminalamt (BKA), was instructed by the Frankfurt Prosecutor's Office to take over complete responsibility for their recovery.

Soon afterwards, two men were arrested and convicted for attempted extortion from the insurance companies. At their trial they both admitted that they were never in possession of the paintings and neither could gain access to them. Dietmar Burchadt (born 28 August 1957 in Essen) was given a two-year suspended prison sentence that was amended to five years probation, and Wolfgang Heinrich (born 19 May 1953 in Essen) was sentenced to eighteen months imprisonment suspended for three years.[9] They were interviewed in custody by Rocky and they provided the name of a Serb who apparently had had access to those in possession of the paintings. Connections could never be made and this man happened to die a short time afterwards.

1998

At the start of the year, having been out of touch for a while, I asked Mark Dalrymple to update me. His view, as on other occasions, was broadly optimistic. Sifting between the false leads, he was still hopeful that one of them would offer a genuine link:

> I base my supposition on my experience of the greed of criminals. Sooner or later they will want to see if it is possible to gain some return after holding such 'hot property'. Whether it is stolen jewels, a shipment of drugs or arms, or high profile fine art, criminals always want and also require a return. That is the way they work.

He wrote: 'Inevitably, it is a long term project.'[10]

But by March 1998 the BKA was thinking of discontinuing its investigative work because of 'technical difficulties' (the actual thieves were well on the way towards being convicted in early 1999). This caused considerable alarm for those investigating from London. According to Mick Lawrence:

> It meant that because of German regulations the police would be obliged to detain a number of people including lawyers mentioned previously. Both Rokoszynski and I were

horrified at this thought as this would seriously impede our own investigations. We had an urgent meeting with Mark Dalrymple, Peter Gwynn of Hiscox and Charley Hill of Nordstern Art Insurers Limited [where he now worked after retiring from the Met] who were in full agreement that we should continue pursuing our current lines of enquiry. The following day at New Scotland Yard we met with members of the Bundeskriminalamt. A full debrief on the complete enquiry from the original theft of the paintings up to the current time ensued. I explained both the police and insurance companies' reservations about the BKA's next intended moves. In particular it was stressed the legend [alias] that had been built up by Rokoszynski and more importantly the credibility of the insurance companies would be completely destroyed for all future matters should they follow their intended course.

Concerned about what the Bundeskriminalamt might do, we decided that a new approach was required and made a request through the [Frankfurt] Prosecutor's office to have access to their files. This is possible as German law allows insurance companies access and so in his role as Jan Koval, Rocky visited Burchard Jacoby of Bach Langheid and Dallmayr, where he spent two days reading through all their files. The information and intelligence gleaned was then fully reviewed and this convinced us that we were heading in the right direction.

Unfortunately in late 1998 a meeting took place between senior officers of the Metropolitan Police and the Bundeskriminalamt in which the MPS decided not to have any further direct dealings with the attempted recovery of the paintings and at the same time blew the legend of Jan Koval which Rokoszynski had spent nearly three years building up. This was done without any consultation with Rokoszynski or myself.[11]

This major hiatus in the pursuit was unknown to me at the time. Also the most important question for most colleagues at the Tate was

not the recovery of the Turner paintings but whether we could create the Tate Gallery of Modern Art (as it was then termed) and renew the galleries at Millbank. A sum of £130 million was required for the Tate Modern project – so the question of funding was on the minds of the senior Tate team, but in a quite different form. The insurance companies had paid out £24 million to the Tate following the theft, and this money was kept in a special interest-bearing account. The insurance payout was not available directly for building projects.

However, an option for bringing some of the Turner insurance funds into use was mooted in 1998, and became part of the work led by Alex Beard, as Director of Finance and Administration. A later Tate press statement described the process:

> The two paintings by J.M.W. Turner in the Tate Collection . . . were stolen from the Schirn Kunsthalle in Frankfurt whilst on loan to an exhibition entitled 'Goethe and the Visual Arts'.
>
> As a condition of the loan from Tate the paintings were insured by the Schirn Kunsthalle for £12 million each. As a result Tate made a claim under the insurance certificate and the insurers settled the claim for the full insured sum of £24 million in April 1995. In accordance with normal procedure, title to the paintings passed to the insurers, subject to an agreement that Tate should have first option to repurchase the paintings in the event of recovery for £24 million plus interest.
>
> By 1998 Tate had become increasingly concerned that the paintings had not been recovered and as a result a large amount of money in the insurance fund was lying dormant rather than being applied for any benefit. An approach was made to Geoffrey Robinson, then Paymaster General, and he helped devise and then negotiate an arrangement whereby Tate bought back the insurers' title for £8 million. This arrangement was approved by the Treasury, the Charity Commission and the Department for Culture, Media and Sport, and a sum of £7 million has been used for the purchase of the Tate store in Southwark.[12]

In his biography *The Unconventional Minister*, Geoffrey Robinson, then Paymaster General, a minister in the Treasury, gives his own account of the Turner case and negotiations with the insurers.[13] He contends that the paintings were stolen by a 'group of particularly nasty Serbs' and misleadingly (indeed mistakenly) states that the insurance money 'was needed for the Bankside building', that is, for Tate Modern. Although the possibility of using the insurance monies as a form of security had been raised, the real point was to see if monies lying dormant could be employed for more productive purpose, at least as collateral. Robinson did, however, spot the opportunity to negotiate with the insurers who after four years might be prepared to write off their loss. As he put it later, 'For both parties, it seemed to me, a bird in the hand would be better than two in the bush. There would be a fight over who got the bigger bird – the usual haggling.'[14]

The crucial figure was Robert Hiscox, Chairman of the lead insurance company Hiscox Ltd, a successful businessman and lover of the arts, previously a member of the Museums and Galleries Commission. Robinson recalled: 'An urbane and cultured man himself, he warned us that we might not receive an altogether sympathetic hearing from the other underwriters to whom he had syndicated the debt.' After an offer of a 50–50 split, Robinson felt that the deal could be enhanced for the Tate. A meeting was organized by Alex Beard for 3 June 1998. By Geoffrey Robinson's account,

> The Paymaster General's room had seen many noisy battles over the past year, but nothing could quite equal the screaming match produced by this bunch of underwriters . . . The motley crew fought with me and amongst themselves about what concessions could be made. It occurred to me that there really was more honour amongst thieves, perhaps even the Serbians.

Robert Hiscox's own description details the negotiation:

> When Robinson rang and said 'Hello Robert, this is Geoffrey Robinson', I was a bit surprised to have the very famous Paymaster General talking to me like an old friend when I had

never met him in my life. He said 'I understand you are the leading underwriter for the stolen Turners?' I said 'Yes', and he said 'Can we buy the title back?'

When we pay a total loss the item becomes our property. If it is recovered, we offer to return it for the money we have paid plus interest. Nobody in my memory had ever bought back the title to an item before it was recovered. I realized that it could be done at a discount depending on the likelihood of recovery, but the owner would be taking the risk that it never came back or was seriously damaged.

Geoffrey Robinson impressed on me that the Tate had the original £24 million paid for the Turners (which had grown to £26 million with interest) sitting waiting to pay for the Turners if they came back, and asked if they could make an offer to buy back the title and free up the £26 million which they badly needed. I was impressed as it was an innovative solution to release some money for the Tate and leave them with the Turners if they were recovered . . . This was an interesting post-race bet on whether they [the Turner paintings] would come back or not.

I called a meeting of the other underwriters on the risk and tried to persuade them to quote a sensible discounted premium for the Tate to pay to regain the title. I argued that we underwriters would be better off having a certain recovery of some of the money paid for the paintings than waiting for years to get maybe damaged paintings back or never getting anything. I also tried to persuade them that it would be good for the Tate, explaining that I had a conflict as a lover of art and of the Tate. The other underwriters were not really interested as they had paid for the loss, it was effectively written off in their books, and some would benefit only marginally from a partial recovery due to the involvement of reinsurers. Also, it is always good to have the possibility of the sudden bonus of a recovery of the paintings at some later date – a sort of hidden reserve.

The other problem was pricing the chance of recovery. Peter Gwynn, the head of security at Hiscox, was keeping

me in regular touch with the recovery efforts, constantly telling me 'If I just reach out, I've got them . . .' I knew how close we were at times as I had impersonated the Chairman of Lloyd's and signed letters promising rewards, and seen photographs of the paintings. But this had gone on for four years and if they did come back, in what sort of condition would they be in having been in the hands of Serbian gangsters? If a painting is damaged we insurers are always made to pay far too much for the depreciation and consequent deterioration in value.

I did turn the full force of my broking abilities on to my fellow underwriters. It was an innovative proposition which we would normally never get from Government; I wanted the Tate to have this deal to release much needed money, and, much as it was nice to have a potential outstanding recovery, a definite percentage of the loss back could be better.

My fellow underwriters and I then had that magical meeting with Geoffrey Robinson at the Treasury in the Paymaster General's office. I was most embarrassed by the insolent and rude behaviour of some of the underwriters who behaved as only certain arrogant Lloyd's underwriters can as they spend their working life trading with brokers in a constant head-butting put-down kind of talk. Robinson did a little speech, and one of them says 'So what's in it for us? We've paid the loss you know; we don't care.' I thought, sit up straight, he is Paymaster General and he is actually trying to do a clever and sensible deal for the Tate . . . They had no concept that you might pay some respect to position when you are in Whitehall.

As we walked out of the meeting, Geoffrey Robinson called me back in. I apologized for my fellow underwriters and said how embarrassed I was. He said he had never seen such a bunch. I told him I would do what I could to get him a deal.

In the event, I persuaded the others to quote a premium of £8 million rising to £12 million if the paintings were recovered within a year. I had believed that we were unlikely to see the paintings again, and if we did, they would be in appalling condition.[15]

The deal that was made – for the Tate's re-purchase of the title of the paintings – involved full approval from Treasury, Department for Culture, Media and Sport (as it was now renamed), the Attorney General's Office and the Charity Commission. It involved three split payments of £4 million, the last only to be paid if the paintings had not reappeared in twelve months' time, by 28 July 1999, the five-year anniversary of the theft itself. Geoffrey Robinson quotes the letter of thanks from Dennis Stevenson, Chairman of the Tate Trustees:

It embarrasses me to write that I should have seen the solution that you saw a long time before! The fact is that amidst a very busy life – within which the Tate, let's face it, is a very small dot on the PMG [Paymaster General] radar screen – you saw a very ingenious way of securing a substantial benefit for the public good.[16]

In June 1998 a full report under 'Any Other Business' was given to the Trustees: 'All parties agree (Treasury, DCMS) that the proposals represented good value for money . . . In terms of the application of the insurance funds, it is proposed that these be partly applied to the acquisition of the freehold at Southwark store and the balance to be invested for use as an endowment.'[17] The Board paper admitted that the negotiations were complex because many underwriters were involved, together with their respective re-insurers. 'It was part of the conditions stipulated by Government that the balance of the insurance funds for the time being be used to act as collateral for the TGMA project.'

Robert Graham of Blackwell Green, brokers for the insurance arrangements, wrote to Alex Beard in July 1998:

I can confirm that I have instructed Verner Southey of Clyde & Co. to draw up a contract based on the agreement that I faxed through to you on 25th June.

It must be remembered that in 1994 when the works were stolen the insurance market for works of art was nothing like the size that it is today and it was necessary to place

insurance cover for the works valued at £24,000,000 under our biggest contract that we had arranged with certain Lloyd's underwriters (14 of them) and the Nordstern. The potentially controversial notion therefore of insurers having to relinquish their rights of title was always going to be a difficult thing successfully to convey across the whole market – especially as we have since ceased to do business with some of the Lloyd's syndicates – and there was an initial reluctance of two or three of the participating insurers to agree the deal. We were able in each case to overcome their unwillingness but we then encountered much greater problems with reinsurers.

This is not the way things would be done on a standard recovery as they would normally be paid back to reinsurers from the top down. Furthermore, many syndicates have programmes with fifteen or twenty participating reinsurers and this has, of course, had a 'mushrooming' effect. Some reinsurers are as far afield as Australia and this has caused obvious difficulties in trying to communicate the unusual concepts of this deal. I apologize for being so long winded but I did not want the Trustees or the Government to feel that the insurance market was dragging its heels and hope that the above explains the difficulties of achieving cross-market agreement on a deal that has never been seen before by the insurance market.[18]

Over the summer of 1998 I was changing my own focus within the Tate. I was not selected for the directorship of Tate Modern, but I decided to stay at the Tate for the time being and agreed with Nick on a number of new areas for development. This included the coordination of programmes across the four Tate sites – a new challenge – and of course the pursuit of the two stolen Turners. In September David Verey took over from Dennis Stevenson as Chairman of the Tate Trustees.

By November 1998, having re-purchased the title to the stolen Turner paintings, it was possible for Tate to utilize part of the remaining insurance monies to acquire the freehold on the Southwark

Store site. An opportunity was taken to convert into freehold a leasehold arrangement for the site, which houses the Tate's storage of paintings and sculptures when not on view at Tate Britain, Tate Liverpool and Tate St Ives and the about-to-be-opened Tate Modern. This offered evident public benefit. But the new arrangements also meant that once the five-year anniversary was reached, at the end of July 1999, Tate would be fully in charge of the recovery and the insurers would no longer have an interest in pursuing the Turner paintings. Alex Beard commented:

Experience shows that it is not uncommon for paintings that have been lost to be recovered over time. But that the circumstances in which they are recovered varies enormously.

The insurance proceeds, and this is a moral point, arose directly as a result of the theft of the paintings and Tate had an obligation to ensure the recovery, and through the insurance monies Tate had the resources to draw upon to enable that process. In my mind there was absolutely no question of being able to deploy those proceeds for anything else, until the paintings were back in Tate's control. Not least because before the title buy-back arrangement Tate had to have access to the funds to acquire the paintings back from the insurers, if they were recovered – and after the title buy-back, to use the monies to fund the continuing operation to try and secure their recovery.

At the stage of acquiring the Southwark Store, the Charity Commission approved a loan from the 'trust' [as the funds relating directly to the Turner Bequest were then termed] to the Tate, so it was not actual expenditure from the monies.

Geoffrey Robinson was crucial, but there was never any question of the monies directly financing the building of Tate Modern. Tate entered into a finance lease which gave rise to a small impact on the PES [public expenditure limit] for the Department of Culture. That PES effect – it was not an actual cash effect – needed to be offset in some way and we were sitting on the Turner insurance proceeds, which in

government accounting were therefore allocated to offset the PES impact of the Tate Modern finance lease. There was no question of the money being expended.[19]

Meanwhile, it was not clear how the recovery of the paintings would continue once the BKA and the Met had drawn back from their own operations and the insurers were no longer involved. The circumstances of pursuit were much affected by the Prosecutor's Office in Frankfurt, where the city's officials still felt very considerable embarrassment that such important works had been stolen from the Schirn Kunsthalle, a city-managed venue. Because the police in Germany are under the direct authority of the Prosecutors, there was a possibility of new routes being opened out by which the stolen works might return. Mark Dalrymple commented:

The Frankfurt Prosecutors acted almost on a political level, that was very clear. Their willingness to respond positively to the Metropolitan Police's discrete discussions on this matter was very telling. They were very willing to allow Rocky to work in Frankfurt when he was still employed by the Metropolitan Police. There was of course competition between the BKA, the LKA and the Praesidium, the local police. This is on our patch, and we will deal with it. The LKA were much more like our own regional crime squads and we had a couple of interesting trips to Düsseldorf to talk with them. They are the Landeskriminalant and could cross the boundaries of the local police.

I knew about a new and serious opportunity on 31 July 1999, when the one year extension of the Tate's buy-back agreement expired.[20] By chance on that day I had the first enquiry regarding the Edgar Liebrucks connection. Rocky came back from a job to which he was seconded with the Czechoslovak unit and they had done a good, simple sting – what they are always good at – and they nicked these guys after a certain rough and tumble, with a couple of hundred million pounds' worth of pictures.

Robert Hiscox commented later: 'I turned out to be completely wrong, but I didn't mind a bit. It was the right response to help the Government help the Tate, and I thoroughly enjoyed effectively getting £14 million for the great gallery. Not often an underwriter enjoys a loss.'[21]

1999

In the spring of 1999, out of the various contacts they had researched in Germany, Rocky and Mick Lawrence identified a particular informant – named here as D – who was in prison and had contacts to those who held the paintings. From June 1999 D was allowed out on day release, and on 14 July he had a meeting with Rocky, which led to an introduction to the Frankfurt lawyer Edgar Liebrucks. I did not meet Liebrucks until the following year, but Rocky had an initial session with him on 22 July in Frankfurt. They both agreed that for his own safety, D should stay in prison. Rocky later described how:

> There were dozens of lawyers from all over the world who were making claims – who needed checking out. But I was very happy once I was on D's track.
>
> My previous alias was burned so I knew that if I went into Liebrucks I would have to declare who I actually was, and this is exactly what happened. After the discussion in Scotland Yard, I was able to explore the situation. Due to the influence of Commander Pearce and RL [the principal senior officer advising from the Met] I was given the go-ahead to arrange a meeting.
>
> I was in touch with the informant, D. It was important for me to get to Liebrucks via someone else, rather than come to him cold. I wanted to explain to him that I had worked as an undercover agent, and I was still in Scotland Yard, and he could trust me. Liebrucks said he would have to go back and speak to those who might instruct him. Because I had found out so much about him, I knew that I could not use him in any other way . . . The only way that we were going to get the

paintings back was at something around 10 per cent of their value, as this might be allowed as a payment for information. When the figure emerged later of DM10m, that notion of it being 10 per cent of the overall value of the works was absolutely in my mind. I thought we could justify 10 per cent as opposed to anything else.

I thought that if Liebrucks had represented Turk and Weiss in court, they never would have been convicted of the theft. And the same was true for the handler – because Liebrucks would never have advised them to deny being in the Schirn. They could have said they had been there but challenged the prosecution to prove that they had undertaken the theft. What convicted them was that they said they had never been to the Schirn – never been there at all. Whatever you say about Liebrucks, he is a superb lawyer.

When I first met him he did not yet have immunity from prosecution. I said I might be in a position for the Tate to trust me with the money, and he would need to be trusted with the paintings . . . and we might then make some kind of arrangement. This was the only way that it could happen. He agreed. We needed to establish a rapport. I can't begin to tell you how many places we visited as part of that process.[22]

In July 1999, following the re-purchase of the title by the Tate, the Charity Commission was drawn into discussions on the status of the remaining insurance monies. But at this stage the Commission was reluctant to come to a definitive view as to whether the monies related to the Tate as a whole or to the Turner Bequest more particularly, which would define the scope for their use. With the expiry of the one-year extension, the reward offered by underwriters at Lloyd's and AXA Nordstern Art Insurance Ltd no longer applied. Withdrawal took effect from midnight on 28 July 1999. But an equivalent $250,000 reward, on the same 'terms and conditions', was reinstated by the Tate after agreement by Alex Beard and myself. Alex saw this as being for the purposes of circulation to the general public only, because we hoped that any of the more

closely linked criminal fraternity in Germany would be drawn into an ordered process through this specific contact, the lawyer, Edgar Liebrucks.[23]

After the meeting in Frankfurt with Liebrucks and the informant D, Rocky phoned Mark Dalrymple to say that Liebrucks was definitely the right man with whom to negotiate – 'He knows where the paintings are.'[24] What Liebrucks had clarified was that DM10 million (at this time around £3 million) would be required to pay for information leading to the return of the paintings. This figure was not offered for negotiation. It was a take-it-or-leave-it deal – but it appeared like an astonishing breakthrough after all this time with nothing but false leads.

Mark Dalrymple:

> By July 1999 we had had many approaches from solicitors in Germany offering to act as go-betweens ... but the problem was that they dropped out. I guess because they were simply too frightened.
>
> I did not know for certain that this was different. But I did know that the source of the information came from a minor criminal in prison who had been on day-release. This coincided with Mick Lawrence, who was Rocky's boss, making sure that Rocky could, in effect, be available to help us.[25]

On 6 August 1999 I was called to a meeting led by Commander Roger Pearce to discuss the option of pursuing the connection with this German lawyer Edgar Liebrucks. Sitting in a bleak office in the Scotland Yard building it was hard to sense much hope, because the Turner paintings felt a very long way away. 'But this could just be a way forward for you', said Pearce, while making clear that the Tate would have to finance the expenses. The hope was that a promised offer of Polaroid images could be discussed in the first instance, and that the Tate should pay for this. A much smaller sum than the full DM10 million might be exchanged in advance for the 'proof of life' that Polaroid images could give.

Clearly, however, the Tate could not proceed with this new connection with Liebrucks without absolute certainty about the correct

authorizations. Internal processes also had to be revised. David Verey, as Chairman of Trustees, created a small sub-committee to oversee matters relating to the recovery of the Turners.

> Nick and I agreed that we should have a very small group. It would be myself, Christopher Mallaby, Nick, Alex and yourself, and we would keep a very careful record of what we decided . . . As long as Christopher and I were clearly kept in touch with what was happening, then we could be the guardians for the full Board . . . With a small, tight group one had the best way of avoiding any confusion. Judgements had to be made, and I saw it as my job as Chairman of the Board of Trustees . . . to make sure that whatever was done was done with proper formality.[26]

At a meeting at the Department for Culture, Media and Sport on 11 August the whole matter was discussed with the senior civil servant in the Museums and Galleries Division, Richard Hartman. 'I'd very much like to help, but I'm not sure that this fits into any usual scheme of authorisation', was Richard's cautious conclusion. In a subsequent letter he was forced to set out the doubts of the DCMS Permanent Secretary, Robin Young, who was not persuaded that anything over £1 million was justified or appropriate – and that this would also need NAO (National Audit Office) and Treasury approval. Young was suspicious as to why the making of such a payment 'for information' came just after the Tate had taken over responsibility for the operational recovery. He also worried as to how any larger scale payments would be seen alongside the Tate's bid for extra resources to run the new gallery at Bankside.

The letter ends:

> Robin's current view, therefore, is that any payment in excess of £1m will require Treasury approval. He would find it difficult to support a recommendation to Treasury for a larger payment without a clear and justifiable case. Furthermore, before any payment is agreed he would like, for the purposes of accountability, to see a breakdown, in general

terms, of the relevant operational costs of the recovery to which it would contribute.[27]

Discussions continued in London as to whether such arrangements were appropriate and how the negotiations might be taken forward in Germany. Edgar Liebrucks wrote in October suggesting how to progress. He referred to consultation with the Prosecutor's Office in Frankfurt and that he was 'in direct contact with the people who are now in possession of the paintings . . . These people are very suspicious, they are afraid that the return operation might also be used to convict them. They are therefore expecting an advance payment in order to establish a basis of trust. They obviously have confidence in me personally.' He went on to refer to photographs of the Turner canvases that would be produced for an advance payment of DMI million, and also to Rocky as the proposed intermediary.

On your side I am in touch with a gentleman in whom I have full confidence and I have conveyed this to the people currently in possession of the paintings. At the same time that person should now be confident that my only concern is to ensure the recovery of the paintings, but there must be no mistakes on either side. I believe that the ideal circumstances have been created, which will never happen again, and consequently there has never been such a good chance of returning the pictures to London as there is now.[28]

Critically important was the approval of the Metropolitan Police, who had written to confirm that the arrangement with Liebrucks, which gave him immunity from prosecution, was regarded by the authorities in Frankfurt as part of an ongoing investigation.[29] This separated it from being a 'ransom' or a 'buy-back' or even an enhanced 'reward': it was a payment leading to recovery of the stolen works, and was regarded by the Frankfurt Prosecutor's Office as a means to catch those who had received the stolen works, who would be pursued along with any cash transferred through the lawyer, Liebrucks.[30] Much of my time at the end of 1999 and in early 2000 was occupied with contributing to the submissions for the Charity

Commission, the Attorney General and the Department for Culture, Media and Sport. The submissions and confidential briefings were coordinated by Alex Beard, Director of Finance and Administration, and Sharon Page, Tate's senior legal administrator. The DCMS finally resolved their view of the proposed arrangements at the end of 1999, and Robin Young wrote Nick a note to say 'Here is a special Christmas present.' It was his approval to move forward with the first stage of a scheme through Edgar Liebrucks.

<center>2000</center>

In February 2000 the Charity Commission provided Tate with a 'Section 26' order that would allow a 'deposit' of DM1 million to be paid into Liebrucks's special account in Frankfurt, if he could provide Polaroid images of the Turner paintings. These would be 'proof of life': a demonstration that the people Liebrucks was in touch with did genuinely have access to the actual Turner paintings, and that they were in reasonable condition. The Commission had to be certain that neither the Tate, nor itself, could be criticized for undertaking a recovery operation using this proposed route and means to recover the paintings. The Commission became increasingly firm in its view that for the arrangements in Germany to develop beyond this initial stage (of payment of DM1 million – at this time around £300,000 – for the Polaroids) a different level of judgement would be needed: a definitive legal adjudication. There had to be certainty about acting in the public interest and within the law. They concluded that a court case would need to be held *in camera*, and the Tate would have to brief a QC, and present a clear proposition to the High Court.

I could accept that this was necessary, but my initial reaction was of exasperation. It seemed that this was another heavy layer of bureaucracy, another arena in which matters might go backwards rather than forward.

Rocky recalled:

> Call me big-headed, but I was absolutely convinced that we were definitely on the right lines . . . We were at an advantage as I could go into the organized crime squad in Frankfurt

and obtain information. I could go to the BKA and obtain information, and I could go to the Prosecutors and lawyers and do the same. I spent about a week in Frankfurt and went through all the evidence and that was well before 2000 because I was still talking to different lawyers. Jan Koval was finished as an alias and it really upset me ... It related to the fact that they, in Scotland Yard, were going through a bad time and were nervous. By contrast, I was saying that we could get the Turners back – this could be great news.[31]

By March 2000 the necessary paperwork with Liebrucks was in place for an initial payment to be made. In exchange for this, he would offer images to demonstrate that he had working contact with those who now held the paintings.[32] There was much difficulty as to the right arrangement for the first payment, how the Tate could pay into his account at the Deutsche Bank in Frankfurt. And I organized a contract linking Liebrucks with the recovery operation and return of the paintings, and which he signed in advance.

Once the initial DM1 million payment was made to Frankfurt, two Polaroids were dispatched to London, arriving on 10 April. At last, here was some actual contact, if only in image form. It felt remarkable – nearly six years after the theft, in these small-scale images was some token of the extraordinary paintings we had lost. I wanted to shout out that the paintings were alive. Roy Perry, the Tate's senior paintings conservator, provided a proper and more sober analysis. His report detailed:

Although the Polaroids are of poor quality and lack definition they do appear to be of the actual paintings and not reproductions. This is particularly true of the photos of the backs ... They are photos of wax-resin lined and stretched canvases and could not have been derived from another photographic source as no other photographic record of the lined backs exists ... The colour (wax-resin impregnated linen), shiny surface (from the Melinex release sheet) and slightly aerated appearance (from air trapped at the back of the canvases during lining) is consistent with a wax-resin lining

done on a heated, vacuum hot table ... The stretcher expansion keys in each corner are secured in 1960s 'Tate' style with twisted fishing line secured to the stretcher bars with brass screws and cups.[33]

This was a fantastic report and gave Nick and myself the confidence to move forward. Later that month Liebrucks reported that his contacts indicated that the paintings might now be available, if the Tate would have all of the rest of the money ready and available for an exchange. This led to investigation of how to withdraw large cash sums in Frankfurt. An essential element was the reassurance provided by the Frankfurt Prosecutor's Office to the Deutsche Bank of the legitimacy of sums coming into the bank from the Tate, and then being withdrawn, not being part of a money-laundering operation. Equally, it needed our investigators, Rocky and Mick Lawrence, to convince Liebrucks that the court case being set up in London was serious, and needed to be determined in the Tate's favour for a fee to be paid out in Frankfurt.

On Friday, 28 April, Roy Perry and I flew out to Frankfurt with the prospect of translating all these discussions into an exchange. This followed the elaborate production of material for a QC, the setting of dates for a hearing in court – as well as the conclusion of bank arrangements through a special new account controlled by Rocky but within the defining terms of the exchange. The four of us were soon sitting in the rather prim but restless environment of the Arabella Hotel, having over-priced cups of coffee waiting for Edgar Liebrucks to appear. The reception area extends through to a large, tall atrium in which a bar and café are merged. Small padded bucket chairs and low tables make it a fundamentally uncomfortable place: good for short exchanges, but not for serious meetings. And yet its purpose was clear – it is a space in which individuals can be seen. There are no corners; you cannot hide. In this instance we did not have 'cover' from the Frankfurt police or from any security people of our own. It suited us to be in the open – and we hoped that we would not be there for long. It was only Liebrucks who could tell us if something would happen that day.

This would be my first view of the Frankfurt lawyer – 'Notar' in German terminology. He bustled in, wearing a light grey suit with

waistcoat, a low-key patterned shirt and tie, and I thought that he could be a figure from a museum or a library. Perhaps in his early fifties, and very slightly worn at the edges, he appeared more like an academic than a lawyer. His brown leather shoes were certainly not part of the image of a sharp, criminal-linked practitioner, but we knew that he was successful and trusted by those who employed him.

It was apparent that he was very flustered, and his behaviour distinctly jumpy. The nerves were understandable because he was waiting to hear if the paintings would be available for us to view, as promised. And he turned quickly to me: 'Are you ready for an actual exchange? Do you have the money here in Frankfurt, and able to be released? These people are not playing about.' His worry that we, the Tate, were not actually ready was justified because this was the day of the court case in London. Of course, we refused to have cash in hand, since it was crucial to have seen and authenticated a painting before any money could be released from the special account in Frankfurt. I explained: 'By lunch-time I expect to hear that I have full authority for an exchange. When will we get to inspect the paintings? We must see them first and then Rocky and I can arrange the payment of the fee once I have the word from London.'

The day spun out with much to-ing and fro-ing. Liebrucks would break off to see contacts – or so he said; lunchtime came and went. He gave contradictory views as to whether the 'other side' had brought the paintings into Frankfurt or not. Soon it was Rocky who was pacing about as much as Liebrucks. At one point we were joined by the Assistant Prosecutor, Herr Hauschke, to reassure Liebrucks that the immunity that had been promised was still in place, and to give assurance that the Tate was serious about what it was offering to do.

All the time I was getting more nervous about the silence from London. I kept feeling in my pocket to check that my mobile was working and switched on. In the event, the call came from Sharon Page mid-afternoon. It emerged that Judge Ferris, who was hearing the case, had become so intrigued that he asked for additional information. He had also wanted to be certain that the connection with the Metropolitan Police was in place, and had directly questioned RL, the senior supervising detective within the Met. But in the end

he had given his judgement – and it was positive. This was a huge relief, because it was the final piece in the jigsaw of official support and backing for the recovery of the paintings.

But they did not emerge – not at the hotel, or anywhere in Frankfurt. The day ended in considerable confusion. Liebrucks even seemed relieved when he was able to say: 'The paintings will definitively not be available in Frankfurt today.' Something seemed to release him from immense pressure and his whole demeanour changed at that moment. 'They will not be available tomorrow either. These people are too nervous.' We talked about the future. When would Rocky next be available for an exchange? When could Liebrucks make it happen? June might be possible. It could be necessary to go for one painting first, to establish trust in the logistical approach. Nobody quite knew how it might happen, but over a drink (still sitting in the Arabella) I worked hard to feel positive, and Roy and I flew back to London that evening.

The Tate's solicitors had taken an affidavit from myself, which had been submitted with other documents to the court on 27 April. Following the lead provided by the Frankfurt Prosecutor's Office, the Ferris judgement made on the 28th gave the definitive go-ahead for the Tate to undertake the arrangements in Frankfurt, with oversight from the Met. The judgement was made public five years later. It reads:

Chancery Division: Friday 28 April 2000
The Honourable Mr Justice Ferris
It is ordered that . . .
2 The Court hereby approves the Claimant proceeding with the second stage of the transaction aimed at recovering two paintings by Joseph Mallord William Turner . . .
3 The Court hereby further approves the payment out of the funds of the Turner Bequest, pursuant to the resolution, of:
(i) DM 10,000,000 inclusive of the DM 1,000,000 paid under the order of the Charity Commission dated 31 January 2000, to the persons holding the paintings in exchange for their return, subject to the condition that, before any money

is paid, the Director of National Programmes of the Tate Gallery, Mr Alexander Nairne, (a) has satisfied himself that the painting or paintings to be exchanged is or are genuine and (b) has been advised by the Metropolitan Police in liaison with the German police that the arrangements for the exchange are such that in their opinion it is justifiable to proceed with the exchange; and

(2) incidental expenses reasonably and properly incurred by the Claimant in connection with the transaction[34]

It emerged within the next month that the 'other side' – whoever was holding the paintings – wanted a further advance, despite Liebrucks having already been paid DM1 million for the Polaroid images. Another DM1 million might be needed to get the first painting into play. I did not think it wise or acceptable for the Tate to put up more money, with nothing in return. Yet I was determined that the door should not close on the Turners when we had just had a glimpse of a workable way through. At a rather difficult meeting of the Trustees' Sub-Committee on 25 May 2000 the pros and cons were debated (just ten days after the opening of Tate Modern, when the organization was somewhat overwhelmed by the huge and positive response).[35] RL, attended, and the Committee Minutes record:

In his [RL's] view it was vital that Tate took a more relaxed approach. There had been a number of efforts to recover the paintings, and this was the one which showed most signs of success . . . The German authorities were keen that the paintings should be recovered and had created a unique framework to allow this to happen. However, the individuals holding the paintings were still suspicious of those arrangements, although Liebrucks had made every effort to persuade them that the arrangements with German authorities were genuine. It was their nervousness that had led to the last minute change of mind on 28 April.

The Committee needed to try and understand the psychology of criminals. Some of them were reasonable, but some had genuinely murderous intent and Liebrucks's fear

was well founded. In his view it stood the Tate in very good stead that, so far, they had behaved with integrity and kept to their word . . . It would not be possible to conduct negotiations in the classic business sense. These were negotiations of a different order.[36]

The Trustees still felt uncertain about how to proceed, and I could not yet give them a clear plan, so no decision was made. Liebrucks wrote later that:

After having seen the Polaroids with the unchangeable [*sic*] details I was quite hopeful that we are on the right way. When the receivers [those holding the paintings] agreed to give me the paintings each for 5 Mill German marks I was quite sure the deal will be successful. But the uncertainty started to grow up, because the Tate was not ready to pay another Mill German marks in advance, while the criminals refused to give me the first painting without paying the amount they asked me for.[37]

Another meeting of the Committee was held at the start of June. The Tate needed to stick to its position, but I asked the Trustees to consider whether Rocky might be paid a fee (on a percentage basis) so that he would provide the 'icebreaker' of DMI million. Rocky had retired from the Met and was now employed as an independent investigator and consultant through Tyler & Co. Rocky's advice was that a further advance was justified, but that Tate would do better to pay a fee for him to take the risk, rather than bear it directly. That agreement was finalized on Friday, 23 June, with a rate of 10 per cent set for the extra fee that he would be paid for providing the advance.

As a small instance of the myriad of complications in moving monies around, the local branch of Rocky's bank in Mile End initially refused the cheque he was using to transfer these funds. When they later apologized, they wrote: 'The cheque in question was presented to us for payment . . . [and] we noticed that the style of handwriting on the cheque differed to the signature . . . and we took

the decision to return the cheque unpaid.'[38] Rocky was partly appeased when they sent him a crate of wine, along with the apology. Nevertheless, the wheels were beginning to turn, and a recovery operation for the return of one of the two Turner paintings was being planned for Germany for July 2000. I was desperate that we find a way through.

three

Recovery

Thursday, 13 July 2000

In the late afternoon things got difficult. I was walking back across the central area of the Millennium Dome at Greenwich – about to meet my partner, two children and parents – when my mobile rang. It was the end of a day off work, an exception to the norm. Not only a weekday away from the Tate, but spent with grandparents and grandchildren together, with a visit to the much-maligned displays of the Millennium Dome. The day before I had mentioned my plan to Nick and he had teased me with the Dome's own slogan, 'one amazing day'.

With my mind distracted from work the mobile's ring was startling, and quickly led to unwelcome exchanges as Rocky shouted at me from Germany: 'Why is the Tate's money not here? It isn't in the account. So where the hell is it?' The Tate's fee money should have been transferred to the Sparkasse bank – an account in Würzburg created after Rocky's research trip the previous week. Arrangements had been settled then for the return of the first of the two Turner paintings, number 531. Securing one painting was all that Edgar Liebrucks, our go-between solicitor, could arrange with those claiming to hold the pictures – the 'other side'.

Rocky was furious – he had expected that DM4 million (equivalent to nearly £1.2 million) would already have registered in the special account. I knew nothing of the exact timing of the transfer, because I was unable to. Banks transfer money, following an order, but never give a clear account of when it has been sent or received.

Information seems to flow one way. In the case of moving money out of an investment account, it was perhaps more complicated. I got on to Sian Williams, Head of Finance, and on to Coutts, Tate's bank, to find out what was (or was not) happening.

Sian reassured me: 'The orders for the fees were all sent by email yesterday: on Wednesday. They would be acted on this morning, and DM4m will then be in that Sparkasse Bank account.' She confirmed that an additional £10,000 for security and other expenses was ready to be picked up in Frankfurt and £6,000 to be collected at the bank in London, signed for by Sian herself and then passed to Mark Dalrymple to give in cash to RL, the senior supervising officer from the Metropolitan Police, who was with Rocky in Germany. He would take it with him to Germany. The DM4 million was an internal transfer within Germany since the money was already in an account at Citibank, and had, with the extra work put in by Graham at Coutts, been transferred within the day. So why had it not arrived? Rocky was obviously hopping up and down. So was RL, who was equally embarrassed at having set up an arrangement with their colleagues in the Bavarian Intelligence Service, in Würzburg, only to have the prospect that the whole recovery operation might collapse. 'This is just ridiculous. Fucking ridiculous', was Rocky's terse response.

Being at the receiving end of Rocky's verbal abuse is not much fun – not least because his principal tactic is to make clear that *you* are the single feeble fool incapable of completing arrangements properly, failing to do things as agreed, and without the strength of character to bend institutional rules as required.

This all cast a considerable shadow over the rest of the day at the Dome. I forced myself to try to put it out of my mind, although I knew that our thirteen-year-old daughter had heard me say that things were not going well.

Friday, 14 July

I was at my office at Millbank early so that I could get onto Graham as he arrived at his desk at Coutts. It was 9.00 a.m. in Germany, and I knew that Rocky and RL were due to meet the senior officer in

Würzburg at 10 o'clock. I finally spoke to Graham at 8.40 London time and was able to relay to Rocky that the transfer was being checked again by the bank in London. He listened to this with dismissive grunts. Within another ten minutes Graham had reported that the problem lay with the Sparkasse – the bank in Würzburg by which the funds were being routed – where the computer was antiquated and might take three hours to register fully the arrival of the DM4 million fee (this would be three hours from 8.00 – so at best at 11.00 . . .). But soon the estimate grew to six hours for the money to be recorded. And then, just as it seemed to be about to connect, I had Rocky on the phone again: 'Sandy, no actual money has come through. It is fucking well NOT here. The bank in London are talking total shit. What the hell is actually happening?' Back to square one.

But by noon it emerged that the problem was entirely with the Sparkasse, which had, unbelievably, failed to connect its computer into the central German clearing network. By the end of an edgy day, RL was at least able to console me that two out of three of the crucial tasks had been accomplished: 'The money is now sorted and available here in a secure way. And we have confirmation that the arrangements for viewing and exchange are approved by the Frankfurt Prosecutor's Office. We now just need to settle the exact final details with Edgar.'

Saturday, 15 July

RL rang me on the mobile in the late afternoon just as my son and I were returning from taking part in a punting regatta. It was not good news. It emerged that in talking with Edgar Liebrucks, Rocky had mentioned the Bavarian Intelligence Service and their role in advising and offering a route for the money. Liebrucks had exploded, since he was worried that this would somehow get back to the 'other side', and much shouting had followed. I could not believe this was now threatening the operation.

Luckily, Rocky then persuaded Edgar that an alternative safe route could be found for the money, through the Deutsche Bank in Frankfurt. The money would be present in the bank in cash, but made available to Liebrucks only at the point at which I gave specific

approval to Rocky. And that could only happen when I knew that the painting was the real thing: the Tate's Turner, *Shade and Darkness*, in good condition and securely in our own hands, under our control.

Monday, 17 July

I packed clothes and papers for an overnight trip to Frankfurt, hoping to return by the end of Tuesday. Indeed, the only purpose of Roy Perry, the senior Tate conservator, and myself going on Monday was to avoid flight delays early on Tuesday morning. If the painting and the fee money were both to be ready on Tuesday, it was essential that we were both there in person. The Ferris judgement stipulated specifically that I had to certify that any recovered painting was genuine.

By the time we were liaising on pick-up times from Frankfurt airport, Rocky and RL sounded happier. Martina, the new bank manager at the central Deutsche Bank branch near the Prosecutor's Office and the Court building, was being helpful about setting up this transfer route: a Tate account but linked to Rocky's name. This would now replace the Würzburg arrangement. Cash would be available at 11.00 a.m. on Tuesday. I finalized these arrangements from my mobile while slipping in and out of Tate meetings in the board-room, pretending as ever that nothing was going on.

I saw Nick Serota briefly in his office in the afternoon and explained what was now proposed. Of course, he reinforced how careful I had to be. The previous week Nick had met with RL and with Rocky. He knew RL from earlier meetings of the Trustees' Sub-Committee. But this had been his first meeting with Rocky: a very different character altogether. In that conversation Rocky had given an excellent account of the security arrangements and Nick had responded with a rather tart: 'I am sure that I do not have to remind you that lives are worth more than paintings.' I summarized the situation for Nick, and reminded him of the tortuous arrange-ments by which Liebrucks, with some support from Rocky, had offered a financial advance ahead of the remaining authorized sum of DM4 million. But nothing further was paid in advance from the Tate. When I was back at my own desk he phoned me, and follow-ing a characteristic pause said: 'Don't do anything that would involve

a threat or danger to Roy.' It was well judged, knowing that all my instincts would be protective of a colleague.

Arriving late in the evening at Frankfurt airport, Roy and I found ourselves at the agreed meeting point with no sign of Rocky or RL. After a lot of misconnecting I got Rocky on the mobile, and he explained that the delay was due to Liebrucks demanding further discussion. We set off, crammed into Rocky's BMW Alpina: me in the front, and Roy and RL sitting in the back with Mick Lawrence. Mick was a very experienced detective, also retired from the Met and a colleague of Rocky. This vehicle had the bold number plate of WAR II. When challenged about it Rocky said: 'It announces where I am to certain people. But I always hire another car locally, so that I'm not where anyone thinks I am.'

It emerged that Liebrucks had calmed down and had accepted the new route for the money through the account opened at Deutsche Bank. He and Rocky had checked that it would work for Tuesday morning. Liebrucks had just wanted further reassurance and had confirmed, once again, that everything was on for the following day, Tuesday.

We drove from the airport to Bad Homburg, near Frankfurt. Rocky made elaborate loops around the back streets to make sure that no one was following. If he saw a car behind us for any length of time he would turn late into a lay-by or slip road, and the vehicle would pass us by. We stopped at an inconsequential business hotel, supremely anonymous. Rocky laid cash on the desk for Roy's and my rooms, and then we assembled round the corner for beers in a little Greek taverna.

Our supper conversation was dominated by Metropolitan Police Service banter. Amid the chat we learnt that Liebrucks, having argued with Rocky on Friday evening, had nevertheless set off to talk to the 'other side'. Liebrucks spoke often of such journeys to meet with those who held the Turner paintings, or at least their representatives (I was never told which). The trip apparently took him anything from five to seven hours. At the next meeting on Saturday evening he had been confident, and evidently calm and determined. Mick observed that he still wore the same clothes as on Friday night. The impression was of a journey to the east, away from Frankfurt.

These people had now given him a particular mobile phone to use. They would ring when the first painting was ready. It was a very specific version of 'don't call us; we'll call you'.

Tuesday, 18 July

I had breakfast with Roy and Mick, with another conversation about the police, companionship, trust, sport, adventure, wrongdoing and the criminal mind – not entirely reassuring when I already felt nervous.[1] Apparently, we would not hear from Rocky or RL until at least 11 a.m., since this was the time when the cash would actually be available at the Deutsche Bank branch and the operation could move forward. The plan was that once Roy and I had seen and inspected the painting I would give the signal to Rocky by mobile. Then he would telephone the bank and instruct them to transfer the money into Liebrucks's own special account and he could then withdraw the fee in cash. Branches of German banks have strict limits as to how much cash they can have in the building and how much they can keep overnight. Martina had revealed on Monday that if as much as DM4 million had been delivered on a particular day and was not paid out, then it must be returned to a larger branch. Rocky had been upset at the news of this regulation, but then came up with the simple idea of extending the insurance for the branch (at the Tate's expense) so that the cash could stay until Wednesday if necessary. I guess he already reckoned this to be likely.

Rocky and RL joined us at the Bad Homburg hotel mid-morning. They were very glum. An earlier phone call from an absurdly titled informer, Harold the Dentist, wishing Rocky 'Happy Birthday', had set off several alarm bells. First, he obviously knew that Rocky was in or near Bad Homburg, and secondly that an operation was 'on', and that money might be changing hands. He already knew far too much.

How did he know anything? Was it from the Frankfurt police themselves, one of whose senior officers was controlling him as an informant? The Frankfurt police were not meant to know the details, although I understood that the Bavarian service would make a courtesy call to say that they would be providing security cover for the

actual recovery and inspection, with agreement from the Frankfurt Prosecutor's Office. So if anything had slipped out it could spell disaster for the operation. Either the 'other side' would find out and abort the exchange, or the Frankfurt police might intervene to catch somebody in the middle of the process: perhaps a 'courier' with a painting in their hands. Rocky said that the Dentist had apparently been part of attempts to broker a deal two or three years earlier, working through a lawyer in Essen. He seemed to be regarded as highly unreliable. Somewhat wild stories emerged of how he kept a large personal arsenal of weapons at home. It was unnerving to see Rocky so put out.

We hung about at the hotel in Bad Homburg. There was still no news from Liebrucks. Evidently instructions had not arrived through the special mobile. So Rocky and RL went back to Frankfurt to check matters with the bank, and to make sure that the additional independent security personnel were in place (provided by associates of Rocky's from Poland, paid for by the Tate at an agreed rate). I sat writing letters, and reading Tate paperwork. By mid-afternoon it was clear that an inspection was very unlikely for that day. Rocky and RL returned mid-afternoon and we all sat crammed in Mick's small bedroom. Roy was shouted at for suggesting that Edgar Liebrucks might already have the first Turner painting in his possession. 'He doesn't and couldn't', said Rocky. Actually, it did not seem such an unlikely idea, and years later we speculated whether he might have had possession for some time – but chosen to make it seem otherwise. Sullen silence was not Rocky's or Mick's usual state, but there was anger now, following the disappointment of the day.

The difficulty passed and we went for a drive in the woods nearby, to take coffee and cakes at a café, our three mobiles laid out on the table. I found it impossible to sit and enjoy the late afternoon sun, constantly wanting to ask Rocky to test whether his mobile was switched on, working and connected to a signal. He was reluctant to call Liebrucks. I was aching for his 'handy' – the German term – to ring. Such twitchiness did not match the long, low shadows where deer were quietly grazing at the edge of the forest. Time passed very slowly – to kill some more we drove into the centre of Bad Homburg itself.

I made a quick call to Suzanne in Nick's office to update him, and another home to say that I would be away another night. A call came back from Nick as we drove, but it was hard to convey the tension or the anxiety. Before dinner we all walked through the park around the spa baths. A call came in from Mark Dalrymple, from the Middle East, where he was advising on a claim – and finally, finally the call that *was* from Liebrucks.

But no news – all that was happening was that he was keeping the Assistant Prosecutor in the café next to the courts, so that if the painting came that evening he could still open up the Court building for the canvas to be stored. Rocky conveyed that Liebrucks was exceptionally anxious. He did not know why the 'other side' had not called. The special mobile remained silent. But these people did not offer reasons or apologize for delays. Whoever they were, they appeared to have the upper hand.

Wednesday, 19 July

I went for a walk before breakfast. I had checked, and my mobile was definitely switched on. I felt extremely low. Surely this was not going to work. Although it was the culmination of almost a year's work, and endless discussion, more than 24 hours had passed in Germany and there was no sign of an exchange. The operation must have been disturbed in some way. If the Dentist knew about it, then perhaps others did. Wasn't it likely that Liebrucks had been deluded – that they would walk off with the money paid as an advance (and this might be as much as the original DM1 million paid by the Tate, plus potentially the further DM1 million offered by Liebrucks and provided by Rocky) and would never return a Turner painting? Or even if they wanted *in principle* to return the paintings for the full fee, when it came to actual arrangements, to the possibility of handing over these incredibly valuable works of art they were holding, they would always reckon that it was far too dangerous – that it must be a trap?

As I walked, I also thought about my own position. After six years of pursuit this was not the time to give up. We were incredibly close physically, and there might still be the chance of bringing one painting back into Tate control. Liebrucks was well and truly caught

in the middle: he owed the Tate money, and, possibly worse for him, he also owed Rocky money. Whatever else was happening it was crucial that I stayed resilient and was seen to stand firm: to be outwardly optimistic and to keep what there was of the operation intact. This was not simply a matter of stiff upper lip. Were I to be *seen* to be wavering then it would make it very difficult for Roy, and ultimately impossible for Rocky, Mick and RL too.

Mick flew back to London early that morning. His father-in-law was dying of cancer and it was his turn to give support at the bedside. Rightly, he felt he should be in London. As I walked I also mused on the moral issues around the pursuit. I had had previous moments of concern about RL being allocated to this investigation when I knew that much of his detective work involved nailing Chinese gangs trafficking in human lives. Later he was leading crucial work in counter-intelligence against the Real IRA and, after 9/11, he was drawn into mainstream anti-terrorism responsibilities. This had to be a huge priority for the police and national security services. Could one justify a complicated chase after two oil paintings, over six years, against operations that had the real and immediate aim of saving people's lives?

The only workable answer was one of degree: the highest security priorities need not extinguish investigating art theft. The Tate had resources to finance recovery work because of the resolution of the insurance, with monies paid to the Gallery. It had a duty to try and recover the paintings, and was hiring the best and most appropriate people, while working in the closest coordination with the police forces in Britain and Germany. Capturing any of those who held the stolen paintings and pursuing fees paid out in the course of recovery was part of the process agreed with the police and judiciary in Germany and Britain.

Wednesday passed slowly too. Rocky and RL reviewed the situation with the bank, checking that the money was still available. In another call to Liebrucks, Rocky discovered that the Assistant Prosecutor had torn strips off him that morning, furious that the plan had not gone forward the day before. Rocky made clear to Liebrucks that we would be leaving for London unless some real information was forthcoming. There was little point in sitting in Bad Homburg.

Rocky suggested at mid-morning that we should go south, away from Frankfurt and, as a distraction, visit the great monument for the founding of the Second Reich. The statue of *Germania* was built in 1883 on the banks of the Main near the confluence with the Rhine. If there was some symbolism in this visit, I wasn't sure what it was.

We looked for lunch in the nearby riverside town of Rüdesheim. We were all attempting to remain optimistic, trying not to speculate about what was or was not happening with Liebrucks. Just as we settled on somewhere to eat, a call came through. He was full of apologies. 'I quite understand why you cannot continue to wait. It is all most unfortunate. I am very, very sorry.' I, at least, would have to fly to London that evening, but we agreed to meet in his office later in the afternoon, just to complete the conversation and to deal with his own disappointment. 'I can assure you', he said, 'It more than matches yours.'

We drove back towards Frankfurt, and as we moved away a large, glorious paddle steamer was leaving the river pier, heading upstream. I could read its name: *Johann v Goethe*. Half a mile along the road there was a plaque on the side of a wall, indicating that Goethe had worked and lived there (there must be a myriad of such plaques). Given that the paintings had been stolen in 1994 from an exhibition about Goethe, two sightings of his name seemed suggestive and somehow encouraging. I tried not to see it as some kind of sign, but I was clutching at straws.

As we drove in busy afternoon traffic into the centre of the city, towards Liebrucks's office, he rang again. Things had changed. He now had the painting in his possession. We should meet him at the café below his office. This was astonishing, but questions – about the 'rules', about security – were instantly racing through my head. Could we proceed with the same plan: the inspection before the release of money? Weren't we incredibly close to the Deutsche Bank branch closing time? How would this affect the payment of the remaining fee?

As Roy, RL and I sat downstairs in the Greek café and ordered coffee, Rocky went up to Liebrucks's office (which is conveniently above the café, across the street from the Court building). Waiting in the plain and mostly empty café was a new agony. But after a few

minutes Liebrucks came downstairs with a grin and shook us each by the hand and invited us to follow. Was this OK? How did we know that Rocky had not been kidnapped ahead of us? Where were Rocky's security friends or the Bavarian intelligence officers, or anyone else except the café owner? I looked to RL and tried to say something, but he simply indicated that it was fine. So, in silence we filed upstairs and into Liebrucks's apartment. And then across the hall and into what appeared to be a small library or panelled office. There, leaning against the front of the bookcases, was number 531, *Shade and Darkness*, the first of the Tate's stolen Turner paintings.

It was impossible to believe that this really was the actual picture: the square of painted canvas at the centre of all this anxiety. However, of all the matters that might be in question, the painting itself seemed the least troubling element. The canvas was out of its frame, bounded around the edge with black tape, looking vulnerable and somewhat unloved, although, as far as I could tell in good condition.

Roy worked quickly but would not be rushed. The canvas was laid out flat on the office table, and he took out the black-and-white reference photographs and his headband magnifying glass. The process of comparison then started: seeking absolute certainty through minute but telltale signs: that this was indeed one of the missing Turner paintings and could not be a faked version. Using the greatly enlarged record photographs of the painting, which showed both the cracquelure and the paint strokes under the glaze, Roy could make comparisons between the surface of the canvas lying in front of him and the photographic record of the painting, as it had been captured at the Tate many years previously.

This, lying in front of us, was the wonderful late Turner painting: *Shade and Darkness – The Evening of the Deluge*, probably now worth at least £18 million. Slowly we started smiling and grinning at each other. Liebrucks's rather svelte wife joined us. And at a certain moment – as all the consequences of getting this wrong loomed in my head – I asked Roy rather formally the question: 'Roy, is this the genuine Turner painting?' After an extended pause, he said: 'It's like meeting an old friend.'

* * *

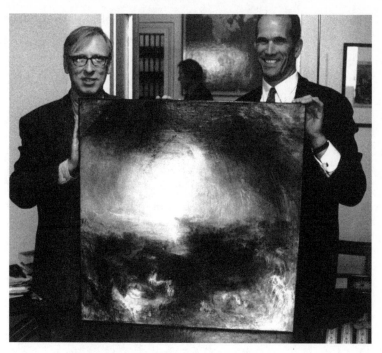

Roy Perry and Sandy Nairne with (531) *Shade and Darkness –*
The Evening of the Deluge, 19 July 2000.

After several calls ahead to the Frankfurt Prosecutor's Office we
processed across the street to the administrative section at the back
of the Court building. It needed a little care to protect the painting,
which Roy had now wrapped, and to make sure that we were still
covered by our own security team. This could be a vulnerable moment,
and Rocky and I wanted everything to be watched closely by our
own people. The Assistant Prosecutor, Herr Hauschke, was ready to
receive us and he organized for lock-up space to be found. After
being checked through the security doors and gates, and taking the
lift to an upper floor of this anonymous office block, a small room
was unlocked and *Shade and Darkness* was locked away in a wall cup-
board. This was hardly a proper lock-up store, and appeared to be
stacked with confiscated pornographic video tapes.

At this point we had missed the Deutsche Bank closing time,
but Liebrucks seemed surprisingly relaxed about the arrangements.
And this was a relief to me after all the endless debate about the

timing and the best way to pay the Tate fee. I telephoned the Tate and, as Suzanne put me through to Nick, I knew she had guessed why I was ringing. 'Nick, I am standing in the Frankfurt Prosecutor's Office building and we have just locked up the first Turner.' A lump swelled in my throat. Nick was both gracious and excited. I phoned home and quickly conveyed the news. It still seemed very dreamlike and extraordinary.

After a drink in Hauschke's office and signing papers for the return of the painting – and the release of the funds to Liebrucks for the next morning – I took a taxi to the airport. Liebrucks had looked incredibly relieved, like a man brought back to life. The van had been ordered from London, and Roy would travel back to London as courier the next day. The question of where the painting would be stored in London was the next puzzle. Roy and I had already decided that it would be much better to keep the painting well away from the Tate. The very fact of having it in the Store or the Conservation department would be likely to produce rumours that could well leak out. I felt it essential that we should not allow any factor within our control – particularly one that would cause gossip or an unplanned press report – to get in the way of the negotiation for the return of the second painting. The most expedient arrangement was to import the work under a different title, as a nineteenth-century landscape, and take it to a secure commercial store, lodged there by Tyler & Co. I rang Mark Dalrymple from Frankfurt airport and, after offering congratulations on the news, he said that he was ready to make the arrangements. When Roy rang me in my Tate office two days later to say that number 531 was safely locked up in the commercial storage depot, I felt a deep sense of relief. Now it was possible to focus on the next part of the whole operation and the return of the second Turner painting, number 532, *Light and Colour*.

* * *

Rocky returned later that summer from sailing in the Southern Pacific. Tate energies over these months were mostly taken up with responding to the success of Tate Modern. But my principal focus was on Tate Britain and on trying to make the enlarged organization work

well. In August 2000 Rocky and I resumed discussions. We thought it might take six months to prepare the ground and make everything ready for the return of the second painting: number 532, *Light and Colour (Goethe's Theory)*. Despite disruptions and delays the recovery of the first, number 531, had finally happened. It did not seem that much could stand in the way of the second missing Turner.

Liebrucks then submitted a revised invoice for his professional fees as the negotiating lawyer. A year after the start of his work having been through periods of tortuous negotiation with those holding the paintings and the complications of the various police and judicial authorities in Frankfurt, he asked for a considerable increase. This, he said, would need to be paid now if we were to pursue the second Turner. I found his form of words far from endearing, however, mixing what seemed, even in translation, to be a defensive but firm stance. He was summarizing his own view when he wrote:

> I have to express that this whole business has put me under extraordinary stress. When I decided a year ago to tackle this operation with Rocky, I had no idea of the difficulties that both sides would prepare for me ... I offered myself as an intermediary and had to carry a liability that no human being would normally accept. You should consider whether it was right to burden me with the risk of the arrangements collapsing, instead of carrying it yourself. It is after all, the Tate that wants something, not me ... I am confident that Rocky and I will return the second picture before long.[2]

By talking it through with RL and Rocky I became reconciled to the larger fee that would need to be paid. He was the one lawyer able to make contact with whoever had control over the second Turner painting, and I had no choice but to convince Nick and the Tate Trustees that paying the fee was necessary to move forward. I also consulted the Metropolitan Police and they regarded an increase in payment as acceptable. What had already been clarified by the Frankfurt Prosecutor's Office in July was that no payment could be made to Liebrucks from the 'other side'. Rocky said: 'Look, it is very simple. Liebrucks really has been through exceptional strains. It was

no fun for him keeping up negotiations with the "other side": For Edgar it really has been physically and mentally demanding, well beyond what I – or anyone – expected.' In the end I shared this view, putting into the new agreement that he should also secure the two original frames, both of which were valuable to the Tate.

Costs needed to be re-examined as part of evaluating the operation. It was clear that the additional expenses and payments for the two investigators, Rocky and Mick Lawrence (since April 2000 when Rocky had retired from the Metropolitan Police and was retained through Tyler & Co.), together with the added independent security team for the actual operational days in Germany, and the many additional days that the first stage had taken, had increased the costs against my original estimate. The Trustees had also approved the payment of a small fee to Rocky for the provision of the second advance: the so-called icebreaker of DM1 million. The fixing of terms with Edgar Liebrucks in 1999, to arrange the recovery, had been drawn out because the offer was made to the Prosecutor's Office in Frankfurt, passed to Scotland Yard, and then conveyed to Mark Dalrymple at Tyler & Co. It had taken longer than it might have done to create an effective relationship between Liebrucks, Rocky and Tate – all of which increased the time taken.

Alex Beard, Tate's Director of Finance and Administration, and I had talked through with Nick the state of the insurance funds available. The original sum of £24 million paid out by the insurers had grown with interest, but the Charity Commissioners had already allowed some funds – £7 million – to be spent on the purchase of the freehold of the new store at Southwark. This expenditure would emerge with the publication of the 1999–2000 Tate accounts in the autumn of 2000, and might be identified by a specialist journalist. This was a moment at which the Tate could have decided to cut its losses and announce the return of the first painting, and then be assertive about the outcome. Others might view it differently. Brian Sewell had already pointed out in the *Evening Standard* in July 1994 that the Tate had plenty of other Turner paintings to exhibit and care for already. Was it worth spending another million pounds straining to get one more painting back, however famous? I knew that the long-term public benefit would

be enormous. I also knew that the announcement of an incomplete operation would appear as a failure, rather than the success it was.

The framework for the recovery of the second painting was still provided for in the original contract, signed by Edgar Liebrucks in February 2000, and renewed in May 2000 with an extension to October. The overall agreement was still for a DM10 million fee for information leading to the return of both paintings (and linked to police pursuit of criminals in Germany) with the addition of Liebrucks's own professional fee. DM5 million was therefore available for information leading to the return of the other stolen Turner painting, number 532. Rocky and RL hoped that the operational arrangements for the second painting could broadly follow the pattern of the first. I needed to keep Liebrucks reassured that the fee for information would be made available by the Tate, in exactly the way promised, and that the Frankfurt Prosecutor's Office would stick to their agreement to pursue any monies after the return and the inspection had been completed.

In September 2000 the Trustees' Sub-Committee approved proceeding with the next stage. Some time was spent in setting up the new arrangements, and a recovery operation was organized for the weekend of 28–9 October. Frustratingly, the attempt was aborted because of the arrest of one of the controlling group on the 'other side' – on a quite unrelated charge. The second Turner painting was apparently very close to being released, with Liebrucks travelling three times to see those controlling it. But ultimately the environment was too unstable and the 'other side' seemed to regard the situation as too dangerous. The Tate had to spend funds on having all the independent security in place, on the presumption that Roy Perry and I would be in Frankfurt during the last week of October in order to carry out the verification of the painting. And the DM5 million, which had been placed in the Tate account in Frankfurt, was returned to London again. I began to realize that the second painting was not coming back easily.

Amidst my other Tate work, with new responsibilities for digital and international developments, I was constantly thinking about the missing Turner. The main issue through the rest of 2000 was how to construct the exchange in such a way that the 'other side' would

be convinced that the authorities would know nothing about when, where and how it would take place. This was clearly necessary from their perspective – although it was, in effect, a contradiction in terms. Somebody in authority was always going to know. At the same time we had to stick to what was approved through the Ferris judgement: that the painting must be seen and inspected safely before the remaining fee of DM5 million could be handed over to Edgar Liebrucks. There were critical risks to be considered. As David Verey put it later:

> We had to make sure that if the record was examined (which it now has been) things had been done in an orderly and proper manner, making sure that the right people, the right authorities, the court, the police, and others had approved the process we were undertaking – it was inevitably bureaucratic . . . I always returned to the four key areas of risk – human, financial, reputational and operational.[3]

Crucially, the Prosecutor's Office remained entirely supportive of the recovery operation and continued to authorize the work through and with Liebrucks. As well as briefing the Met, I continued to telephone Richard Hartman, the senior museums official at the Department of Culture, Media and Sport. Although there was not much to tell him, it was essential to comply with the agreement made with the Permanent Secretary, Robin Young, in December 1999. I was also prepared to give a confidential briefing to the minister if required.

After the disappointment in October, we hoped to meet with Liebrucks again in mid-December, to plan an exchange for January or February 2001. At a Tate 'team' meeting in my office at Millbank on 9 November 2000, with Rocky, RL and Mick, we discussed the overall prospects for the recovery. 'Is it still feasible?' I asked. 'Is it still better for us to stick with Edgar as the intermediary?' Other lawyers, said Rocky, had apparently been raising their heads above the parapet in Frankfurt claiming that they could lead the investigators to the paintings. We all thought that alternate routes did not make sense, and that we needed to stick with working in Frankfurt where Rocky and Mick knew the physical locations for an operation.

But we needed to make it happen. However, concerns about possible leaks of information and press interest dominated the months ahead. They probably distracted badly from the main pursuit, but could not be ignored.

* * *

The situation was complicated quite specifically by a concern that other Scotland Yard officers, and possibly some of the German police, and even a member of the specialist crime press, had discovered that one painting had already been recovered. It seemed unlikely that the return of the first Turner painting could be kept a secret for long. In November 2000 an *Evening Standard* reporter, Nigel Rosser, speculated about links between the shifting political situation in Serbia, and in Belgrade in particular, and the possible return of the paintings. He published a detailed article under the headline 'Closing in on the Stolen £24m Turners'.[4] Much of the piece featured commentary from Mark Dalrymple, in which he gave his own view that: 'We always suspected somewhere along the line that one of those involved was Arkan [a 'warlord' leader of the Serbian underworld]. Now he is dead the whole Serbian underworld is unravelling. I am optimistic it might create an atmosphere where they could be returned in the future.'[5] The article also quoted a 'British police source' as saying that: 'The signs that the paintings might be on the move are linked to the state of flux in Serbia, without a doubt.' Nick questioned me as to whether I was doing enough to 'control' those working with us and preventing anyone from speaking to the press.

During 2000 the comments in London caused a sensational headline to be publicized in Germany: 'Balkan Terror Gang has Tate's Stolen Turners'. This led directly to the informer D (with whom Rocky had talked and through whom a first meeting with Liebrucks had originally been arranged) receiving a severe beating in jail. He was released from custody later that year.

Press and public interest took other forms. The publication in late October of an autobiography, *The Unconventional Minister*, by former Treasury minister Geoffrey Robinson, raised further questions. Robinson included his version of the story of how he had helped the Tate

Closing in on the

Germans lose Tate's Turners

By Sean O'Neill and Robin Gedye in Bonn

The fate of the Tate Gallery's two Turner paintings stolen while on loan to a German gallery six years ago may now depend on the struggle for power among Serbian gangsters. **NIGEL ROSSER** reports on delicate negotiations with their intermediaries

The plot thickens: loss adjuster Mark Dalrymple believes he is making progress on the Turners' trail

Shade and Darkness – The Evening of the Deluge: theft of the Turner works has haunted the art world for six years

Closing in on the stolen £24 million Turners, *Evening Standard* (24 November 2000).

come to a new arrangement with the insurers, and had facilitated the special acquisition of title to the two paintings. Robinson's assertion that this was all for the potential benefit of the Tate Modern project was misplaced, and his proposition in the book, that connections with 'Serbian gangsters' were being explored, was fanciful.

Senior Met officers working alongside RL, who attended a de-brief meeting in my office in November, now reckoned that Scotland Yard

stolen £24m Turners

> **❛Signs that the paintings might be on the move are definitely linked to the flux in Serbia❜**

Scene of the crime: Schirn Kunsthalle museum in Frankfurt, from where the works were stolen

was taken from about five feet away," Mr Dalrymple said. "The image seemed to float on top of the paper. It was very flat — like it was copied from a poster. When we looked at these photographs we couldn't see a frame or an edge, just a flat, bland image which was clearly not the painting.

"There is no doubt they are out there and we may have got close to a real representative. But there are layers of people involved.

"We strongly suspect they are held by very powerful criminals who don't need to sell them. They are very cautious people who do not want to be trapped by the police."

BECAUSE the paintings are essentially unsaleable, police believe they may have been used as collateral for a series of Serb-linked criminal deals across eastern Europe.

Serb criminals linked to assassinated warlord Arkan generally act as middlemen transporting drugs from the near-east into Europe. They are also known to have been involved in various art thefts in the former Yugoslavia and eastern Europe.

Mr Dalrymple said: "There was a case where a group of criminals were trying to swap a lorry load of stolen Sony TVs and hi-fi equipment worth about £400,000.

"We know that the buyers didn't have hard cash so they offered valuable paintings instead — and it was thought those may well have been the Turners. We checked it out but at the end of the day there was no hard evidence."

Mr Dalrymple and the other investigators' suspicions about where the Turners are hidden were reinforced as they followed the trial last year of the three crooks who carried out the original robbery at the Schirn Kunsthalle Gallery in Frankfurt.

Ringleader Stephan Weiss, 32, had twice visited Belgrade in the weeks preceding the heist, and he and fellow robbers Yusef Tuerk, 26, and Stefan Hoefler, 25, had links with the Serbian underworld in Frankfurt.

Despite heavy pressure from the authorities they resisted all attempts to reveal who they had passed the paintings on to after the raid.

They had received £330,000 for the paintings but their freedom did not survive long enough for them to enjoy the proceeds. Eventually they were jailed to serve sentences ranging from three to 11 years.

When quizzed about his trips to Serbia beforehand, Weiss only replied, "tourism".

Police and private investigators say the thieves feared retribution from the Serb gangs.

One said: "There is a saying in the Balkans: 'You will not betray me because I know your son.' The implication being it is not just you, it is your family who get it as well. They are vicious. This is what makes them good criminals, they only deal with themselves, and the people they deal with are frightened because they know if it goes wrong it is a bullet in the head for them and maybe their family. It is a closed network and there aren't many informers who survive."

But the Turner thieves were by no means international master criminals, just competent amateurs.

Weiss had worked in an electrical store and had gained, it not expert knowledge, then certainly a bluffer's guide to burglar alarm systems.

Police said that the plot consisted of what is termed in the art insurance world as a "stay behind". It involved Weiss getting himself locked into the Schirn Gallery when it closed, and emerging at night to disable the alarm system on the rear doors leading to a public car park by slicing through cables with a pair of industrial bolt cutters.

Once his accomplices were inside

Serb underworld warlord Arkan was murdered in January. Investigators are sure he was linked to the Turner paintings

with him they overpowered the sole night watchman and rode the freight elevator to the floor where their intended haul was on display. The guard was stuffed into the same cupboard Weiss had hidden in at the gallery's closure that day.

There was a security system connected to wiring on the gallery windows but the paintings were not fitted with an alarm.

With the picture removed in moments, the operation took 20 minutes from the time Weiss let himself out of the cupboard to the moment the pictures were covered in paint-spattered decorators' sheets and loaded into the back of a stolen van outside.

It was professional — but not foolproof. Weiss, who had a record for housebreaking and car theft, and Tuerk, a petty crook, mugger, handler of stolen goods and sometime greengrocer, left their fingerprints all over the freight area at the back of the gallery.

Hoefler, the driver, was apparently the only one far-sighted enough to wear gloves.

Police believe the thieves, who drove the paintings to a rented flat in the Sachsenhausen district of Frankfurt, had no idea of their real value. They say another artwork which they stole, Nebelschwaden by German romantic painter Casper David Friedrich, was only taken because it could be easily

removed. Certainly they ignored several far more valuable paintings nearby. The gang was caught in 1995 after Hoefler was informed on to the federal police who then set up surveillance on the three men and two others. But they refused to talk after being arrested.

A SENIOR German police officer said: "It became apparent at their trial they had absolutely no clue about the value of what they had stolen. We suspect that they had been promised cash for the two paintings from the gallery plus whatever they might manage to get away with.

"We are also convinced they were far more frightened of the people we believe they were dealing with than anything we could threaten them with."

However, early efforts to recover the Turners were hampered by what sources at Scotland Yard's Arts and Antique squad describe as heavy-handed work by German police operating out of their Frankfurt HQ.

A British police source said: "They used rather robust traditional methods in the early days. Yes, they basically rounded up the usual suspects and dealt with them by old-style methods, if you see what I mean.

"It set them back and created a lot of animosity among criminals and

no one was prepared to help them."

The fate of the Turners almost certainly lies in the outcome of events in Belgrade.

Police sources in Belgrade say the Serb underworld is in a state of flux with assets being moved on as old allegiances crumble and gang members turn on each other.

One Serb police source said: "There is a brutal battle going on. People are disappearing into the woodwork. Nothing is stable.

"These people have links all over Europe and are heading there, particularly to Germany where they control that end of the smuggling. That is where they send the money because it is safe and that is where paintings would go."

One British police source said: "The signs that the paintings might be on the move are linked to the state of flux in Serbia, without a doubt."

Ironically the Tate is in no position to offer any ransom for the painting's return other than the $250,000 reward money put up at the time of the heist.

Mr Dalrymple said: "We cannot be dictated to on a ransom. It is not someone's life. If they said, 'Give us £10 million or we'll burn the paintings', we'll say: 'Go ahead; burn them.' They know that. But then they would have nothing. All it would do is encourage other thefts. So we're patient."

Light and colour – the Morning after the Deluge: police think Serb gangsters have used the paintings in criminal deals

should limit its part in the next stage of the operation. The worry was that a further recovery operation, although fully authorized by the Frankfurt Prosecutor's Office, might be taking place without the full participation of the Frankfurt police force. This could be damaging to long-term cooperation between the London and Frankfurt forces. The perception was certainly heightened by the publication of Robinson's book. I knew that Scotland Yard officers were to visit

Frankfurt to make sure that the lines of communication with the Prosecutor's Office remained clear. The meeting took place just before Christmas 2000, at the same time as Rocky and Mick were themselves trying to revive their own connections in Frankfurt.

It then emerged that someone had talked to the senior crime writer on the *Mail on Sunday*. He had heard that one painting was back in London, and he was keen to find some corroboration for this notion – something I wanted no one to know. It seemed likely that his source could be a senior officer in Scotland Yard, and although he had yet to publish an article, he might do so at any point. It was imperative to have help with press enquiries, and to establish working procedures with the press office at Scotland Yard. On Nick's advice we brought in press consultant Erica Bolton. In the light of Robinson's 'revelations' a press release was drafted.

> Tate Press Statement November 2000
> Turner Paintings
> There has been much speculation over the years about the whereabouts of the two paintings by J.M.W. Turner stolen in Frankfurt in 1994. And like the authorities in Germany, Tate has always been interested in any serious information which might lead to their recovery. But currently there is no new information, nor are there any current discussions being conducted. Of course I remain hopeful that one day the paintings might return to the Tate.
> – Nicholas Serota, Tate Director

The *Mail on Sunday* did not publish and my fears about further investigative pieces, with imputations about 'Serbian criminals', receded. Nick and the Trustees' Sub-Committee confirmed at the end of December 2000 that they were happy that the Tate should continue with the operation, at least into the spring of 2001. They remained of the view that the Tate should not reveal the return of the first painting unless it was forced to change tack by press revelations.

I worked with Sharon Page, Tate's Head of Legal, to check that the authorization from the Charity Commission was still in place (given the fact that some months had now passed) and that the Tate

did not have to renew Judge Ferris's legal approval for this kind of recovery operation. I extended the contract with Edgar Liebrucks, but with a letter that made it clear that while being grateful for his recent efforts, the Trustees would almost certainly not continue with attempting recovery beyond the spring of 2001. I put it to him that ultimately there are many other Turners in the Tate collection and the Trustees might eventually be minded to declare that no further efforts at recovery would be made.

Early in January 2001 the Tate Press Office was called from Antwerp with the news that a police operation had resulted in the arrest of two men caught trying to sell the two stolen Tate paintings to an Antwerp art dealer. The informant was the press officer for the Antwerp Court House, and when I rang her back in a state of some excitement, she told me: 'These men have been trying to pass off "fakes" of the two Turner paintings.' This seemed somewhat surreal. I spoke to the judge in charge, Judge Mahieu, who was quick to tell me: 'These cannot be the real paintings'. 'Why not?' I wanted to say – even though I knew that one painting was locked up in a store in London. 'Please could your staff provide me with the dimensions and the shape of the images. Because, with respect, if someone is to determine whether these are or are not Turner paintings, then I think it must be the Tate.' He assured me somewhat coolly that staff from the Museum of Fine Arts in Antwerp had already given an expert opinion and the matter was cut and dried. But he did not object to my sending a conservator or curator to give a definitive view of the works.

In the event Roy Perry was able to travel, accompanied by Rocky, and his professional opinion came back quickly. Not only were these not Turners, but also their surfaces were almost still wet, and they had, on their wooden stretchers, the name of a 'studio' in Germany that specialized in making copies. They were worse than student daubs. After inspection Roy Perry filed a report to the Tate:

> The images only correspond to the originals in the broadest terms. There are discrepancies in all parts from the characteristics of the corners to misinterpreted or missing elements. No area viewed in detail matches the photographs of the original paintings in structure, form or colour. There is no evidence to

suggest that the person(s) making the copies had access to the originals. If they did, they made little use of it . . .

The sizes did not match either. It was hopeless mimicry, 'transcribed' from some very poor reproductions. Rocky was quick to identify the two arrested men. He knew them from previous occasions in Germany (between 1994 and 1996) when claims were being made through a lawyer's office in Essen. They were confidence tricksters. Rocky agreed to go back to Antwerp and to give copies of all the relevant documents that could be helpful to the Antwerp Court in establishing not only their guilt, but also the degree of persistence with which they had sought to profit fraudulently from the loss of the actual works. Once again, criminality bred criminality.

The matter was first reported in the Belgian papers, then by the Frankfurt daily paper, and then picked up in the February issue of the *Art Newspaper*.[6] It led to press interest in London and a story emerged that implied that the Tate had been duped into thinking both that it was about to get its two paintings back, and that all the 'Serbian' background information was a ruse created by these two German confidence tricksters arrested in Antwerp. An article published on 23 April by the crime correspondent of the *Guardian*, Nick Hopkins, suggested that: 'Neither the police, the Tate, nor Mr Dalrymple are sure whether rumours that abounded last year, suggesting the two Turners were about to be given up by the underworld, were linked to the men behind the attempted scam.'[7]

In one stroke, this removed the immediate interest in the case from all the specialist crime writers. Which was very useful. The *Guardian* quoted Mark Dalrymple, who (though knowing the actual situation) helpfully put the lid on things: 'It's possible that the paintings have been destroyed, but I hope not. Once villains have pictures they are loath to get rid of them. We are in a waiting game. We just don't know where these paintings are. I don't think we have ever really been close.'[8]

* * *

By February 2001 connections with Edgar Liebrucks were re-established; the Tate's funds to cover the DM5 million fee were transferred back to Frankfurt and an exchange seemed possible again. Rocky and

Mick had further meetings with Liebrucks. Despite certain worries about his stability (arising from both the pressure of the Turner recovery and from personal difficulties), they were positive about a good outcome. The same 'rules' would apply: that we must have time for inspection, in a safe, agreed environment, before I would authorize the handover of the agreed fee for information. The discussions were characterized by Liebrucks's insistence that the recovery *could* be undertaken, while not providing any convincing evidence from those controlling the Turner painting that it *would* actually happen. He claimed to have made a further visit to the 'other side' in mid-February, but did not offer operational detail.

I was desperate not just to get things moving but also to get a result. I wrote to Liebrucks emphasizing that the current contract expired on 31 March 2001 and that the Trustees might not be minded to renew it. I emphasized again that there could be a point at which the Tate might announce the recovery of one painting, and leave the other.

Keeping the final stage confidential remained paramount. The Prosecutor's Office was prepared to keep the Frankfurt police away from the detailed arrangements, while Scotland Yard officers remained involved as advisers. RL was promoted to Superintendent in early 2001, and given responsibility for managing a larger section of anti-terrorist operations, but he remained within Commander Pearce's domain and could still be allocated (with another officer as back up) to support any operation. Although I felt more confident now, as an expert in criminal psychology RL remained a critically important adviser. However, continuing concern was expressed in 2001 from higher echelons of the Metropolitan Police. Whatever the wording of Judge Ferris's judgement of April 2000, the Met could not be involved in any situation where it might be inferred that money was being handed over to criminals, even indirectly. The Prosecutor's Office had given its reassurance that the Frankfurt authorities regarded the operation as legal and justified, but a difficulty arose when senior Met officers checked with their counterparts in the Frankfurt police – as opposed to the Prosecutor's Office – and got the confusing reply that there was no 'operation' at all. Of course, this was because the Prosecutor's Office had decided to limit their briefing.

By mid-March 2001 Liebrucks confirmed that his contacts could produce the second Turner painting, number 532. A full operation was set up with the Tate fee money transferred back to the Deutsche Bank. Indeed, everything progressed with such certainty that I dispatched a van to Frankfurt (in order to avoid having to wait holding the second painting after an inspection). But by the time the van got there it had become clear that there would be no painting. The van returned home with the crate, custom-built to the exact size of number 532.

These two weeks in March while Rocky and Mick worked in Germany were hugely frustrating. Every occasion on which Liebrucks claimed – following information from the 'other side' – that the painting was about to appear, arrangements then collapsed. Liebrucks and Rocky and Mick travelled to three different border destinations. But Liebrucks repeatedly made excuses and put off an actual exchange. At the end of March I transferred the funds back to London again. Rocky made clear to Liebrucks, in no uncertain terms, that since this was the third occasion since September 2000 that we had arranged for the recovery sum of DM5 million to be available in cash in Frankfurt, and the second occasion when we had paid for additional security to ensure the safe inspection of the work, as well as sending a van from London to Frankfurt – we had done *everything* possible from the Tate side – it was he who had failed to produce access to the painting.

The end of March also brought the expiry of his extended contract. A major fall-out ensued, with Rocky shouting at Liebrucks over his mobile in Frankfurt airport. He promised that he would never call Liebrucks again; he wanted to hear from him only when he had actual control of the painting itself. It was a very low point.

In April Liebrucks wrote apologizing for the difficulties. He claimed, however, that the recovery could be achieved *only* if the Tate was to make a new contract in which the DM5 million fee was paid a short time ahead to him – and with him offering a guarantee to return the money if we failed to get the painting – he would then obtain the painting and we would be able to authenticate it. I rejected this absolutely, and repeated what I had always said: that we could not pay the DM5 million fee for the second Turner until we had seen and checked it.

Liebrucks got in touch with Rocky again in early May, saying that he had now viewed the stolen painting in the flesh, and its return was quite possible. But some way had to be found to provide part of the fee in advance. It could either come from himself, or from Rocky (which was how we had made available the second DM1 million 'ice-breaker' in advance of the inspection in July 2000). Rocky and Mick returned to Frankfurt again on 5 June. In turn, Edgar made two trips to talk to the 'other side' to discuss the terms and confirm absolutely that number 532 was available. But with my encouragement Rocky also started to explore discussions with other informants who might have contacts with the 'other side'. We needed to discover another option for recovery, though Rocky estimated that it might take at least a year to establish. This was not helpful.

Liebrucks then offered to put forward DM1 million himself, as an advance payment, and asked whether the Tate would provide a second DM1 million. Rocky's view was that no funds must be seen to come from the Gallery itself. It was crucial that the line was held that the Tate would not pay any further money until I had examined and verified the painting. There were clearly options as to how this could be achieved and I discussed these with Nick on 11 June. I felt strongly that it was much better for the Tate to pay an additional small fee to Liebrucks and for him to provide DM2 million himself ahead of an inspection. He might obtain and then offer the DM2 million to the 'other side', knowing that the Tate would pay him back for having done so – if the painting was successfully returned. He would be taking a risk, but a risk that he could assess in relation to what he knew of the 'other side' and whether they would produce the painting. The Tate itself would be protected from further risk, and could continue to offer the fee of DM5 million for information leading to the return of the second painting. If this scheme worked, then DM2 million of that fee would in effect be paying Liebrucks back for what he had advanced. On this basis we were ready to transfer funds back to the account in Frankfurt in the middle of June, and I offered a renewed and extended contract running until 10 August 2001.

I was also trying to complete discussions with David Hamilton, Head of Legal Services for the Metropolitan Police, satisfying their renewed concerns about the Met's involvement. It was essential that

their advice was available in order to fulfil the Ferris judgement. The crux of it was the correct interpretation of *justifiable*, as in 'advised by the Metropolitan Police in liaison with the German police that the arrangements for the exchange are such that in their opinion it is justifiable to proceed with the exchange'. Did this mean just the safety of those involved in the recovery operation, or the security of the surrounding operation, or the whole idea of trying to conclude such a deal at all? My understanding was that it meant the first, or possibly the second – but definitely not the third. By mid-July, to my relief, the renewed permission came through from the Met. What they required also suited me: that I must consult RL, and he would confirm to any other colleagues that the circumstances for inspection were acceptable (justifiable) and that any personnel involved would be safe.

In late July we headed as a family to New Mexico for a holiday. I deliberately did not take my mobile phone (although Penny in the Tate knew my itinerary). Everything was then planned for early August. But Liebrucks called Rocky only after the 10th, past the expiry date of the current contract. He claimed to have seen *Light and Colour* again and that everything was possible, but returned to his earlier demand that the Tate had to come up with more money in advance. I wrote on 20 August to spell out to him – very clearly – that I was not prepared to continue with this new version of stop–start. I implied in the letter that we were now seeking other routes and talking to other informants.

In the last week of August Rocky, Mick and I met in Frankfurt in order to see the Assistant Prosecutor, Herr Hauschke. We met him in the Prosecutor's Office, over the road from the Arabella Hotel where we had previously organized meetings in the foyer. As we were about to park, I saw a familiar figure crossing the road. 'Could Edgar actually know that we were in Frankfurt today?' Rocky thought not. But we certainly wanted to avoid him at this point. Hauschke was helpful, and reiterated that he would expect the operational arrangement to involve a straightforward examination and payment of the fee. 'I think Mr Liebrucks is asking too much if he is really expecting some money to be advanced. Any money cannot come ahead of a proper inspection of the painting.' He felt that there should be a

straight swap of the painting and the agreed sum of money, the fee. He was crystal clear that the authority still existed from the Prosecutor's Office for the operation to continue. He also confirmed, helpfully, that we could legally explore alternative routes for recovery with other solicitors. Perhaps another route might be possible.

I wrote to Liebrucks setting out that the Tate would have to seek another intermediary and was now taking steps to do so with the authorization of the Assistant Prosecutor. Liebrucks was furious, asserting that he, and he alone, had access to those holding the painting. However, after Rocky had made an actual approach to a lawyer who had offered information on the whereabouts of the paintings some years previously, he came back with a refusal. An alternate route was already looking too difficult. The situation was not helped by the fact that Herr Hauschke was off work for a period. It emerged that he had been released from the Prosecutor's Office because he was unwell. A female colleague was now in charge of our case, but she had had difficult relations with Edgar Liebrucks, and was apparently keen to avoid him.

In November 2001 Liebrucks wrote saying that everything was off – if the Tate was not prepared to come up with an advance to facilitate the return of the second painting then he could make nothing happen. It was all finished. I wrote back to say that I was sorry – but that was the way things were and I was not prepared, or indeed able, to bring any money forward prior to inspection. We simply wanted a straightforward arrangement for *Light and Colour* – we had a fee of DM5 million available for information leading directly to the recovery of this painting. The canvas must be inspected and checked in advance; that was intrinsic to the offer. We stood our ground.

I had to believe that whoever was holding the second missing Turner would come back to us. But it felt peculiarly painful to let things go.

four

Return

Rocky was driving to Poland in January to visit relatives and develop his plans for a new house. 'On my way back I could travel via Frankfurt and explore whether we can get near the second Turner painting. What do you think?' he asked on the phone. The whole affair, otherwise, felt completely stuck. Any alternative routes to the Turner painting had been fruitless. 'I want to explore whether our Assistant Prosecutor friend, Herr Hauschke, will grant access to the actual thieves in jail.' Hauschke was now back at work after a period of illness, which was good news. And any opportunity to talk to the thieves, Yusef Turk and Peter Weiss, to hear their story and discover whether – with the passage of time – they might share information, seemed potentially fruitful.

There were considerable worries in my mind. Should the Tate still put time and effort into making the connection through Edgar Liebrucks? Or try again to plot a new route to those holding the painting? Relations with Liebrucks, however, proved sufficiently friendly for Rocky to divert back through Germany on his return to England and resume discussions in February 2002.

Thursday, 21 February 2002

Rocky telephoned to say that Liebrucks was now very positive about a new operation. I was attending an Arts Council conference at the Royal Opera House on cultural diversity. Mick and Rocky therefore came to the Opera House at the end of the day, and we took a

corner table in the Floral Hall. Waiters flitted to and fro, preparing tables and glasses for the evening rush. It was a quiet time at the end of the afternoon, and perfectly suited to our purpose, although the three of us – a museum manager and two ex-policemen – perhaps looked a little out of place. We talked through the practicalities of what had to be arranged, particularly for the fee monies to be transferred again to the special Tate account at the Deutsche Bank branch in Frankfurt. For the first time we were now working in euros, although our thinking was still shaped around the figure of DM5 million as the agreed and final amount for the return of the second Turner painting.

'Here's the deal. It's surprising, but Liebrucks has now agreed to provide – himself – the DM2 million advance, up front, against the overall fee. He wants a small increase in the money you would have to pay him. But he is serious about this. He really wants to do it.' This meant that Liebrucks would be bearing a considerable personal risk. I rang Sian Williams, Tate's Director of Finance, to check that we could make the cash transfer, the 'Turner' funds now being held at the Tate's clearing bank in London rather than in an investment account. I decided to step things up. Nick Serota was in New York and could be briefed on his return. I needed to check that he was happy with proceeding and for him to sign a new contract for Edgar Liebrucks. We also needed Rocky to be able to pay the security support team, in cash, in Frankfurt. At last, we were ready again for an operation.

Friday, 22 February

I went early to my office at Millbank to prepare the transfers. I sent an email to Nick and the Trustees' Sub-Committee (composed of the Chairman of Trustees, David Verey, and Sir Christopher Mallaby), explaining what was happening. The crucial point was that the initial risk was with Liebrucks, since he had finally accepted that he had to put forward any cash in advance – the figure was still DM2 million – if this was the only way to take possession of the painting. No one else was going to do this. But it would allow us to inspect the Turner canvas and, if everything went smoothly, Liebrucks would be paid the full DM5 million fee as agreed. I worked with Stephen Wingfield

in the Tate Finance department after Rocky had phoned the Deutsche Bank in Frankfurt to get a 'fix' on the exchange rate. Technically, it was now a fee of €2,566,460 instead of the DM5 million. At the end of the day I prepared a new contract and the accompanying letter that set out the fee for Liebrucks. As I walked home, I rang Richard Hartman at the Department of Culture to let him know that things were on the move again. He simply murmured acknowledgment, since he must have felt he had heard it all before.

Saturday, 23 and Sunday, 24 February

I phoned Nick on Saturday (he had just flown in) and took the new contract round to his house. We sat in his front room and I talked him through the likely scenarios. Although slightly bleary, he was pleased that progress was being made. Rocky came round to our house the next day to collect the contract. He sat with his big frame hunched over the kitchen table, sipping his strong black coffee and talking through the current position. Liebrucks seemed to him to be more stable than previously (apparently with a new 'girlfriend') and more consistent in what he was saying. All the early risk was to be his, because he would obtain the DM2 million in cash and take it to the 'other side' – whom we had to presume were the same people who had somehow obtained the first Turner painting, although not the gang who had organized the original theft. In effect, this would be the first part of the recovery operation. Then, and only then (as far as he would tell Liebrucks), would Rocky go to Germany and expect an advance viewing of the painting. Once Rocky had seen the canvas, the plan was that Roy and I would travel to Frankfurt to examine and authenticate it, allowing me to authorize payment – if everything went well. In fact, Rocky had decided anyway to drive to Germany that Sunday evening, and he and Mick would be in Frankfurt by Monday. I rang David Verey that evening and brought him up to date.

Monday, 25 and Tuesday, 26 February

I was on edge all day waiting for the vibration of the mobile in my pocket – but nothing came through. And it was only the next day that Rocky called to say that he had spoken to Liebrucks and all was well. Liebrucks was leaving Frankfurt in order to borrow the DM2 million equivalent in euros and would be back on Wednesday evening and ready to discuss when and where the exchange would happen. Rocky had explained that he would come to Germany on Thursday. This meant that Liebrucks thought Rocky was spending Wednesday travelling to Germany when in fact Rocky was already there, keeping a close track on Liebrucks: on where he was going and who he was meeting (and certainly without being seen).

Liebrucks had asked Rocky about the contract, which I judged to be an encouraging sign that something 'real' was happening. The contract, as I interpreted it, really protected Liebrucks even more than the Tate, given that it set out when the fee leading to the recovery would be paid. So it stopped him from being cut out in the final stages of the process – something I thought he might fear.

Wednesday, 27 and Thursday, 28 February

Rocky rang me at home just before 11.30 p.m., after his meeting with Liebrucks, when he knew that everything was on track. Liebrucks now had to take his advance money to the 'other side' and make the first part of the arrangement. I also spoke to Rocky the next morning as I was travelling with Nick by train to Liverpool for a Tate Liverpool Advisory Council meeting, and he promised to alert me as soon as Liebrucks offered something more specific. As I walked up and down the corridor in Tate Liverpool, overlooking the Mersey, I felt my mobile, as ever, burning a hole in my pocket.

Friday, 1 March

Rocky rang that night – Liebrucks had handed over his DM2 million advance to the 'other side', but had been unable to pick up the Turner. He had seen it, and could confirm that it looked in good

condition, but, crucially, they had simply not allowed him to take the painting away. They insisted that they would choose when the painting would be 'delivered' to him. And it could be any time between this Friday and the end of Tuesday. This was not good. Rocky was meant to be flying to the Galapagos Islands via Ecuador for a long-booked holiday on the following Monday, although Liebrucks overcame this restriction by promising to pay for a new ticket himself if Rocky would agree to stay in Frankfurt at least one more day.

Previously, Liebrucks had insisted that he would not hand over any money to the 'other side' unless they placed the painting directly into his care. This new twist was a considerable puzzle, and a big problem. Looking back, I could see that it matched the fact that number 531 had been 'delivered' in July 2000, without any warning, and only at a time when we thought the operation had failed and were about to return to London. But taking Liebrucks's money in February 2002 without handing over the painting simply broke the 'rules' – but then these were not gentlemen players, so what did I expect? Rocky was disconcerted. It put the whole operation in jeopardy, with any progress seemingly dependent on the whim of the 'other side'.

Although Rocky and Mick were already in Frankfurt, Roy Perry and I were still in London. I put Roy on standby, although I decided not to alert the art transport company, given the disappointments of the previous year. Mick and I had already talked through the practicalities of security staff being needed for extra days and concluded that this would cost around another £32,000. Once again, I arranged for additional funds for the security to be transferred to Frankfurt. Despite all the uncertainties, the operation had to go ahead on the Monday if it was to be successful.

Sunday, 3 March

Returning home after a lunch with friends, I found a message from Rocky. His instruction was to move forward, since Liebrucks 'guaranteed' that the painting would be available on Tuesday, and could be inspected before the banks closed so that payment could be completed the same day. Liebrucks assured Rocky again that he would

pay for his new ticket to Ecuador. Roy and I would prepare to come out early on Tuesday, and Rocky argued that I should definitely order the van to leave London on Monday, so that it would also be in Frankfurt the next day.

At face value this seemed a reversal of our declared strategy. Why would I go and wait on the spot when we had previously insisted that none of us would come – or transfer the funds for the fee – a stipulation already broken – until Liebrucks could *prove* that he had control of the painting to Rocky's satisfaction? Rocky and I discussed the situation on the phone. Rocky explained:

> I am quite prepared to go back to Liebrucks and say that we are sticking to our position, to what we said before. Which would mean that Edgar would have to wait until we all get to Frankfurt. And we would only be there *after* he demonstrated to me that he has the painting in the city, and can show it to us.

But against this I knew there was the huge operational efficiency of having myself and Roy on hand and a van available. Tuesday, however, was regarded by all of us as the absolute final day.

I felt I had another motive for going back to Frankfurt. I wanted to be able to look Edgar Liebrucks in the face and tell him exactly why I could not keep doing this (not least because this eight-to-ten-day period would itself have cost the Tate a considerable sum in security and other expenses). I would explain that the Trustees were not prepared to wait this long, and that if the 'other side' would not provide the painting now – after all this time – then why should they ever do it? The emotional stress was too great. It had to be a direct conversation, not a letter or a fax, and not one conducted by Rocky on my behalf.

Even as I was thinking this I knew it was not the complete story. Surely we *would* wait? We had already waited for seven and half years, so what difference would a few months make? And surely I *could* take the strain, and wouldn't those on the 'other side' eventually realize that this would be their only *real* offer? The question shifted to how best I should play the next bit of the game. Whatever else, I knew

that I wanted to be there, to be part of what took place. This was not in itself a risk. The van was a factor principally in terms of expenditure (the company's crews are often entrusted with confidential information, so although the drivers just might say something out of place, it was very unlikely), but the cost was not itself large compared to that of security and other expenses. So I said 'Yes – OK. I will send the van. And Roy and I will get ready, and fly out to join you on Tuesday morning.'

Monday, 4 March

I sent early morning emails to Nick and to Sian to relay the proposal, and later had confirmation from Nick that he was happy with this move, and another to book flights. I talked to Rocky later to give him our flight information and the direct mobile number for the van so that he could instruct the drivers. Once I had consulted with RL at the Met and Roy had finalized the transport he rang me on the mobile (and I slipped out from an evening meeting to take his call) to confirm that the van had set off for Germany, carrying the empty crate.

Tuesday, 5 March

Roy and I were picked up early by Mick at Frankfurt Airport. All the news was good; they had seen Liebrucks the night before and he was very confident that everything would run. We drove to the Hotel Wald, beyond Bad Homburg, in an isolated location on the edge of the forest. Roy, Mick and I had lunch and were joined for coffee by the two drivers. It was difficult to know what to say to them at this stage, except to expect a lot of waiting around. They seemed relaxed enough, and I was quietly optimistic.

It was a long afternoon. As we sat in the hotel lounge, reports came in by mobile of Rocky's observations from the centre of Frankfurt: of Liebrucks pacing up and down in the road outside the Greek café below his office, obviously expecting something: a person or a message. Liebrucks had then gone off and returned after a short while, apparently very agitated. He had disappeared again – we

hoped this was to make an actual pick up – had changed cars and was now driving a Mercedes. Meanwhile, Rocky was watching from a telephone box. Eventually, Liebrucks called Rocky to say that he must meet him immediately at the Arabella Hotel, and with the Assistant Prosecutor.

Another call came from Rocky at 5.15 p.m. to say that a major difficulty had arisen. Apparently, those on the 'other side' had been informed (it was not clear by whom) that the fee paid by the Tate for the recovery of the first painting, number 531, was 5 million *sterling*, not Deutschmarks, and they thought Liebrucks must have kept a large slice of the funds. They wanted a letter of reassurance from the Prosecutor's Office. Assistant Prosecutor Hauschke had returned to his office to write this, and Liebrucks had driven off at speed to take this document to the 'other side' for them to inspect it.

Mick and I drove into Frankfurt to meet Rocky and Hauschke to see how the situation might be salvaged. Sitting once again in the foyer of the Arabella, Rocky was almost in despair, and Hauschke was fairly glum, presuming that it was all unworkable. Meanwhile, I kept reiterating that noon the next day, Wednesday, was the absolute deadline for us – after which we would go back to London. Rocky managed to get Liebrucks on the mobile and after speaking for a few minutes started shouting. So I took the handset and attempted a calmer conversation. Liebrucks sounded somewhat bemused. He elaborated on what was becoming a 48-hour delay (until Thursday), against which I repeated my determination that we would only stay for less than 24 hours (mid-Wednesday). He reiterated that he had handed over his DM2 million and had been *certain* that they would bring the painting on the day they had agreed. He said he had no means to persuade them to honour the arrangement with him. After a pause, he said: 'They are criminals.' Everything was now in the air.

We returned to the Hotel Wald while Rocky went on to Bad Homburg to talk to some informants about another case he was helping with. We picked up the two drivers and Roy, and headed back into Bad Homburg for dinner at the Jade Chinese restaurant. Meanwhile, while ringing home on the mobile, my daughter refused to talk to me, claiming that in an earlier conversation I had been unsympathetic about her sore throat. I protested that this was not the case.

A late-night call came from Edgar Liebrucks at the restaurant – he was even *less* certain of the timing of the delivery of the painting. Rocky's voice and his were both raised: Liebrucks was on the long drive back from the meeting with the 'other side'. Eventually, after some 35 minutes of continuing debate, the others left the restaurant and I stayed with Rocky for the conclusion of his shouted exchanges. I rang home again to explain the situation – I would almost certainly decide to stay until Thursday.

Back at the Wald I sat with Rocky in Mick's room (while cars screamed around an ice-coated race-track on the hotel TV in the background). We debated at length whether it was better to stay until Thursday or go the next morning. And, more crucially, how we might influence the current situation. Eventually, there was nothing more to say – we would wait and see if the Turner painting emerged the next day – and then we slept.

Wednesday, 6 March

In the morning I woke and read the motto from my fortune cookie from the Chinese restaurant: 'Patience with other people is a virtue.' Irritatingly apt. I walked in the woods early, and then we talked over breakfast. We explained to the drivers that they were free for the day as long as they stayed within mobile phone range. I called Nick briefly, and Rocky told Liebrucks that we *would* stay until Thursday after all. He was hugely relieved, and offered profuse thanks. Rocky and Mick went to meet the security guys who were still on standby, while Roy and I stayed in to work (or draw, in Roy's case). The morning still passed tediously.

We drove for lunch together at a local restaurant in the forest. After lunch I tried to work and then took a long walk up to Feldberg Tor, with its concrete communications tower and lookout post (designed apparently by Albert Speer). I was beating the rain away during a stiff climb and all the way through the woods I was looking for signs (earlier from my window I had seen a red squirrel that I had somehow interpreted as positive). Did I expect a stag with a cross between its antlers? Or an eagle soaring overhead? There was hardly any wildlife visible, perhaps because it was so wet. Not even birdsong.

I resorted to picking up and tucking a sliver of wood in my pocket; needing a memento of that place at that moment in time.

In the early evening we drove into Bad Homburg. Liebrucks called Rocky during dinner to say that he had bad news. He wanted to see Rocky on his own. Inevitably, as Rocky headed off at about 10.15 p.m., we all felt more depressed. About an hour and a half after we had arrived back at the hotel, Rocky called to say he needed to see us. Liebrucks had explained that an issue apparently emerged in relation to two other Prosecutors from the Frankfurt Prosecutor's Office who had been visiting the thieves, Turk and Weiss, in jail. They had offered them some kind of a deal, with better conditions. The thieves had been misinformed that the Tate had paid a £5 million fee, not DM5 million, for the return of the first painting. And with this presumption came the implication that Liebrucks had taken some money on the way through, and the 'other side' would therefore expect more money for the second painting – thus driving a huge wedge between Liebrucks and the thieves in prison and the rest of the 'other side'. This, in Liebrucks's explanation, was what had caused the non-appearance of number 532.

Liebrucks's contacts then said that they would give his money back while they sorted out what was really happening. This story involved the proposition that two different Prosecutors went to visit Turk and Weiss in jail. It was not clear what had or had not been said. There seemed to me to be five possible sources for a breakdown in this operation – (1) Edgar Liebrucks, (2) the 'other side', (3) the Frankfurt police, (4) the regional police and (5) the Prosecutor's Office. And it appeared to be the last of these that had caused all the disruption – the one that I had least expected. There was clearly no point staying in Germany. We needed to go back to London in the morning. But before leaving I wanted to meet Liebrucks face to face. Before collapsing in sleep at about 1.30 a.m., I tried to sketch out a diagram that would express the relationships and interconnections surrounding the recovery operation. This partly settled my mind.

The van set off home, with the crate empty – a poignant image of failure – dropping Roy off at the airport on the way. I went with Rocky and Mick to return their hired BMW to Bad Homburg. Rocky had spoken to Liebrucks who agreed to see us when he was free from court business. In Frankfurt, we took the car to the Arabella Hotel for the meeting with Liebrucks. Looking around at the groups of business visitors, the transient human traffic of a large-scale hotel, and the hovering waiters, memories seeped back of my first meeting with Edgar Liebrucks in April 2000. I could never have predicted the subsequent complexities and uncertainties. Then I had been hopeful, now I was desperately fighting off dejection.

When we sat down over coffee, Liebrucks repeated his account of why he thought things had gone wrong. Assistant Prosecutor Hauschke responded firmly: 'Sorry, but you are wrong. I have checked and none of the other Prosecutors has had contact with the prisoners.' So the story was not clear and possibly not true. But could Hauschke be certain? Was the story simply invented, or even partly true? The claim from the 'other side' sounded too particular, too specific by way of name and detail, to be dismissed entirely. Yet now Liebrucks's contacts would allegedly *not* give him his money back *or* produce the painting. He had also had someone check the jail visiting records, and no one had been to see Turk or Weiss. Intriguingly, Weiss was on day release that day, Thursday, so Liebrucks could not find him to sort out the truth or otherwise of the story. It all sounded as much like fiction as fact.

We went through the basics all over again. Liebrucks either needed his DM2 million back, or the Turner painting, number 532, so that the DM5 million fee could be offered to obtain it for the Tate. He was desperate, he said, because he owed the DM2 million back that night, and would have to start paying extra interest. And those who had lent him the money might think he was double-crossing them. He did not know whether he was being double-crossed himself (would the 'other side' simply walk off with his cash and never return his money or the painting?) or whether the 'other side' simply wanted to clear up any uncertainty. We reassured Liebrucks that he

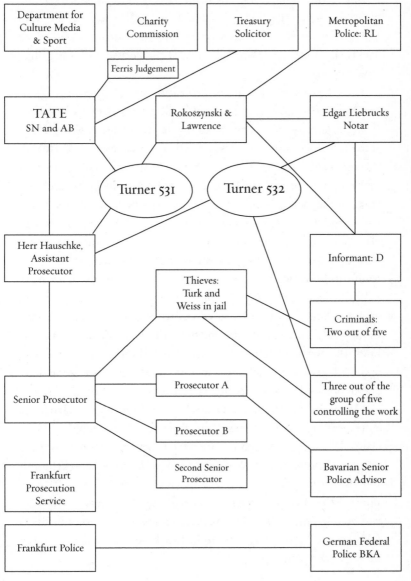

Diagram of Turner recovery, 2002.

must be firm (while refraining from putting more pressure on him, given that he was getting as much pressure as he could handle from the 'other side'). Either they provided the painting as agreed, or Liebrucks could have them all arrested and convicted for handling stolen goods.

On this point he wanted clarification that if the painting was secured during an arrest, he would still get his DM2 million back from the fee money – I confirmed that he would. He might still have some influence, although it was clearly compromised by his fear of the 'other side'. Apparently, when he had been back to see them, they had simply ripped up the letter from the Assistant Prosecutor setting out the facts (about the earlier fee relating to number 531 paid in Deutschmarks, not sterling), treating it as of no value. Liebrucks also told us of another case – in January – when a 'Yugo', as he put it, was arrested on charges for counterfeiting currency and was found to have two crude copies of the Turners in his apartment. (Why had we not been told? And did this connect to the Antwerp arrests in January 2001?) I assured Liebrucks that we would retain the money in Frankfurt until the end of April, although not in cash. He knew that we were definitely leaving (myself for the airport, Rocky and Mick to drive to London) and he acknowledged that he *must* have actual possession of the painting before we would come back.

We walked across to the Deutsche Bank branch to say thank you to the manager and her assistant. Rocky's mobile rang just as we crossed the River Main on route to the airport. Liebrucks wanted an immediate meeting. We turned the car around, hearts thumping, desperately wondering whether he had gained possession of number 532. Rocky happened to drive the wrong way in the one-way system, and although I joked about losing those on our tail, I felt nervous. When we got there Liebrucks offered a new story, but sadly not the painting.

As I was leaving earlier, a messenger came to my office and told me to go to a particular location in the city to meet one of my contacts, one of these guys. I then talked with one of the five from the 'other side' – this is one out of the two that I have regularly had discussions with. This man said that

they still wanted to do it. They had also been finding out about this prison story — and it relates to one of the other Prosecutors back in the autumn of 2001. He went to the jail, with someone, to visit Turk and Weiss. This Prosecutor claimed to want to find out about the missing painting and had offered immunity from deportation, a certain amount of day-release time, and the possibility of more money.

Liebrucks repeated that the Prosecutor appeared to have spread confusion about the deal in 2000, claiming that the fee had been paid in sterling rather than the truth, which was Deutschmarks.

Liebrucks's particular contact also said that he wanted to help make the recovery happen and that if necessary *he* would raise the necessary DM1 million (in return for a fee of €200,000) to pay off the third of the other three, the other two having been allegedly paid off from Liebrucks's DM2 million advance. But this was absurdly over-complicated, and even Liebrucks admitted he did not really believe this story. It was little more than gossip, and did not justify a reversal of plans. Rocky and I left him in the Greek café. We would return only when he had the painting *actually* in his hands. I arrived back at the Tate late on Thursday, exhausted, and with a few close colleagues asking jokey questions about whether I had been wandering in the woods. I was overwhelmed by a determination that this had to stop — absolutely. It was too disruptive, on so many levels.

* * *

When I met with Rocky and Mick at the end of July 2002, Mick said: 'This phase of work is finished. We have to go back to finding another way to obtain the Turner painting — and this may mean going around Edgar'. I agreed, and conveyed this proposition to Nick, and to close colleagues and members of the Trustees' Sub-Committee.

Why had we come to such a negative conclusion? All the months since Christmas had been hard to understand. At first I thought of external factors such as the February changeover of currency in the European Union, when the Deutschmark gave way to the euro. The

demise of the Deutschmark might cause other people to be moving large quantities of Deutschmark or wanting to get rid of spare cash, but it emerged that, if anything, the reverse was true: that if everybody had new notes then other new notes did not stand out, and there were now many more countries through which the same currency, the euro, could be distributed or traded.

Edgar Liebrucks had never been able to explain the exact reasons why the advance was required. It was bound to relate to lack of trust – to reduce risk from the point of view of the 'other side'. But who was really demanding what? The most coherent explanation was that five men controlled the painting, and two of them were particularly demanding and had to be paid off first. With hindsight I am aware of lost connections that might have been significant. At the time I felt the priority was just to seek the actual location and availability of number 532. Once Liebrucks had said in February that he would borrow funds as an advance then everything had seemed to move forward. I had to hope that getting this wrong was bad luck, or perhaps a miscalculation, rather than just our being blindly optimistic. After the early March operation even Liebrucks recognized that we really were not coming back to Frankfurt unless he had demonstrable control of the painting. He had to have actual possession of the Turner – physical possession – and be able to convince Rocky of this.

After the failure of early March there had been various opportunities in the early summer. At the end of May, when the Golden Jubilee long Bank Holiday weekend seemed a possibility, I knew it was ruled out because of bank closures. In the early summer I was worried about potential clashes with the dates for interviews I had for director posts at the Courtauld Institute and the National Portrait Gallery. However, this was nothing compared to the prevarications emanating from Edgar Liebrucks, caused, so he claimed, by the 'other side'. Frequently, some event of theirs (a minor car crash, a further disagreement, someone being away) was the reason why he could not gain control of the work, why the recovery could *not* go forward. Occasionally, reasons of his own intervened, such as court appearances (at one point he was defending one of five terrorists allegedly linked to al-Qaida). My hopes were sometimes

raised, but at least without more resources being used up before they were dashed again.

It was not clear to me why, in this period, Liebrucks was making no further reference to his advance payment made to the 'other side' (and the cost of the loan to him). Why had Liebrucks *ever* handed over the euro equivalent of DM2 million to them? Had he been under physical threat at the time? Had he in fact been paying off debts that he already had in relation to the fee paid for the recovery of the first Turner painting, number 531, in 2000? Could it be possible that Liebrucks had not passed on all of the recovery fee in July of that year? These were awkward questions and impossible to answer.

Given that alternate routes were not emerging, we needed Liebrucks to agree to what we thought of as a new 'special' operation, in which he would cooperate completely from the beginning instead of negotiating with us along the way. It would need to be developed as a matter of joint interest. In June he agreed in principle, and on this basis Rocky and Mick went back to Frankfurt for a sequence of meetings. We now expected Liebrucks to provide much fuller information in advance: names, addresses and locations of all those involved, so that an operation could be set up with the authorities more closely involved.

Liebrucks had previously insisted, understandably I suppose, on no direct police engagement in any actual operation. Indeed, the agreement with the Assistant Prosecutor was based on his immunity from prosecution (for handling stolen goods) and a promise that the Frankfurt police would not be involved in the handover. Liebrucks's very real fear was that if the 'other side' found the police to be involved, in any way, then it was not just recovery that would be threatened, but his life. My additional concern was that in the years after the theft there appeared to have been leaks in Frankfurt, with information possibly being passed to those associated with the robbery, or those holding the paintings.

Rocky's new proposal was to work on this 'special' operation with the Bavarian unit that had supported us in July 2000, with whom he had worked many times before – and with the Assistant Prosecutor's approval. In the next meeting with Liebrucks, in July 2002, Rocky and Mick pressed him for as much information as

possible, and he described how the 'other side' had driven him with a hood over his head, in circular routes, before any actual discussions took place. He explained to Rocky about the threat of another 'buyer'. Someone was prepared, apparently, sight unseen, to pay the euro equivalent of DM5 million for the painting – a collector, a well-known producer of musicals (which seemed to hint at Andrew Lloyd Webber). This appeared to be a ludicrous invention (although Rocky and I agreed that if necessary I would check this out with Lloyd Webber himself). In the next meeting, already prevaricating about actually writing anything on paper or sending a fax, Liebrucks said that the painting was now controlled by only two men, one of whom lived in Frankfurt, and this was where the painting was: in an apartment in the city. All the previous assumptions were that those who controlled the painting – and presumably the painting itself – were some five to six hours away from Frankfurt, and across a border.

By the third meeting with Rocky and Mick, they could not tell if he was deliberately spinning a line or simply did not remember what he had said previously. This was perfectly possible. But it cast all the exchanges of the previous months into further doubt. The Edgar Liebrucks that I had met during the March operation had seemed genuinely distressed that things had gone so wrong and the painting had not materialized. He appeared to tell the truth, including the bizarre element, told somewhat against himself, that the thieves, Yusef Turk and Peter Weiss, believed that he had been handed a fee of £5 million rather than DM5 million (and pocketing the difference). But if part of his narrative was compromised, then the present strategy was clearly in jeopardy. The 'special' operation was not going to work. The plan to get around Liebrucks would be even more necessary, not least to discover whether recent (or indeed earlier) information was true or false. The broad objective was clear but the means of achieving it less so.

August 2002

Rocky and Mick wanted to put the facts of the situation to the two jailed thieves, Turk and Weiss, in the hope that they were in touch

with some of those holding the Turner painting. We hoped to make them aware (indeed, show them bank statements to prove) that a sum of money had been sitting in the Frankfurt bank since March and was ready to be paid as a fee, through Edgar Liebrucks, leading to the recovery of the second painting. We were bemused as to why it was taking so long to accomplish this. Perhaps *they* might know how to move forward? One danger was that such a discussion would get straight back to the authorities or the police – but that might not matter very much. The most probable outcome would be to demonstrate to Liebrucks that if he was unable (or unwilling) to cooperate in a 'special' operation then we would work energetically to find another way to those holding the Turner painting. This might leave him out and should strengthen his resolve to get his DM2 million back. He had admitted to Rocky that he had asked the Assistant Prosecutor Hauschke if his present status as a 'facilitator' could be changed to that of an 'informant/participant' in which case he would, theoretically, be able to earn some of the DM5 million recovery fee.

Rocky, Mick, RL and I also discussed the alternative approach of announcing that number 531 was already back in Britain, something that we had resisted for two years. I had now been appointed Director of the National Portrait Gallery and was aware that I would leave the Tate in October. I had in mind that the first Turner, *Shade and Darkness*, could go on display in September. Nick signed a new extended contract with Liebrucks, and I explained to him the growing importance of the autumn strategy and the possible display of the first painting, number 531. We agreed that this would need a decision by the Trustees' Sub-Committee. Rocky, however, soon conveyed that the whole idea of pursuing another route was being blocked by the Assistant Prosecutor. Hauschke would not allow a visit to Turk and Weiss, being concerned about a precedent being set if Rocky and Mick were to talk to the thieves. This was another setback.

Given our lack of alternatives, Rocky spoke to Liebrucks, who was in Sicily but about to return to Frankfurt. Liebrucks now had the idea of involving his ex-wife in the discussions. Apparently, she had put up a guarantee that had allowed him to borrow the DM2 million and therefore she had a stake in the recovery of the painting.

Rocky rang me from Frankfurt on 13 August to say that through talking to Liebrucks and his ex-wife, he had been thinking about the ways in which it would be possible to obtain another DM1 million, which was now required by the 'other side' on top of the DM2 million already advanced by Edgar. The new thinking was that Rocky would obtain the money himself as an icebreaker. In order to facilitate this, Rocky should be allowed to see the painting so that he could convince others that the loan was genuinely required – and that an exchange was feasible.

I thought this all very unlikely. However, Rocky said that he was quite happy to be driven blindfold to wherever the 'other side' wanted to go, as long as they let him examine the work and take a Polaroid photograph of it. Rocky would then 'obtain' the further icebreaker of DM1 million, offer that in a straight handover, after which I would be able to inspect the painting, and take possession before authorizing the release of the full DM5 million fee. I weighed up the question of whether Rocky could recognize the right marks on number 532 and undertake the authentication himself. He was certainly well informed about the Tate stencils, the frame maker's marks on the back of the stretcher and the look of the craquelure, the cracked glazing that cannot easily be faked. Although far from being a curator, he could certainly undertake a basic identification. Nothing, however, seemed to be happening with these discussions. This was the point at which I believed the Tate should take a different approach: reveal the recovery of the first Turner and use the publicity to establish new routes to those holding the second.

September 2002

At the end of August I made preparations for a Trustees' Sub-Committee meeting at which I wanted to persuade members that we were not going to get the Turner back through the present methods. Nick made clear that he did not like this idea – although it could go to the Sub-Committee if I wanted. In my Committee paper I summarized the history of the pursuit of the Turner paintings and set out my recommendations. Rocky attended the meeting, and he and I spoke about the options. In the event the Trustees supported Nick's

view. A new strategy might anyway have become irrelevant because Liebrucks had rung Rocky the day before the meeting to say that he had renewed contact with the 'other side', and was now very, very keen to undertake the operation as soon as possible. In the circumstances, Liebrucks's optimism was remarkable.

I was getting anxious about leaving the Tate and having to abandon the Turner recovery incomplete. At the September Trustees' Sub-Committee, David Verey said: 'Sandy, you've really got to hand this over to others at Tate. You must be ready to "let go" of the operation. The whole recovery will now have Alex Beard in charge.' Even Rocky was a little shocked by the way in which this was conveyed. Although I had total confidence in Alex, it felt a bit like a kick in the backside.

October 2002

Liebrucks suggested a new operation organized on the same basis as our earlier discussions: Roy and I would inspect the painting first, in a secure environment, and would then provide the euro cash equivalent of the DM5 million fee, within the terms of the Ferris judgement. Whatever he said, I was reluctant to transfer any Tate funds back to the account in Frankfurt unless there was the serious prospect of the Turner being available – after all the time and resources wasted in the previous year. He confirmed, however, that Rocky could have a 'pre-inspection' viewing, to give confidence to the Tate and trigger the transfer of funds to Frankfurt, and conversion into cash. After much deliberation, Rocky and Mick travelled back to Frankfurt on Monday, 7 October. Over the next week, there was a constant relay from Liebrucks that his contacts were ready for Rocky to be able to see the work. Discussion took place about what Rocky should wear (a tracksuit, being the most easily searched garment) and how the visit would be conducted (with talk of Liebrucks seeing a place set up with an inspection table and lights, and a stolen car sent to collect Rocky – a bizarre suggestion given the greater possibility of a 'hot' vehicle attracting the police). But arrangements soon started to fragment because one of the group was not happy; he had declared that he would not be 'dictated to' and was holding up the pre-inspection of the painting.

Here was the double-bind that we had met so often before. There was no way of making the 'other side' less nervous if, on each occasion, although they wanted to make arrangements for an inspection, as soon as everything was set up they blocked actual dates and times from being fixed because this brought the threat – in their minds – of a sting or covert surveillance. The split within the group became the apparent blockage, and by mid-October it emerged that the painting would not come after all. Liebrucks could not get any clarity about the situation – he had always claimed that communication with the 'other side' was based on them getting messages to him or meeting them in distant locations. On 14 October Rocky and Mick travelled back to London, hugely disappointed and very frustrated. Once more I was left saying to Liebrucks (somewhat pathetically, given the repetition), 'We can *never* come back to Frankfurt until you have absolute and complete control of the painting.' There was also considerable recrimination between Rocky and Liebrucks. Once again, we needed to find another route.

Rocky was preparing to take a long-planned sailing trip around part of Australia and on to New Zealand. At about the same time Liebrucks reported a visit from two different men claiming that they could offer access to number 532 and also the stolen Friedrich painting. Having established with Rocky that these were not undercover police checking up on Liebrucks, we presumed that they were a splinter group of some kind. It seemed they were willing to do a deal for euro/DM5 million (DM4 million for themselves and DM1 million paying back Liebrucks for some of his loss), although this would leave him without the full sum he had paid as an advance to the other group. Rocky and I discussed this new twist in the story and agreed that although it was interesting as information, we *must* stick to our position that unless Liebrucks had actual possession we would not travel to Frankfurt. I confirmed to Liebrucks that the Tate money was being withdrawn from Frankfurt.

A further call from Liebrucks came as Rocky was in the departure lounge for his flight to Australia. Liebrucks claimed that the 'new people' had already allowed him to see the painting – and he had examined it closely, checking the labels on the back. They would allow an immediate inspection by Rocky and seemed to him

to be much more straightforward. Did Rocky really need to fly away now? Rocky telephoned me from on board the flight, just as passengers were taking their seats. 'It sounds intriguing, but I think we need to stick to our position', I said. Rocky told Liebrucks what he already knew: that he had first to gain control of the painting. If he did this, while Rocky was away, then Rocky would fly straight back to oversee the operation. Otherwise he (and they) must wait. That was it.

Edgar Liebrucks rang through to the Tate on 24 October 2002, and a message was relayed for me to call him, as I was then in transition between jobs. Liebrucks repeated a similar story to me: 'Can you and Roy come to inspect the painting early next week? That way I can be sure that it is the genuine item. This is necessary, given that the Turner has mysteriously changed hands.' After speaking with Mick and Alex, I told Edgar: 'You really do have to control the work – not least to prevent a swap between an early inspection and an actual handover. And we must avoid any danger of hostage taking.' I had always been conscious of these dangers surrounding inspection and payment of a fee. 'But you could take some Polaroid photographs of the front and back, and particularly any labels. This would help a lot, allowing us to know that it is the genuine work.' He accepted this. Subsequently, Rocky rang me from Cairns and reiterated that we should not be tempted into any pre-inspection deal. He was happy with the photos idea as a way of checking the painting, and keeping the link open. He repeated that if Liebrucks actually had possession, he would return to Europe directly.

I travelled with my partner to New Haven at the end of October, where she was giving a paper at a conference at the British Art Center at Yale, alongside a loan exhibition of works from the National Portrait Gallery collection. There were odd moments, not least wandering into one of the bookstores in New Haven, and seeing a whole pile of a new book on art with number 532, *Light and Colour*, reproduced on the cover.[1] It didn't feel like a helpful sign.

I started my new job as Director at the National Portrait Gallery on 5 November, and immediately faced a sequence of phone calls from Liebrucks in which he explained his discussions with the 'new people' and the ways in which he wanted to accomplish the recovery before the end of November. In the meantime I had been asked by Nick and Alex to stay as unpaid adviser on the recovery. All formal decisions and authorizations would lie with Alex Beard, now sole Deputy Director at the Tate, but I would continue to organize arrangements for the recovery. Having consulted my own Chairman of Trustees, Sir David Scholey, I accepted the arrangement on condition that I would be fully involved in how – if we were successful – the paintings would be made public, and would also be able to write an account of the pursuit.

Quite soon I was caught between Edgar Liebrucks pressing me hard as to whether we could move forward ('Why can you not come over? It is so easy') and Rocky's concern that he could be messing me about. Were the 'new people' described by Liebrucks simply an invention of his, given that he could not explain why this scenario came only a week after the breakdown of the previous operation in October, or was Liebrucks, in Rocky's words, 'just trying to work a flanker'? However, I soon received a single floppy disc, in an envelope sent on from the Tate, together with a letter from Liebrucks dated 30 October. The disc had jpeg images not of the front of the painting, number 532, but of the reverse, including details of the Tate accession 'number', and one temporary exhibition label, torn off and re-stuck on with tape: a label for a major Turner exhibition organized by the British Council at the Grand Palais in Paris in 1983–4. I emailed these images to Alex and Roy, and we knew very quickly that they seemed genuine. They could only be faked with enormous difficulty. It was hugely encouraging – the first actual, clear evidence of number 532, *Light and Colour*, I had seen for eight years. I sat and stared at the images on my screen. It was just thrilling – a definite breakthrough.

Liebrucks was quick to demand that I come to Frankfurt and Rocky should return from Australia. They spoke directly and a

Jpeg image of the back of the canvas of (532) *Light and Colour (Goethe's Theory) – the Morning after the Deluge – Moses Writing the Book of Genesis*, October 2002.

shouting match ensued in which Rocky emphasized that while the Polaroids were encouraging they were not yet the painting. Liebrucks still had to get possession. In my next conversation he sounded wounded from his exchange with Rocky, and seemingly innocent of the definitive conditions already established. How could anything ever happen, he protested, if the Tate was so intransigent? I tried, calmly, to explain: 'Edgar, you do need to persuade these "new people", whoever they are, to let you have the Turner – to "lend" it to you for a few days.' Liebrucks could not see why they would agree to this. But I repeated:

> I think they have no choice, since this is the only way they
> can obtain any of the fee. If, for any reason, we do not come
> up with the fee money while you have the painting 'on loan',
> then you can simply give it back. The key is that they have to
> trust you with it.

I offered to write a letter that could be shown to the 'new people'. And this, with a new extended contract, was sent in Alex's name on 14 November. It emphasized the work that had gone into eight and half years of pursuit. It went on to suggest that the best sequence would involve Liebrucks being trusted sufficiently to be lent the missing painting, so that it could be seen by Rocky, and then inspected by myself and a Tate conservator, after which the remaining fee would be paid. The letter emphasized that the contract was the defining arrangement, and that if for any reason the fee was not paid then the Turner painting could be returned to those holding it. And the letter concluded by saying:

The Tate is the only museum or gallery which will be able to pay [a fee for information leading to the return] . . . of this painting. It is too famous to be exchanged with anyone else. Over these recent years there have been many occasions when the Tate had the money ready for an exchange and the painting did not appear, and so nothing progressed, causing very great distress for Sandy, myself and my director Nicholas Serota.

I played everything at a slow pace in the hope that this could be strung out until December when both Rocky and Mick (who was making a separate trip to Bermuda) would be available. The most workable scenario was a Friday to Monday set up, with Liebrucks gaining control – being 'lent' the painting – on a Friday morning and after an initial examination by Rocky, the funds for the fee being transferred back to Frankfurt. A full inspection would take place on the Monday in time for the fee to be handed over before the banks closed at 4 p.m. The only dates possible were 13–16 December, although I knew that Rocky held a ticket that only took him out of Auckland on the 14 December. So not back into London until the 15th. This would mean a new ticket – as long as he could be persuaded to return.

* * *

By 20 November Rocky had arrived in Sydney and the yacht was now docked for mast repairs. We talked on the phone about possible itineraries to get him back to London, ready for the hoped-for call from Liebrucks – with the painting in his hands.

Wednesday, 4 December

A sense of urgency was building up. Even if I remained sceptical about whether the 'new people' were really new, the firm evidence of the photographic images made me feel closer to success. I briefed Alex and the small circle of Tate colleagues.

Friday, 6 December

In the morning I was pacing up and down in front of the Imperial War Museum (ahead of a meeting of the National Museum Directors' Conference), and speaking on the mobile to Rocky. He had now made landfall in northern New Zealand. The weather there was sunny, so he was not clear when they would sail on. He sounded very unsure about coming back early, based only on Liebrucks's word that he *would* gain possession the following Friday. Reluctantly, he agreed to investigate ticket options, but still based on getting to Heathrow only on Friday, 13 December. This worried me because it was so very tight. As we spoke, I saw Nick's tall, rather gaunt figure coming up the path, beneath those huge guns. There was some amusement on his face as he realized whom I might be talking to.

Tuesday, 10 December

An email to Alex – having briefed RL at the Met and given an update to Richard Hartman at the Department of Culture – summarized arrangements:

> E[dgar] L[iebrucks] has confirmed to me today that the 'new people' say that it is all on for Friday and they will be giving EL 532 in the morning. Fingers crossed . . . Tonight I will speak with Rocky again and will confirm that he should fly home on Thursday night, arriving at 10.05 on Friday morning, or earlier if he can get a flight. I will discuss with him whether he books an economy ticket (*c*. £685) or a Business class seat (£2,900, unless he can get a discount locally). I will also tell him that tomorrow I want to move the money to the Frankfurt account (the overall fee plus whatever is needed for security) and that he should contact and warn the bank manager. Could you line up Stephen W ready to do this tomorrow?

I was still very nervous as to whether Rocky would take the flight home. But with a business-class seat reserved for him, he stepped on to the flight in Auckland on Thursday, 12 December.

Friday, 13 December

Liebrucks rang early at the Portrait Gallery to say that he had possession; and was positive when I asked if the painting was in good condition. As things worked out there was more than an hour before Rocky touched down at Heathrow from Auckland. When I heard his voice from Heathrow I was hugely relieved. By 4.30 p.m. he and Mick were off in the car to Germany. But not before there had been an altercation with Liebrucks in which he suddenly said that he could not show the painting to Rocky in advance of Monday. I rang Liebrucks and reminded him of what had to happen, and insisted that the money would not be transferred (although in fact I had already ordered it to move), and that Roy and I could not – invoking a possible instruction from Nick – leave Britain until Rocky had seen that it was indeed the Turner painting. In the end I negotiated a compromise that Rocky would see the picture at some point after midnight on Sunday, and I would be called and given the go-ahead to fly.

Saturday, 14 December

Quite unexpectedly, at 9 p.m., Rocky called me at home: 'Sandy, I have just spent thirty minutes with the Turner painting – and it is in good condition.' He had no immediate explanation as to how he had got ahead of the Sunday/Monday arrangement. 'I am 95 per cent certain that this is number 532' – which was pretty good, although I would have preferred him to say 99 per cent. I then spoke to Liebrucks, who was standing next to him: 'Edgar, this is great, great news. I will see you in Frankfurt on Monday morning.' I hoped to sleep much better, but I knew there was still some way to go. But the painting suddenly felt within reach.

Monday, 16 December

I woke at 4.30 a.m. (or before, if you count the fretful moments, tossing and turning). A taxi at 5 a.m. and the 7 a.m. flight with Roy, although delays meant we didn't get to Frankfurt until after 10.30 a.m.

As we drove into town I noticed a street sign for Tischbeinstrasse; Tischbein was the artist who painted Goethe reclining in a classical landscape, a postcard of which sits above my desk at home. This was a good sign for the day.

Once settled in the familiar lobby of the Arabella Hotel, and coffee served, Rocky and Mick reassured me that the money had finally come through to the Frankfurt branch. But as soon as they were in the bank that morning Liebrucks had been on the phone to check – and had started to try and lay down new terms: Roy and I must go to a certain place in the city; Rocky must go to the bank; I must ring Rocky after I had seen the painting, etc., etc. Rocky said this was simply not acceptable and we would discuss it once I had arrived. 'It is crucial', Rocky insisted to me, 'that you stick to what we have agreed: that we must not be split up and that you and Roy can *only* examine the painting in a location that I have approved'. Liebrucks joined us, and in the languid atmosphere of the Arabella lobby we sat – as ever – and watched those watching us. It felt too much like a replay of all the times that an operation had not worked out.

Liebrucks immediately said: 'Sandy, you can come with Roy and myself, and we can go to a hotel nearby to see the painting. I have it locked in a room there. You can inspect the Turner and then ring Rocky, and he will bring the money. And we will make an exchange, *zug kum zug*.' This was the kind of arrangement that we had always expected. *Except* that an unknown location was out of the question. It was critical that we all stay together. We had no idea who might be watching Liebrucks: if someone else from the 'other side' believed that we would play it differently, they might swoop on us. If someone wanted to kidnap the painting or us, then this would be their best chance. We all tried to convince Liebrucks that we should go to the other hotel *together* and then all go to the bank with the painting with us. He did not like this: 'I have an agreement with these "new people". It is a contractual agreement with them – I have to stick to that. It is no good if you do not trust me.'

There was much to-ing and fro-ing with Rocky getting very noisy and pacing up and down, his big frame gyrating as he turned between the tables. 'Edgar, I will not be dictated to.' The idea that Liebrucks, who had handed over DM2 million against Rocky's advice,

should now give directions on security matters was particularly galling. There was talk of trust, fear, threats, security and agreements, without much progress. More than an hour passed and it appeared to be a total impasse. Rocky then said that he could agree to another location if we all visited this hotel room and made an inspection, then he would go to the bank and collect the money and then two cars would meet, one with Rocky and the money, one with Liebrucks, Roy, Mick and the painting and myself. The location for such a meeting would be agreed between Liebrucks and Rocky only after the inspection. All phones would be switched off. This was then agreed by me – Liebrucks would now phone the 'new people' and gain their agreement. Liebrucks complained again and again (without seeming to see that this sounded so suspicious to us) that Rocky had already seen the painting on Saturday evening and did not need to see it again. But he went off to make the call.

Within an hour he called to say that he would meet wherever we suggested and I said the Arabella Hotel (given that we were already in the lobby, as Mick had planned, and had reserved a room upstairs), and he agreed to bring his car into the basement garage. This was the peculiar advantage of this hotel, that you can go direct from the garage to an agreed room at a higher level, using the lift, without passing Reception. Once he had driven in then we knew that whatever else happened, the painting would never leave the hotel other than in our hands. Later that evening I wrote:

At 2.20 p.m. in Room 210 of the Sheraton Arabella Hotel in Frankfurt, Edgar walked into the room with a blue cloth bag seemingly designed to hold a canvas. And with no further wrappings, out came the painting and we laid it flat under the light, near the window, on some spread out towels over a marble side-table. It looked magnificent. We all stared intently, but Roy did the real work. I felt a really curious mix of elation and relief that flooded my whole body. While Roy examined I paced about, and then he took me through a few of the comparisons with the photographs of the drying cracks and then I signed the release form – and after taking a few photographs and Polaroids, Rocky and Liebrucks

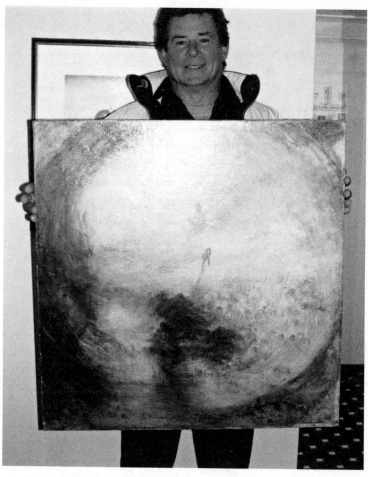

Rocky with (532) *Light and Colour (Goethe's Theory) – The Morning after the Deluge – Moses Writing the Book of Genesis*, 16 December 2002.

headed off to the bank. After all the fuss and argument he came like a lamb, and he also seemed vastly relieved to have passed it back to us, even before the bank work was complete. And then we all started making phone calls.

I called home – it was an emotional moment – this was the completion of my eight and a half years of searching.

Tuesday, 17 December

Early the next morning I sent an email to Alex at the Tate:

> Current state of play is that the van will get to Frankfurt at
> some point mid-morning today, but . . . don't expect Roy
> back until later on Wednesday.
>
> I have made contact with Mark Dalrymple, through whom
> the access to the Store (where 531 is already) is organized
> and he will liaise direct with Roy. The basic idea is that both
> pictures are examined by Forensic [the Metropolitan Police
> Unit] at the Store prior to coming to Tate for public display
> at an agreed time . . .
>
> Then the works will need a suitable space to be displayed.
> Nick will have a view. For what it is worth I think Tuesday
> 7th January would be a good day for a morning press confer-
> ence, and photocall . . . obviously the publicity needs to be
> geared to getting people to come and see the pictures and
> visit Tate Britain.
>
> Talk later on. It's still a bit of a dream!

* * *

Dr Sabine Schulze, as the 'relieved curator of the exhibition *Goethe und
die Kunst*' (Frankfurt, 1994), wrote to Nicholas Serota to say: 'For this
news I have been waiting anxiously for 8 years and 145 days – ever since
I stood on the night of 28 July in total desperation in front of the empty
wall at the Schirn. I am overjoyed and congratulate you and your cura-
tors with all my heart for the return of the two unique Turners!'[2]

Friday, 20 December

At the end of the week a press call was organized at Tate Britain with
the arts correspondents. Nick had made the point that they hardly
ever get positive stories that are real news rather than merely pro-
motional material.

PRESS RELEASE
20 December 2000
Tate's stolen Turners are recovered

Tate is pleased to announce that two paintings by J.M.W. Turner, stolen from an exhibition in Frankfurt, Germany, on 28 July 1994, have both been recovered and will go on show at Tate Britain from 8 January.

The two paintings, *Shade and Darkness – The Evening of the Deluge* and *Light and Colour (Goethe's Theory) – The Morning after the Deluge – Moses writing the Book of Genesis*, are two of Turner's most significant works.

Investigation continues to try and recover a painting by Caspar David Friedrich from the collection of the Kunsthalle, Hamburg, stolen at the same time, and therefore no further information about the recovery of Tate's paintings can be made available.[3]

Shade and Darkness was recovered on 19 July 2000 but no announcement was made for fear it might jeopardise the recovery of the second painting. *Light and Colour* was recovered on 16 December 2002 and returned to this country on 18 December 2002.

The recovery operation was carried out in continental Europe but both paintings were recovered in Germany. The Metropolitan Police have provided advice throughout. For Tate, Sandy Nairne, formerly Director of Programmes, now Director of the National Portrait Gallery, co-ordinated the recovery operation. He and Tate's Head of Conservation, Roy Perry, have both seen the paintings and are satisfied that they are the original works and that they are in good condition although they are without their original frames.

Nicholas Serota, Director of Tate, said this morning: 'These two paintings are amongst Turner's most important works and, in their references to Goethe's colour theories, show him to be at the forefront of European intellectual enquiry. I am grateful to all those who have worked over the years to make their recovery possible, and particularly to Sandy Nairne for his assiduous work towards this successful outcome.'

In the event of persistent questions, the Tate's Press Adviser, Erica Bolton, and the Tate's own press team had a number of possible responses, which included:

Q&As

How much has this operation cost Tate?

The combined costs over eight and a half years including insurance, travel, legal fees and investigative expensive expenses amounts to just over three and a half million pounds. Tate took on the additional costs for the investigation when it acquired the title of the two works in 1998.

Did you pay a ransom or reward?

No.

What were the investigation expenses you mentioned?

It is perfectly normal for the police to pay for certain information which they believe may lead to recovery. The Tate was legally responsible for the costs incurred for this operation. Throughout Tate has acted under authority from the Charity Commission, the DCMS and a court order issued in April 2000.

Why wasn't the insurance money used on Tate Modern or Tate Britain?

Because the money was related to the Turner Bequest until the paintings were recovered. Furthermore, it was never Tate's intention to fund its capital projects with this money and this was not the motivation behind seeking release of the funds.

How have the police been involved?

The Metropolitan Police have advised on the process throughout the whole operation.

Have the German authorities led this investigative work?

The recovery work has been possible because of the full co-operation of the German authorities. We cannot speak in any detail about the recovery itself.

What will you do with the rest of the money?

The Board's intention is that it should be used as a capital sum for the benefit of Tate's collections. We will

finalize arrangements with the DCMS and the Charity Commission over the coming months.

Did you pay any money to criminals?

Tate has not made any payment to criminals and the investigation has been supervised throughout by the Metropolitan Police and the German authorities. We cannot comment in any more detail.

At the press conference on 20 December, a simple story was to be told. After eight and half years, the paintings were now back, and in good condition. This offered a certain level of closure on the case, and the works themselves went on display at Tate Britain on 7 January 2003. Although the full story of how the recovery had taken place could not yet be told (not least because the Friedrich painting was still being pursued), Nick and Alex made the critical decision (in discussion with Trustees David Verey and Christopher Mallaby) to be open about the figure of £3.5 million that had been spent on expenses and information leading to the recovery. The reaction of the press and the response in the papers, from the *Financial Times* to the *The Times* was fairly straightforward, although the *New York Times* asked how the arrangements for the buying back of the title from the insurers would benefit the Tate.[4] Journalists and writers may have wanted more information about the final process, but at this point the celebration of the outcome was more important than how it was achieved.

Two stolen Turner masterpieces worth at least £20m apiece, which were recovered by the Tate Gallery after an exhaustive search, went back on public display yesterday. The paintings were returned to pride of place at Tate Britain eight years after they were taken from an exhibition in Frankfurt. Sir Nicholas Serota, the Director of the Tate, said it was wonderful to see the paintings back in place. 'In the last eight years we have been unable to show Turner's collection in full. There have been these two gaps on the wall, but now it is complete again.'

– *The Independent*, Wednesday, 8 January 2003

Part Two

five

Ethics

Whether private owners or public officials, we are also stewards and trustees with higher obligations than simply the fulfilment of our own preferences. This is a mentality with many roots: a respect for genius and a sense that its creations transcend ownership; a caring about our history and a wish that everyone share in its meaning.[1]
 – Lee Bollinger, President, Columbia University

The Museum is no longer sacred or untouchable . . . The process of rethinking the museum has brought intense examination of values and assumptions, the scope and nature of the services offered, the focus and approach to leadership and management and the relationship between museums and the people they wish to serve – the public.[2]
 – Gail Anderson, *Reinventing the Museum*, 2004

In the spring of 2003 the Tate staged a celebratory dinner to thank all those who had helped in the recovery of the stolen Turners.[3] Yet alongside the thrill of successful operations, the theft and recovery of the Turner paintings raised challenging and sometimes unwelcome questions. As well as issues of security and value relating to the recovery of stolen art and antiquities, there are wider ethical concerns that link to questions of trust. This is not just about whether museums and public galleries always behave impeccably – they may not – but about the expectations and regulations that influence the trust in which they are held, the relations between them, and how this has changed over time. In Britain, Lord

Nolan established in the 1990s what were called the Principles for Standards in Public Life, being selflessness, integrity, objectivity, accountability, openness, honesty and good leadership by which these standards should be promoted. It was hoped that these would engender trust in all public sector bodies, and they have now been widely accepted as the touchstone for judgements on institutional behaviour. The governance and management of museums are matters of such trust, as also the questions around ownership and the lending of high-value objects internationally.

The ethical questions relating to fees and payments in recovery operations are necessarily part of the wider context of stolen art and antiquities, ranging from disputed ownership of excavated works and questions of national cultural protection. Much has been written about the looting of art and antiquities from war zones, most recently in Afghanistan and Iraq, about the longer-term degradation of archaeological sites in countries such as Italy, Greece and Turkey, and about the smuggling of art from countries in the developing world, connected to (or driven by) a worldwide market for antiquities.[4] The possible restitution of objects to their country of origin has also caused much debate, including cases emerging in relation to spoliation – the forced appropriation of works during the Nazi regime in Germany and occupied territories before and during the Second World War.

Responding to these and other ethical issues is an integral part of the work of museum directors and their trustees – whether those caused by national and cultural conflicts, or linked to acquisitions or the removal of works from collections; conflicts of interest with trustees, sponsors and donors; the rights of artists and their estates or good governance and the public accountability of museums. All have grown in public and media prominence in recent years.[5] In large part that prominence reflects a shift from museums being regarded as lofty institutions, assuming their own importance (and impregnability), to a position of far greater accountability within the many communities they serve. Some differences of approach have reflected the constitutional differences between museums that are private foundations (such as the Whitney Museum, the

Guggenheim and the Museum of Modern Art in New York) and the European model where museum trustees join the board through a system of government-supervised appointment, as with the national museums in Britain.

The ethical and legal issues relating to the return of stolen works of fine art might appear to be more particular. Yet, the lengthy and drawn-out nature of the Tate's work to gain approval from all the relevant authorities in the case of the Turner paintings illustrated the complexities and the degree of uncertainty (given the sums of money and risks involved) and also the broader principles of appropriate institutional behaviour. The term 'novel and contentious' is a phrase that applies here, since it matches the British Treasury reference to payments for which there is little precedent. But however novel this specific situation, it is crucial to understand it in a wider context and to share such an analysis.

The Museum Today

A great city department store of the first class is perhaps more like a good museum of art than are any of the museums we have yet established. It is centrally located; it is easily reached; it is open to all at all the hours when patrons wish to visit it; it receives all courteously and gives information freely; it displays its most attractive and interesting objects and shows countless others on request; its collections are classified according to the knowledge and needs of its patrons; it is well lighted; it has convenient and inexpensive rest rooms; it supplies guides free of charge; it advertises itself widely and continuously; and it changes its exhibits to meet daily changes in subjects of interest, changes of taste in art, and the progress of invention and discovery.[6]

 – John Cotton Dana, *The Gloom of the Museum*, 1917

The critique made by John Cotton Dana, radical director of Newark Public Library and Museum from 1902–1929, satirized the ways in which newly established American museums were, to his mind, simply aping the interests of rich, aristocratic collectors who revere high art and foreign objects. In his view, this was at the expense

of an interest in contemporary applied art and design, and in the home-grown creative arts burgeoning within America.

If Dana was prescient in focusing on the failings in the activities of museums, what underlies his critique is a considerable degree of distrust of museum trustees and their appointed directors. Of course, this was written nearly a century ago and museums have expanded and responded to the demands of growing numbers of better-educated visitors and cultural tourists, created considerable amounts of community outreach work, developed new forms of display and interpretation, and transformed the provision of public facilities (the 'ace café with a museum attached'), as well as exploiting new technologies.[7] They have also become – to a degree – more transparent in offering an account of their activities and finances to those who enquire. In the same period museums have become much more energetic, seeking to serve a wider public, mixing private as well as public funding, but questioning has become proportionately more intense.

The Tate, like the Museum of Modern Art, New York, and the Guggenheim Museum, is a prominent international art institution and used to being the subject of critical attack, whether during the 'Tate Affair' of the early 1950s or David Hockney's criticism of the narrowness of its acquisitions policy in the 1970s.[8] As sponsorship grew in the 1980s, questions arose about the business interests and connections of sponsoring companies, and in the 1990s links between museums and patrons and collectors, together with questions of global influence, were in the spotlight.

Following the recovery of the Turner paintings, Michael Daley of *Artwatch*, and some members of the Turner Society, felt that questions went unanswered when the two paintings were put back on display at Tate Britain on 7 January 2003. In the background was a potential lack of trust in the governance and management of the Tate, although the specific question was whether it had pursued the lost paintings in the right way. Was active pursuit even the right course of action? This writer, and the Tate, contends that there was an institutional as well as a moral duty to use all means available to get the paintings back – but questions about methods and means were inevitable.[9] Further questioning arose around the

use of the insurance monies – were these to be spent on matters related only to the Turner Bequest or across all of the Tate's responsibilities? The last was answered in legal terms through counsel's opinion and accepted by the Charity Commission in 2006 – the benefit of the insurance monies was for the institution's work as a whole.

Do people trust museums as institutions that will act on behalf of the wider communities they serve? Or are they thought to be biased towards certain interests, through intellectual bias or the sources of their financing? Has the general shift from being more scholarly institutions, in a process of popularization, caused the modern museum to be seen in a more cynical light? Hans Haacke is amongst those artists who have raised these and similar questions in their work over many years.[10] Whether being questioned by artists or under greater scrutiny from audit systems, government reports or the media, I would argue that the museum as an institution has benefited from such external pressures and the need to be more open about processes and decisions.

Looting, Smuggling and Restitution

We face a future in which there may be no past beyond that which is already known and excavated. Or equally sad, what is left may be so ruinously mutilated as to afford only a forlorn fragment of a vanished legacy.[11]

– Karl E. Meyer, *The Plundered Past*, 1973

In December 2002 the directors of eighteen European and American art museums signed and published a joint 'Declaration on the Importance and Value of Universal Museums: "Museums Serve Every Nation"'.[12] It opened by stating that the 'museum community shares the conviction that illegal traffic in archaeological, artistic and ethnic objects must be firmly discouraged'. It goes on to argue that what may have been moved or removed in former centuries took place under very different conditions. And it ended with the proposition that museums

serve not just the citizens of one nation but the people of every nation. Museums are agents in the development of culture, whose mission is to foster knowledge by a continuous process of reinterpretation. Each object contributes to that process. To narrow the focus of museums whose collections are diverse and multifaceted would therefore be a disservice to all visitors.

Prompted by continuing calls for the return of the Elgin Marbles from the British Museum to Athens and the Pergamon Altar from Berlin to Turkey, the 'statement' was viewed by some as a defensive and institutionally self-serving document rather than an overarching set of principles. Certainly, those who have argued hard for the interests of 'source' nations do not take it as self-evident that works of international importance in large metropolitan cities are in the most advantageous location and should be insulated from further discussion about relocation. Some historians and commentators simply regard the loss of major works from the countries where they were produced as a form of theft.

These differences of view derive in part from a legacy of looting, theft and plundering as part of aggressive military policies (whether pursued by Napoleon in the nineteenth century or Hitler in the twentieth), as distinct from the legal acquisition (however disputed, as with the Elgin Marbles) of works excavated or obtained in other countries. The plundering of the Baghdad museum in April 2003 is a chilling contemporary example, when approximately 15,000 objects were stolen over two days and of which only some 9,000 have been recovered. Yet the idea of a 'universal museum' is itself the product of a relatively small number of cultures with the power (and often the intellectual determination) to collect specimens or artefacts from across the globe. In one sense it is the product and legacy of the Enlightenment – a belief that a benign, inquisitive interest in all other cultures is desirable and creditable.[13]

Perhaps the greatest fear in the later 1960s and '70s was that the marked rise in the values for works of art and antiquities – objects of all sorts from earlier civilizations – would cause a rapid increase in looting and illicit trading. Karl Meyer, writing in 1973, points to

the plundering of tombs and temples as 'assuredly the second-oldest profession, practised as widely if not always as profitably as the first. Like the courtesan, the tomb robber knows there is money in beauty, and rarely a shortage of customers. Laws, moral constraints, and bodily hazards have had roughly the same deterrent effect on one calling as on the other.'[14]

The alarm is considerable among archaeologists and historians, and much has been undertaken in recent years, principally through UNESCO, to try to uncover and prevent the illicit trade in antiquities. In 1999 the British Government established an advisory panel under the chairmanship of Professor Norman Palmer. Its recommendations included Britain signing the UNESCO convention of 1970 and the creation of a new criminal offence of importing, dealing in or possessing stolen or illegally excavated cultural objects. In January 2002 the British Government joined the other 91 signatory nations to the Convention. This followed a period in which public collections in the West, principally in the US, had acquired important works from dealers or collectors, for which the provenance was not always clear or ethically sound.

The J. Paul Getty Museum is one of several US museums involved in controversy regarding the acquisition and proper title to antiquities in its collection. Marion True, the museum's previous curator of antiquities, and an art dealer, Robert Hecht Jr, were dramatically indicted in 2005 on criminal charges relating to trafficking in stolen antiquities.[15] Similar charges have been raised by the Greek authorities. But in 2007, the then director of the museum, Michael Brand, supervised the return of a number of works. Various pressures, including from the Italian government, seemed to play a part. In 2006 the Metropolitan Museum and the Boston Museum of Fine Arts had returned Greek and Roman antiquities to Italy acquired between the 1970s and '90s, in effect acknowledging evidence that these works had been looted and illegally exported.

Similar disputes have arisen around the emotive question of human remains. While many museums have accepted return in certain circumstances – relating to cultural and religious significance within a source country or culture – others have wished to retain human remains acquired in the eighteenth or nineteenth

centuries for present or future research, regarded by Western scientists as of over-arching and universal significance. For many years the Natural History Museum resisted claims made by the aboriginal people of Tasmania (pursued by the Tasmanian Aboriginal Centre on the basis of aboriginal belief that a soul cannot be at rest unless its mortal remains are in its own land, but made more highly charged by the knowledge that British settlers had watched their almost complete wiping out on the island through fighting and the introduction of Western diseases). However, following a 2005 framework for handling claims for the return of human remains in UK museums, the museum set up its own Human Remains Advisory Panel which concluded that the remains of seventeen Tasmanians and the skull of an aboriginal person (thought to have been illegally exported as late as 1913) should be returned to the Australian government.[16] The Natural History Museum director, Michael Dixon, said: 'We are a science-based organisation but we do not believe that the scientific value should trump all other claims; nor do we believe that the ethical, religious, and spiritual claims should necessarily trump the scientific value.'[17]

A further significant issue arising from the return of the Tasmanian remains was whether or not the museum had the right to undertake DNA sampling in order to investigate the genetic characteristics of the early-contact aborigines. Such intrusion into their ancestors' bones was strongly resisted by the Tasmanians, while being regarded by the London scientists as essential analysis for the investigation of patterns of migration among human communities, and even for future research into the spread of diseases. In a final compromise, data collection on the remains was carried out in early 2007, but the results were put under dual control of the museum and the Tasmanian Aboriginal Centre, for use only with joint approval.

In such a dispute there are completely opposing views of human remains as objects: the integrity of human bones being regarded as sacred, or the necessity of scientific investigation as paramount. The principles are perhaps more straightforward in the case of plunder from empire-building states, totalitarian aggression, ethnic cleansing or warfare. Nothing can justify the Nazis' approach to removing

assets as part of the persecution of Jewish families and businesses in the 1930s. Of the many thousands of works of art looted, some have, not surprisingly, been offered without full information to collectors and museums in the post-war period. Over the past decade a considerable degree of national and international cooperation has gone into checking museum collections for such works, unwittingly acquired, which derive from Nazi spoliation. Britain established a Spoliation Advisory Panel in April 2000 in order to offer independent investigation and arbitration on claims made in relation to works in British collections. The panel can also indicate if it thinks there is a case for restitution of the work or for compensation, taking this out of the hands of the trustees of any individual museum. Although the resolution of complex cases relating to events more than half a century earlier is complicated, the very process has underlined the absolute importance of maintaining public trust in the integrity of museums as public institutions.[18]

Rewards, Ransom, Buy-backs and Payments for Information

> There can be a serious downside to the advertising of rewards, and their indiscriminate use has in the past acted only to encourage criminals to commit more thefts in the mistaken belief that the reward offered is little more than a price tag and that they will in effect be able to sell back the stolen art to the owners or to the insurers. There is a fine line between paying a genuine informant a reward for information given, and the use of a reward to buy back stolen property and for the investigator it is an area that is legally fraught and requires great care.[19]
>
> – Richard Ellis, 'Investigating Stolen Art: The Reason Why', 2005

Under the bold headline 'How Tate Laid Money Trail To Recover Turners', Nigel Reynolds, writing in the *Daily Telegraph* (in November 2005), used the BBC broadcast of a German-made documentary television programme about the Turner case to set out a number of allegations.[20] The byline referred to 'millions' being passed to 'Balkan underworld figures in a cloak-and-dagger operation', and the article claimed that the Tate had set out to 'buy-back' the paintings, that

monies were handed over to 'unnamed criminals connected with the theft'. He posed the question 'Did the Tate knowingly pay a form of ransom?', and quoted my own, factually correct, comment that 'a reward would be involved' in recovering the paintings. Thus the Turner case illustrates the difficulties of defining terms and the complexity of ethical issues surrounding recovery operations.

The actual points were answered within six weeks when, on 19 December 2005, the Tate published the Consent Order by which the original text from the Ferris judgement of April 2000 and related documents were released for public scrutiny. It was then clear to journalists and commentators that the Tate – myself and colleagues – had been scrupulous in ensuring that full permissions were granted before going ahead with the recovery operation. The operation itself was under the guidance of the Metropolitan Police, as specified by Judge Ferris in the High Court.

Given the novelty of the situation, however, one of the risks to the return of the Turner paintings was that one of the bodies concerned (Department of National Heritage, Charity Commission, Attorney General's Office, as well as the Frankfurt Prosecutor's Office) would not agree or approve, or be so cautious as to make it untenable to proceed with the operation. The final authority of the High Court (enacted by Judge Ferris on 28 April 2000) clarified the public interest. But the judgement was not made public until five years later – three years after the Turners were put back on display – and only then (when the Caspar David Friedrich painting had also been recovered) could the Tate's actions begin to be understood.

Rocky commented about the Turner operation:

> We had the highest judge in the country telling us that it was legal and the judiciary in Germany saying: yes, go ahead and do it, we are OK with that. It was not for me to question it. I would not stop and ask whether it was 'moral'. Absolutely not. Paying the money was a prop with which to get the paintings back.
>
> Call the money whatever you like. I look at it from a different perspective. Tate got a lot of money from the insurance

company, and a small part of that money got the paintings back, and this will give millions of people the joy and pleasure of appreciating them. Being devil's advocate, wouldn't Tate have been criticized by some, saying, 'You have all that money, can't you spend some of it getting the paintings back?' You are in a no-win situation.[21]

The same questions had concerned the Chairman of Trustees, David Verey:

If these pictures had not been insured, and there was no money from insurance, we would have wrung our hands, we would have said this or that, but to be able to produce some money, on a given day, was absolutely crucial. I often thought, if we didn't have the money, we would not be doing this. Then you get to the question of what is an appropriate price to pay for the information? The net result turns out to be one of the great successes of all time for a national museum.[22]

The *Daily Telegraph* article, however, as well as comments and letters, demonstrated considerable interest and concern, as well as widespread confusion in the use of various terms – ransom, reward, buy-back, payment for information – and also a genuine difficulty for journalists in explaining how these paintings were back on public view, without having the full information about how this had been achieved.

Nicholas Serota commented later:

I am perfectly used to being criticized. That is not the issue. I am content that people should disagree with a judgement that I have made or has been made by the Tate. But what I do hope is that they can respect that care and consideration went into that judgement and that a view was taken which was seen as reasonable at that time.

The sum of money that Tate released was sufficiently large for some people to interpret it as a ransom. And I can understand why people might see it in those terms. But we

went through a number of processes and we received sufficient assurance about how the money was going to be deployed to feel that we were paying for information and our decision was signed off through a legal judgement. That was and remains our position. But I can see why journalists, not necessarily being aware of all the facts, could take a different view.

Inevitably with the recovery of the second picture there was an increasing amount of speculation as to what had happened. There were two reasons to release the information [in 2005]. First to make clear the very careful steps the Sub-Committee had taken – this was neither cavalier, nor a response to a threat . . . The second reason was that it is obviously helpful to other institutions to be aware of the principles that were discussed and the safeguards that were put in place. Any set of precedents will obviously be modified in different circumstances, but to put our deliberations into the public domain seemed to be a responsible thing to do.[23]

After the Tate's public disclosure, the same correspondent for the *Daily Telegraph*, Nigel Reynolds, wrote an article headed 'Tate Comes Close to £3m Ransom Confession', and still used accusatory terms for the ways the authorized payment could be described.[24] Perhaps more pointedly, the *Guardian* reported that 'What the dossier makes clear is that in the judgement of Sir Francis Ferris, the high court judge, the payments were legal and in the public interest. That view was supported by the government and the German authorities What remains controversial is what became of the £3.1m.'[25] This was something none of us could know. I had always accepted that what had been authorized was to pay a sum of money through Edgar Liebrucks, the approved intermediary – in an arrangement that would produce each of the paintings. I presumed that he would pass monies to whoever now had control of them (the 'other side' as we called them, whoever they might be), as authorized by the Frankfurt Prosecutor's Office. On several occasions the German police confirmed that they would pursue the monies paid, using the

information gained in the process to catch criminals associated with the theft.

Whoever they were, those holding the paintings were not the criminals who had organized the theft in 1994, and the arrangement was guided by the view of Roger Pearce, Metropolitan Police Director of Intelligence. Before the operation started, he wrote in December 1999: 'Crucially, the German prosecutor has stated that, should such a transaction go ahead, he will make every effort to recover the monies by tracing and prosecuting offenders.'[26] The *Daily Telegraph* quoted a Tate spokesperson: 'It was acknowledged by the court, and by Tate, that the payments to be made to Edgar Liebrucks might well be passed on to others, including those holding the paintings. However, once the Tate paid money to Edgar Liebrucks, it had no control over it.'[27] I confirmed to the *Guardian* that: 'No money was handed to anyone other than the German lawyer.'[28]

Alex Beard commented on the monies that the Tate paid in Germany:

> The relevant description of the payment is that which is set out in the Ferris judgement, and which formed the authorisation for our actions. This is the only relevant description. The payments were what the payments were: made with the disclosure to Ferris and authority from an English court. They were made with the knowledge of the relevant authorities, in UK and Germany.
>
> Ransom is not remotely relevant in this context . . . because a ransom is something demanded by the perpetrators of a crime for the assets that they have secured through that crime, usually under threat of harm to that asset. And that was patently not the case here. Had it been the case then there is no question that we could have made any such payment.[29]

After the theft of the two Turners in 1994, a reward of up to $250,000 had been offered by the insurers. When their interest came to end in July 1999 (following re-purchase of the title by the Tate), the reward was reinstated on 6 August, for the purposes of

general circulation to the public. Although the theft of high-value paintings can often appear to be a kind of kidnapping (or art-napping as it is sometimes called), the arrangement with Edgar Liebrucks was not a 'ransom'. However complex and difficult the arrangements, no threats to the paintings were made. Whoever had the paintings offered to release them to Liebrucks in exchange for a certain level of payment. It was the German authorities that took the view that this was a logical continuation of their investigations, but it was the Tate that would have to pay and take the risk. But then the Tate could pay such a sum only when the police in London (as well as the other authorities) approved the arrangements.

Mark Dalrymple, as a loss adjuster and expert in handling rewards and who advised on the Tate process, is unequivocal about the Turner case:

> Was the Tate payment a ransom or a reward? Payment of a ransom is an offence in the UK, and a criminal offence would have been committed, regardless of what a judge in chambers might have said. The key element of ransom is the threat of destruction: you can't have something back unless you pay. Ransoms are usually used for threats to human life or animals, like Shergar. If there is a threat like that – pay up or we will burn them – then my answer would be, 'burn them'. Because then the criminals will get nothing as well. But criminals never will. Why burn something they have invested say £100,000 in? Most criminals, unless they are mentally unstable, will ultimately steal things for financial gain in one form or another, and they are not going to burn them.
>
> The point that I have been asked on a number of occasions, was whether it [the Turner case] involved a 'buy-back'? It was not a buy back. A buy back is when you are dealing with a villain who you know to control the stolen object, give them money in the hope that you will be given the picture, and letting the criminal get away with it by not telling the police.[30]

Rocky's view was that:

What Liebrucks was simply saying to me was that the people he was dealing with had nothing to do with the actual theft. I am absolutely certain that the paintings were put into hock or some money was borrowed and they were used as security ... Because right from the beginning, immediately after the theft, the villains wanted money up front, a million DM ... and that may have been to get them released from other people who were holding them.

At the end of the day, Edgar came up with the paintings – it may have taken a long time – but he did. He had obviously paid out money to allow us to recover the first painting. The bonus on the Turners was that the money was available.[31]

The Tate case may have specific characteristics but, however pressurized, standards of institutional behaviour and complex multinational approvals were adhered to. Despite the unsurprising confusion among commentators – between reward, ransom and payment for information – the Tate was, in the end, weighing up the positive and negative elements of offering an approved payment. In many ways the authorities in Germany were far-sighted enough to see how the public interest in this case could best be served. After the paintings had been hidden for eight and half years, the success of the operation was a huge gain for the millions of visitors to whom they were made available once again. Judge Ferris's view in the Turner case was, in effect, that the negotiations and payments ensured that the works came back intact and sooner than might have been the case. They might otherwise have simply been destroyed.

Differences of view remain as to how best to conduct an investigation and recover stolen property at the same time. Private investigators (often those who have retired from police service) have on occasions angered Scotland Yard through negotiations for the return of stolen goods. A 'senior source' from the Met was quoted in the *Evening Standard* in 2003: 'I'm not here to lecture people on their morals. I understand private investigators have a different position from the police. Their job is to recover art for the victim rather than arresting villains.

But we do feel that effectively buying back paintings could be encouraging more thefts.'[32]

Questions raised in the press exemplify fears that in pursuing stolen property the insurers, victims or even the police will put the recovery of stolen items ahead of capturing criminals. And potentially encourage more theft. Police procedures work to prevent this, which is why, when rewards are offered, they come with the stipulation that they are 'up to' a certain amount and offered only 'subject to the usual conditions'. Mark Dalrymple emphasizes that police officers of all ranks 'unanimously and without hesitation consider the offering and payment of rewards to be a desirable feature providing its practice is properly regulated'.[33] And the 'proper regulation' includes the clarity of conditions (it is vital to be clear whether a conviction for the perpetrator of the theft is or is not required), the size of the reward being no more than 10 per cent of value, appropriate procedures for dealing with known informers being in place, and the authorization of payment being through the police. This is set out in the Theft Act of 1968, which was created in part because of fears that payment of rewards had given additional benefit to criminals associated with an original crime. Properly controlled, payments for information help the police to identify criminals and give them contact with those handling stolen property. As Dalrymple put it:

> The actual amount paid is discretionary by the payer and in practice judged according to a number of different factors which will include the ease with which the property is recovered, the condition upon safe recovery of the property and in particular the risk undertaken by the finder or informant in achieving the recovery.[34]

Although what is or is not a ransom may not always be clear to the press, the offering of rewards in the UK is regulated, and more recent legislation, the Proceeds of Crime Act, limits further how stolen art and antiquities can be recovered. Ex-Art Squad detective Dick Ellis takes the view that:

If you offer a reward, you will encourage information. That has been shown to be the case time and time again. But you have to understand the motivation of the person giving the information. And yes, the criminals will use that offer of a reward to try and sell it back – the stolen property. They will sell the information. You cannot always be 100 per cent certain that the person you are paying for the information isn't going to turn around and say OK guys we have made some money on this. But, if you can be certain enough that that person wasn't directly involved in the commissioning of the crime or the dishonest handling, it is arguably safe to pay them the reward.[35]

Everyone discourages direct negotiations with criminals that characterize a 'buy-back' arrangement, but there are still some grey areas in relation to high-value art theft. Vernon Rapley, Head of the Art and Antiques Squad until 2010, takes a tough position:

As a police officer I have a very clear view – If you offer a reward for the return with no questions asked, effectively you are available for a buy-back of the commodity, and you will fuel further crime. The trouble with a reward is that it is a double-edged sword. By offering a reward you increase the use and value of stolen property to the criminals who hold it. You may also increase false intelligence, as you then have all kinds of clowns out there who start coming in and taking up a huge amount of police time and resources . . . On the other hand, it is a way to start the underworld chatting, talking and thinking. And ultimately gives the police the chance to cultivate and work on the intelligence that results. It has to be a balance.[36]

The debate over payments in the recovery of stolen paintings exemplifies the over-arching public interest in trying to combine the return of important works of art – perhaps pawns in a much larger game between the criminal world and the police authorities – with the continuing pursuit of criminal gangs and countering of

underworld activity. An ethical framework can be used to draw a line between the appropriate and police-approved use of rewards and payment for information on one hand, and submitting to ransom demands or buying back stolen property on the other.

six

Value

Value is inescapable. This is not to be taken as a claim for the objective existence or categorical force of any values or imperatives in particular; but rather as a claim that the processes of estimating, ascribing, modifying, affirming and even denying value, in short, the processes of evaluation, can never be avoided.[1]

 – Steven Connor, 'The Necessity of Value', 1993

A painting has no intrinsic value. It is a luxury commodity for which a market is deliberately created and maintained by financially interested parties who are neither more nor less noble than the operators of any other legal sort of market.[2]

 – Robert Wraight, *The Art Game*, 1966

There is much to unravel around the concept of value and how it is constructed, as well as understanding it as the principal incentive behind art theft. Criminals utilize a network of exchanges to translate stolen works into a cash profit – shouldering the additional uncertainties of exchanging works of art through barter or use as collateral. How is this motivation linked to the value of works of art, and does art theft therefore have something to contribute to an understanding of value? Why have certain works of art acquired such a fabulous financial value and what do different people understand that 'value' to be, whether in symbolic or monetary terms? In the underworld there appears to be a desire so powerful that it induces criminals to take calculated but very considerable risks to steal very high-value objects by breaking into art galleries or museums.

The Routine Activities Theory developed by criminologist Professor John Conklin subdivides the primary financial desire of the 'motivated offender' into various categories (see chapter Seven).[3] We are principally concerned here with those who steal (whether commissioned or for themselves) with the intention of ransoming the work to the owner, seeking a buy-back from an insurance company or using the work for barter or collateral. 'Art-napping', involving theft for the purposes of forcing a payment from an owner or insurance company, is one approach. For this reason most such thefts are complex and involve an experienced criminal team, with a division of labour between those who plan, those who break in, and those who have the contacts or the experience to make money from the stolen work. Successful art crime is therefore as much about reconstructing value for the stolen work as it is obtaining the art in the first place.

The process of untangling criminal networks brings out questions of value. First, because it spotlights the fundamental issue of why (and how) our society judges certain cultural objects and activities – jewels, precious metals, paintings – as especially valuable. Secondly, because it underlines the different but parallel formations of value in the art world and in the underworld. The market value for a work will be fundamentally different from its barter value in criminal circles, and in each arena the intrinsic or use value, status value, and exchange or market value may be compared. Thirdly, because it causes us to think both about the construction of value and how valuation takes place. What are the processes by which a work of art, a unique cultural object, acquires (and retains) a specific financial and economic value without the underpinning of materials, such as gold or jewels, that are valuable in themselves?

For the past half-century there has been a continuing and spectacular increase in the prices paid for works of art. This is the background against which high-risk art theft has grown. When the two Turner paintings were stolen in 1994 they were valued at £24 million, but this increased to a calculation of at least £36 million by the time they were recovered in 2002. Therefore, the pair of paintings might have had a barter value in the criminal underworld of between £2.4 and £3.6 million, or around 10 per cent of what they

would notionally achieve in the saleroom. With previous record prices consistently broken at auction since the late 1950s, with the ever more visible success of art museums and their loan exhibitions, and with a wealthy Western society increasingly at ease with the display of its affluence, the potential for black market activity has grown. Criminals make their own calculations of value, on their own scales, hoping that the post-theft exchange value will match the cost and risk of overcoming security defences. These calculations may relate to the wider name recognition of the artist as well as to known market values. However, the recovery of stolen art is, critically, a point of intersection between ideas of value and the processes of valuation.

Values/Value

Not to put too fine a point on it, we live, breathe, and excrete values. No aspect of human life is unrelated to values, valuations and validations. Value orientations and value relations saturate our experiences and life practices from the smallest established microstructures of feeling, thought and behaviour to the largest established macro-structures of organizations and institutions.[4]

– John Fekete, *Life After Postmodernism*, 1987

High-profile theft focuses a spotlight on the importance of works of art – their cultural value and place in society – as well as their purely financial value. A sense of cultural value, reflected in the loss felt to staff, trustees and a community after a theft, increases the determination to pursue works stolen from museums and heritage sites. This may matter more than financial value. Works in public ownership are usually inalienable, in that they can never normally be sold, so market value is hypothetical. But if the stolen work is insured, then for the loss adjuster the pursuit is both about the work itself and about regaining a financial asset, against which an insurance claim has been made.

The idea of 'value' as something intrinsic to a particular object or activity – in the sense that it is specifically cared about or encouraged – is open to debate. What value and social values, such as

truthfulness, respect for property and freedom of expression, hold in common is a concept of goodness, of ideas and things that have merit, and are beneficial within society. As Steven Connor puts it, 'values help us to clarify what we believe to be right or wrong, permissible or impermissible'.[5]

The activity of making art – like an art object itself – is generally regarded as positive and creative, the product of unalienated labour, giving pleasure and having social value, whether aesthetic or educational. The degree to which a particular work of art is esteemed is a very subjective process, since art is not consistently valued, and sometimes valued only by minority interests within society. Conversely, criminal activities such as theft, widely regarded as morally wrong as well as illegal, exemplify the promotion of anti-social values, such as greed and disrespect for others. While relating only to societies in which property ownership is itself a central principle, stealing represents selfishness – the opposite of sharing. Stealing is bad in the deprivation that it causes, and wrong in its disregard for ownership. However, stealing and making art can be seen to mirror each other in representing highly independent, self-organized and anti-bureaucratic forms of work.

Value and Quality

The degree to which the arts are perceived not just as good but also as having wider cultural value is related to how they are assessed by specific groups of people. The quality of a particular work of art, piece of writing, performance or film – in the sense of how much it is valued, culturally or financially – will be judged against criteria (such as levels of aesthetic pleasure, skill or originality) that are collectively determined, and change over time. In Western society one generation often judges works of art (such as the two stolen Turner paintings) very differently from another.

Judgement of quality in the Western tradition relates to specific characteristics, such as style, formal composition, materials used and skill in execution, as well as to elements such as narrative, originality and inspirational associations. How these elements are appreciated depends in part on how they are presented, and therefore to the

likelihood that they will produce specific effects. Works of art have different effects on individuals viewing them. What the viewer brings by way of knowledge is a hugely influential factor in valuing art objects, more than simply the qualities of the work of art itself. We know that the two stolen late Turner paintings, *Shade and Darkness* and *Light and Colour*, were derided by most critics when first exhibited in the 1840s, but over time were appreciated as masterpieces.

To understand why people value certain objects, art historian and theorist James Elkins investigated the reasons when and why works of art caused people to cry. He explored the occasions that produced tearful responses, knowing that the best paintings appear to have extraordinarily emotive powers. He was fascinated by the gap between these special moments and regular viewing in museums when 'It seems normal to look at astonishing achievements made by unapproachably ambitious, luminously pious, strangely obsessed artists, and toss them off with a few wry comments.'[6] Put another way, the responses to particularly powerful works can produce real, significant physical effects that relate back to the skill and imagination of the maker.

One proposition is that art provides additional meaning, significance or intensity to experiences within everyday life. In analysing the relationship between art and life, ethologist Ellen Dissanayake finds that in such analyses 'art has been confused or amalgamated with such other proclivities or behaviours that have selective value, such as ritual observance, play, fantasy, dreams, self-expression, creativity, communication, order, symbol making and intensification'.[7] The experience of art as a ritual human activity, codified within the history and development of Western society, has become what is valued, but the gradation or level of the value of that experience will be greatly affected by what it is that describes or classifies the art itself: what is known of the period and style of the work of art, the name and reputation of the artist, and the medium and scale of the work. These experiences are, of course, much affected by changing tastes and fashions.[8] And a growing 'aura' around the original work of art, in a modern age in which reproductions became easily available, was described in the 1930s by the literary critic and essayist Walter Benjamin, and subsequently analysed by critic and writer John Berger.[9]

The increasing numbers of reproductions might even make an original more desirable to steal.

Economic Value: Art as a Merits Good

A painting is not a loaf of bread or a can of beans or a Cadillac convertible or a share of General Motors stock . . . their value is readily ascertained because there is a market on every street corner for cans of beans and loaves of bread and in every town there is a place to buy cars. But paintings are different because they are unique . . . A single painter in his lifetime can turn out only so many of them and once these are done there can never be anything quite like it. But something more comes into the value of a painting because a painting is a work of art and a painting is worth something because it evokes something in us, in the viewer. What may leave one viewer cold may to another viewer be the most significant sort of statement about our lives and our existence . . . but that does not mean that paintings have no value, and that a painting's value is not ascertainable, for paintings too, are sold.[10]

– Arthur Rosett, Attorney for the US Government, 1963

While works of art are bought and sold like other goods, there are factors that make their exchange somewhat distinct. First is their specialness or rarity. As economist William D. Grampp emphasizes:

Art is scarce. Even though few people value it, they would want more than they now have if it were free. Because it is not, it must be created, made available and held carefully, which is to say economically. That means as much utility as possible must be gotten from it, in the form of enjoyment, pleasure, instruction, enlightenment, inspiration and so on.[11]

Secondly, works of art are subject to social intervention. Over many generations there have been mechanisms in place, in the form of support to public museums and galleries, and through tax incentives, that offer encouragement to the public to enjoy them and an incentive for donations of important works from private to public ownership.

Such arrangements, worthwhile in themselves, emphasize that art is a 'merit good'. Art, like literature and classical music, is something that people say they want to have available, and can afford, even if 'for numerous reasons – habit, procrastination, weakness of will, but not cost – they decline to buy or do to the extent that they say they should'.[12] This positioning of art as a 'merit good' relates to the moral framework, and the presumption that at some level art has a positive effect within society and its loss is particularly damaging.

Art like any other product has a value equivalent to the opportunity cost of not buying something else, and clearly there is a collective opportunity cost if the work is stolen and removed from circulation. Knowledge of art can be acquired – but only at a cost equivalent to the time and opportunities foregone to gain that understanding. Full cost should take account of an investment in taste, in having the means to appreciate a work fully. Equally, the price paid for the work represents the 'value of an object that provides something or other to those who pay it'. If it provided nothing then the buyer would not buy. As Grampp puts it, 'If a collector spends $10,000 on a painting instead of buying bonds that yield 7 percent, he is giving up $700 a year. If he believes the painting is worth what he gave up in order to get it, as he must if he buys it, the yield from the painting is at least $700.'[13] His calculation will include 'pleasure, pride, instruction, enlightenment, instrument or any other kind of utility as economists use the word, to mean a return of one kind or another'.[14] Through buying art, the purchaser may seek both future financial gain and positive social distinction.[15] The equivalent calculation for a thief certainly involves the hope of future financial gain, and an enhanced status in the criminal community, but balanced against the risks of obtaining the work rather than its price. Meanwhile, museums update records of the value of their works by occasionally checking the nearest match for a work in the art market, prompted often by the request for a loan to another museum.

Individual psychology also plays a considerable part in making value judgements. In a research programme at the California Institute of Technology, it was shown that those tasting wine appreciated it more if they believed it was more highly priced. MRI scanning was used to track the reactions of twenty people as they were given two

glasses of exactly the same Cabernet Sauvignon, but told different things about them. As is well known in marketing, the 'Evidence that factors unconnected with the intrinsic qualities of a product can be manipulated to make it more attractive has huge implications for all retailers, not just restauranteurs.'[16] Anna Somers Cocks, editor of the *Art Newspaper*, linked this to the appreciation of art and cycles of pricing, writing that this explains 'the effect first described by the economist Thorstein Veblen in 1899 when he noted that certain goods become more in demand as their price rises. Diamonds and luxury cars are an obvious example of this, but so is art, especially contemporary art.'[17]

Much philosophical debate has attempted to pin down how art – so to speak – 'holds' value. Philosopher George Dickie's definition is: 'A work of art in the classificatory sense is an evaluable artefact of a kind created to be presented to an art-world public.'[18] Such a definition sounds circular, involving a specialist audience that can make judgements, but embraces the idea that art might have both an intrinsic value and an instrumental value. The first – intrinsic value – includes all the elements that are values 'for their own sake', while the second – instrumental value – refers to all those elements that cause other things to happen, whether personal or social. However, philosopher Robert Stecker proposes that 'intrinsic value' is itself a form of 'instrumental value'. 'There are many features of works of art that we admire, but this admiration is contingent upon and bound up with the valuable experiences and other valuable things that we get from these features. This makes the value of these features instrumental rather than intrinsic.'[19]

Economic Value and Use Value

Literary critic and theorist Barbara Herrnstein Smith has written over many years about the history and field of value in relation to literature and culture. She has demonstrated that while at an economic level all objects are subject to the laws of supply and demand,

> It is traditional . . . both in economic and aesthetic theory as well as in informal discourse, to distinguish sharply

between the value of an entity in that sense (that is, its 'exchange value') and some other type of value that may be referred to as its utility (or 'use value') or, especially with respect to so-called 'nonutilitarian' objects such as artworks or works of literature, as its 'intrinsic value'.[20]

Several significant points follow. First, that while there are specialist connoisseurs who will discriminate accurately between specific objects (not least to analyse style and technique to deduce the date and describe the 'quality' of the work), their judgements are within a framework that is exterior to the work itself. The Turner curator and scholar Andrew Wilton would be able to set out exactly the qualities of the two Turner paintings, in comparison with others, as well as giving them – as he did – their 1994 insurance valuations of £12 million each, matching this against appropriate market prices for Turner paintings. Equally, a finely shadowed depiction of a face of a girl in a pastel work by Jean-Baptiste-Siméon Chardin is rated highly because there is a widely held view (and held over time) that such a depiction in this style *is* to be much admired – for other times and periods a more expressionist or abstract style might be more favoured. In this sense, as Herrnstein Smith puts it, 'We do not move about in a raw universe . . . Objects we encounter always [are] to some extent . . . pre-evaluated, bearing the marks of and signs of their prior valuing and evaluations by our fellow creatures.'[21]

Secondly, evaluations are not discrete acts but are 'indistinguishable from the very processes of acting and experiencing'. Given this sense of continuous evaluation, as a fundamental part of human existence, it becomes essential to communicate such valuations, to compare opinions of quality with others, as part of social interaction. Thirdly, over time the processes of valuing cultural objects may consolidate into a 'canon' of accepted classics in the arts, constructed through value judgements that are circular, overlapping, cumulative and still changing. When a canon emerges – a list of great writers, artists or composers – although it may fluctuate, it encapsulates what becomes increasingly regarded, without further question, as of high value.

Price as the Measure of Economic Value

The actual purchasing power of the money is immaterial for the purpose of the comparison. But one also wants to know how much works of art were really esteemed. One wants to know what sorts of sacrifice the expenditure of 8,500 on a single picture entailed.[22]
 – Gerald Reitlinger, discussing the purchase of a Raphael painting
in the 1780s, *The Economics of Taste*, 1961

The art market since the Second World War has naturally been created in the image of post-war society and by its attitude to art. The two most important aspects of this attitude can be roughly termed the religious and the financial. On one hand, there has been a growing feeling that art is a great good in its own right, a civilizing influence, a matter for deep study and deep appreciation verging on worship. On the other, there has been a widespread realization of the investment potential of art and its advantages in an inflationary period as a hedge against the dangers inherent in paper currencies.[23]
 – Geraldine Keen, *The Sale of Works of Art*, 1961

Art is often presumed to be a profitable investment. But despite the media hype around sensational price rises, only works by a very few 'blue-chip' artists at the upper end of the market have consistently offered returns greater than the general rise in stock values when set against inflation.[24] Actual price levels can be very misleading. Knowing the comparison of goods and services foregone can be helpful, but the comparative costs of these will change over time. Even in a rising market – and the trend in the art market has been fairly consistently upward for more than forty years – the price paid for a work will relate both to the value now and to a view of its potential future value.

As William Grampp stresses, most collectors are knowledgeable sellers as well as shrewd buyers. When works of art are acquired, the calculations made both by the seller and the buyer depend on specialist knowledge in order to establish the parameters of value. The questions of attribution, authenticity, date and provenance – the history by which the work can be tracked across time and validated

– are all critical. 'The market is aware of uncertainty. Buyers, sellers, dealers, and auction houses do as much as is worth their while to reduce it by collecting information and making it known (a distinction that is not trivial). There are some people who specialize in collecting it.'[25] This includes art advisers, critics, targeted newsletters for collectors and the work of art historians.

One analyst of particular interest was the German economist and art critic Willi Bongard, who published the 'Kunst Compass' each year for collectors of contemporary art.[26] His magazine *Art Aktuell* offered commentary from 1971–85 on a rather unstable market from a period of experimentation to the so-called return to painting in the late 1970s and early 1980s. The Compass was a points system awarded to the 'top 100' artists, added up from their showing in museum exhibitions, critical appreciation and awards, which represented the evaluation of their work, and was cross-referenced to the average price for their works. Although the awarding of points was to some extent arbitrary, it allowed use value and exchange value to be placed on a comparative basis between artists, in a point/price ratio. A superior position in the points table together with a lower than average price would represent 'good value' for a buyer.

Although Bongard was tragically killed in a car accident in 1985, this annual tradition has been continued by his widow, Linde Rohr-Bongard, and published in *Capital* magazine. The canonical nature of the list, combined with good price information, is useful for those collectors of contemporary art who want to make fine judgements, particularly within an art world dominated by promotion.

There is presumably no equivalent guidebook for thieves or those who commission high-value art thefts. The names of well-known artists such as Rembrandt and Picasso (whose work is among the most stolen over the past 50 years) bring with them the expectation of very high prices. Their work is stylistically recognizable in lay terms and is unlikely to drop in value. If a work might be hidden by criminals over several years then its value must be maintained (even if at the level of 10 per cent for a post-theft criminal exchange) and not itself be the cause of complicated wrangling with other criminals (see Fifty-year table of Selected Notable Art Prices, *overleaf*).

Fifty-year Table of Selected Notable Art Prices

1958	Sotheby's black-tie auction of the Goldschmidt paintings; Paul Cézanne's *Le Garçon au gilot* sells for $616,000 – five times the record for a painting sold at auction	$4.57m
1961	Metropolitan Museum of Art, New York, buys Rembrandt's *Aristotle Contemplating the Bust of Homer* for $2.3 million	$14.3m
1962	The Louvre takes insurance on the *Mona Lisa* for a US Tour, at $100 million	$709m
1965	Norton Simon buys Rembrandt's *Titus* for $2 million at Christie's, London	$13.6m
1967	National Gallery of Art, Washington, DC, pays $6 million for Leonardo's *Ginevra de' Benci*	$38.5m
1970	Metropolitan Museum purchases Velásquez's *Juan de Pareja* for $5.54 million	$27.6m
1973	Australian National Gallery of Art, Canberra, buys Jackson Pollock's *Blue Poles* (1952), for equivalent of US $2 million	$9.65m
1987	Van Gogh's *Irises* sells in November for $49 million at Sotheby's, New York	$92.5m
1989	J. Paul Getty Museum pays $35.2 million for a portrait by Jacopo da Pontormo and $26.4 million for a work by Edouard Manet	$60.6/ $45m
1990	Vincent van Gogh's *Portrait of Dr Gachet* sells at Christie's, New York, on 15 May for $82.5 million	$135m
2000	Blue-period Picasso, *Femme aux bras croisés*, sells for $55 million at Christie's, New York, on 8 November	$68.5m

Year	Event	Value
2002	Peter Paul Rubens's *Massacre of the Innocents* sells for £49.5 million at Sotheby's, London, on 10 July	$58.4m
2004	Picasso's *Garçon à la pipe* sells for $104 million at Sotheby's, New York	$118m
2006	David Geffen pays $140 million for Jackson Pollock's *No 5* (1948)	$149m
2007	Mark Rothko's *White Center (Yellow, Pink and Lavender on Rose)* (1950) sells for $72.8 million at Sotheby's, New York, in May to the Emir of Qatar and his wife, a new record for a post-war work of art	$74.5m
2007	Damien Hirst constructs a sculpture in the form of a diamond-encrusted skull and puts it on sale in June for $100 million	$103m
2008	Lucian Freud's large-scale *Benefits Supervisor Sleeping* sells on 13 May for $33.6 million, eclipsing the Freud record set by Christie's during the previous season for *Ib and Her Husband* (sold in November 2007 for $19.4 million)	$32.9m $19.8m
2008	Damien Hirst organizes special sale in September of his work at Sotheby's, London – with gross sales of £95.7 million	$94.7m
2010	Alberto Giacometti's *L'Homme qui marche I* sells in February at Sotheby's, London, for $104.3 million, a new auction record for a work of art	$104.3m
2010	Pablo Picasso's canvas *Nude, Green Leaves and Bust* (1932) sells in May for a new record price of $106.4 million at Christie's, New York	$106.4m

The Performance of Value

Whispers ripple through the audience ... They are ... simply await-
ing a financial exploit, a sensation, a new flag on the Everest of prices.
And when the hammer does come down on the humongous sum, it
triggers thunderous applause. The spectators at the auction arena
always play the game, uncritically fanning the flames of the bidding.
Higher, ever higher, is their watchword.[28]

 – Judith Benhamou-Huet, *The Price of Art*, 2001

If theft is one kind of performance involving shifts in value, then
auction is another.[29] While auction is an open bartering process
within the market itself, theft involves a move from the exchange
system of the art market to the clandestine bartering of the under-
world, in which a work may lose perhaps 90 per cent of its conven-
tional value. Sales by auction have a number of intriguing charac-
teristics. First, they flourish where there are great uncertainties or
fluctuations in value and therefore difficulties in pricing between
sellers and buyers. As Charles Smith puts it, 'Auctions serve as rites
of passage for objects surrounded in ambiguity and mystery.'[30]
Secondly, they allow a very public process to determine an agreed
price. Thirdly, different sorts of auctions develop varying rituals
and procedures with which regular buyers will be conversant. On
occasions this can appear to cause collusive behaviour, with individ-
ual buyers acting as a group to undermine the transparency of an
open process. In less extreme form it may simply limit participa-
tion at an auction, since only those who feel comfortable with the
process and codes will take part, whether it is a fish auction, a sale
of fine stallions or a smart West End international auction of art
and antiques.

 The 'community' within which the auction is organized is impor-
tant, and the fact that 'Fairness is not an unintended consequence of
numerous individual auction decisions, but it is an explicit, if not
always conscious, objective of the auction community'.[31] An auction
is not simply held, but is staged, and, as Smith puts it, 'Place, setting,
and props are arranged to reinforce the ambience and sense of com-
munity appropriate to the particular auction. These factors convey,

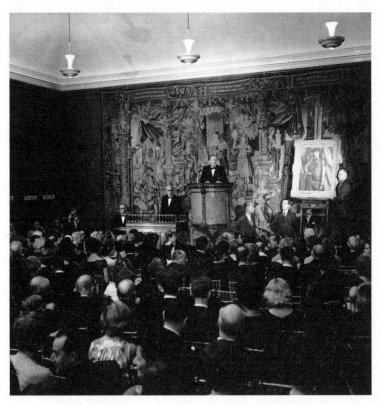

Goldschmidt sale, Sotheby's, London, 15 October 1958.

among other things, different degrees of affluence, seriousness, glamour, order, separation, formality, tradition, and risk.'[32]

The Sotheby's Goldschmidt sale of 1958 marked the start of a new era in terms of high-profile, media-conscious, record-seeking art sales. It included seven outstanding Impressionist and Modern paintings. The auction was staged under the determined direction of Peter Wilson, who was leading the company on to the global stage.[33] It was a black-tie evening event and amongst the guests were Somerset Maugham, Kirk Douglas and Lady Churchill. As *Time* magazine recorded:

Only 400 bidders and selected spectators could get into the green-walled main gallery; the rest of the 1,400 ticket holders were sent to other rooms, where they could follow the

bidding on closed-circuit TV screens. The sale took only 21 minutes. But from the first rap of the auctioneer's hammer, prices leaped upward at a $100,000-a-minute clip to shatter every known art auction record.[34]

Paul Cézanne's *Le Garçon au gilot rouge* sold for $616,000 to Paul Mellon. It was the highest price paid for a painting at auction, with a previous high of $360,000 paid for Thomas Gainsborough's *Harvest Wagon* in Manhattan in 1928. As Peter Wilson commented to the BBC: 'Without covetousness you are not going to have an appreciation of art. And I think that if covetousness by some magic was destroyed art would come to an end. It's very rare to be able to appreciate art without wanting to own it.'[35] It was a hugely influential event.[36]

Applause often greets a final record-breaking bid. Applause is a characteristic of sales in which the audience becomes an active element in the drama. There is a vicarious thrill in feeling the tension between bidders, and being close to transactions of very large sums of money.

It is significant that customers do not clap in department stores or flea markets ... Whether it be Shakespeare, a ballet, a magic show, or a professional tennis match, the applause generally acknowledges that the audience experienced a particular reality through the performance that they could not have experienced without it ... In fact, whenever an item sells for considerably more than its apparent economic value there is likely to be applause. A new 'reality' has been created.[37]

A similar thrill makes art theft intriguing to those who read about it in the media. But when thieves overcome the defences of an apparently well-guarded museum, there are a few, equally, who actually wish to cheer.

The Goldschmidt sale of 1958 went much of the way to spread the word that Impressionist paintings were now worth more than Old Masters, that their value was still rising. This event may even have had unintended consequences in encouraging the spate of robberies of modern European paintings in the South of France in the early 1960s.

Spectacular Exchanges: Art-world and Under-world

> Nowadays people know the price of everything
> and the value of nothing.
> – Oscar Wilde, *Picture of Dorian Gray*, 1890

There are a few occasions when both the material and commercial value of a work of art are put on display. In early June 2007 the British artist Damien Hirst exhibited at White Cube (the London gallery of his principal dealer, Jay Jopling) a new sculpture entitled *For the Love of God*. The sculpture takes the form of a skull, 'a life-size cast of a human skull in platinum, covered entirely by 8,601 vvs to flawless pavé-set diamonds, weighing a total of 1,106.18 carats'.[38] The smile of the skull is based on the teeth of the skull's owner. The rest of the work is a cast, but the teeth are real, the remnant of an eighteenth-century individual, legally acquired by Hirst. The sculpture includes a larger, more regal pink diamond surrounded by gems on the forehead. It was put on sale for £50 million.

Unusually for a small private gallery, viewing the work involved obtaining a ticket from the ground floor and being escorted to the upper floor, where the work was brilliantly lit with micro-spots,

Damien Hirst with *For the Love of God*, 2007.

security guards standing close. The work both demonstrates and embodies the idea of value – while also being focused on mortality. *For the Love of God* reworks the 'Memento Mori' theme, an object or an image that relates to the transience of human existence. In an accompanying publication, art historian and curator Rudi Fuchs claims: 'The skull is out of this world, celestial almost . . . It proclaims victory over decay. At the same time it represents death as something infinitely more relentless. Compared to the tearful sadness of a vanitas scene, the diamond skull is glory itself.'[39] Hirst himself refers to his sculpture as 'Uplifting . . . takes your breath away . . . You just want it to be flawless, like a diamond is flawless. We wanted to put them everywhere. They go underneath, inside the nose. Anywhere you can put diamonds, we've put diamonds. I wouldn't mind if it happened to my skull after my death.'[40]

Amidst initial speculation in the press about who might purchase the work – as to who could afford it and whether there would be a substantial discount – there was a calculation of 'value' that came first from the materials and craftsmanship of the Bond Street jewellers Bentley and Skinner. The diamonds themselves were said to have cost £12 million and the skilled work in setting them was estimated at just over £1 million. Therefore the element that Hirst brought to the work – his conception, his creative oversight and his sheer chutzpah in producing it – could be said to be equal to at least another £13 million, that is, if his dealer would expect to take 50 per cent of the retail price, which would be a standard arrangement for a private London art gallery. Since being exhibited, *For the Love of God* has been rumoured to have been purchased by a consortium, of which Damien Hirst himself is said to be a member.[41] However, the value created by Damien Hirst in its display at White Cube may also have had a positive 'halo' affect on his other prices.

Systems of exchange depend on willing buyers and willing sellers. Whether a work is in the market or the underworld, it will be an object used in exchange if it is valued by both parties. Clearly, in the underworld none of the outward characteristics of the art world apply: there is no public display, no advertised price, no critical engagement or debate about a particular work. Nonetheless, the exchange value will be constructed from the various opportunities open to the holder

in terms of collateral or trade for illicit goods. Analysis of the black market shows that huge numbers of international exchanges take place outside the law, with gangs and powerful criminals smuggling high-value goods between countries without recourse to paperwork or official declarations. This black economy is known to be worth many billions of dollars.[42] Although stolen works of fine art make up only a small part of an economy dominated by drugs, cigarettes, currency and weapons, they will have a significant symbolic value alongside their potential financial value.

Value for Thieves

Questions of cultural value may be intensified through considering art theft, but arguments over cultural value are not the debates of the criminal fraternity. Thieves may use the simplest indicators (including museums' own exhibition promotion) to pick famous works – high cultural and financial value – that they hope will offer the greatest instrumental value to them. This could be a Rembrandt self-portrait, one of the versions of Edvard Munch's *The Scream*, the *Mona Lisa* or important late works by J.M.W. Turner. As Vernon Rapley, former Head of the Art Squad, puts it bluntly: 'If you steal branded work – Matisse or Picasso – then any criminal knows that it is as valuable as it is purported to be.'[43]

Thieves are keen to pursue works that simply combine being the most steal-able with the most financially valuable, and which convert most easily into collateral or barter goods. A circular process encourages the theft of works by top-name artists such as Rembrandt and Picasso, reinforcing the view that these are artists of the highest order, potentially raising the value of their works and increasing the likelihood of future thefts. Referring to the robbery in May 2010 from the Musée d'Art Moderne in Paris of works by Braque, Léger, Matisse, Modigliani and Picasso, Rapley commented: 'These are stolen because they are valuable, and because they are known, and the artists are famous. If you are looking to plan an attack you can see that you had five major works by five major artists. They have been stolen because that brands them for criminals . . . they do not have the expertise to identify them and they do not want to be

scammed.'[44] Despite the difficulty of selling them on, the presumption here is of negotiation with the owners or use as collateral.

Thieves 'value' more highly works of modest scale that can be handled easily or taken from their frames and transported without difficulty: the *Mona Lisa* was manoeuvred off the wall by one man and the two versions of *The Scream* are not large. An element of value resides in this utility. Value in the art market is refracted into value in the underworld, the most 'valuable' works being those from which significant financial gain can be realized (as well as a certain amount of criminal credit). In the process, the integrity of a work and its good condition are critical, particularly given the relative fragility of oil paintings and sculptures, compared to jewels and precious metals. It was significant that those who handled the two Turner paintings after they were stolen from the Schirn Kunsthalle did not retain their relatively heavy original frames, although this greatly increased the risk to the canvases, and they came back with hardly a scratch when recovered in 2000 and 2002. Whoever held them knew enough to ensure that they did not lose value.

seven

History

During the years of pursuit of the missing Turners I became intrigued by the business of art crime and how it operated. What was the context for the theft of these two paintings in Frankfurt? What were the motives and operating mechanisms of those caught up in this world? Were many works of art destroyed by those who had stolen them or subsequently held them? How often were important works recovered? Some things I discovered as we tracked the Turners, others I pursued through subsequent research. This chapter includes an analysis of some of the most notable art thefts.

Art thieves, of course, are not an exclusive category. Criminals do not specialize or confine their activities neatly to one field – such as stealing art. Although the fragility of fine art (and its lack of innate material value) distinguishes it from jewels, cash or gold bullion, its theft overlaps with other crimes. Art crime itself is a broader field than theft, and other activities include the faking of works of art, the forgery of associated documents, confidence-trick work, extortion, smuggling of art between countries and the looting and illicit removal of antiquities from countries that have specific export controls to protect their 'national heritage'.[1] There are increasingly close links with the transit, distribution and sale of hard drugs.

Two Early High-value Thefts: *The Duchess of Devonshire* and the *Mona Lisa*

Instances of serious art theft have expanded since the 1960s, with the rise in the market values of art. But the complications of high-value

art thefts, such as the Turner case in Frankfurt, were already present in the early twentieth century and dramatically prefigured in 1876 in a theft perpetrated by Adam Worth. On 16 May Worth, a notorious American criminal and 'master thief', stole, with two accomplices, a recently auctioned – much-admired and highly priced – Gainsborough portrait of *Georgiana Spencer, Duchess of Devonshire* (1787), from the art dealers Agnew's in Old Bond Street, London.

Worth was born in Germany but grew up in America, and at the end of the Civil War he pursued a complex criminal career, before moving to Paris and then on to London in the 1870s.[2] He carried out various schemes and activities under the name of Henry Raymond, circulated in the higher echelons of society and took a house overlooking Clapham Common, while working with a criminal accomplice called Charley Bulland.

The purpose of the theft of 1876 was apparently to obtain the painting in order to extort money, to be used as a bond in the hope of freeing his brother, John, who faced forgery charges in France. When his brother was extradited anyway, Worth had no immediate purpose for the painting, but determinedly kept it with him, often travelling the world with it hidden in his luggage. He was eventually charged with criminal activities in Belgium and convicted in 1893, serving four years of his sentence before returning to the US. Here, Adam Worth met the detective William Pinkerton, who had pursued him in earlier periods, and through him negotiated the return of the painting to Agnew, himself obtaining the reward fee of $5,000. It was subsequently sold to the banker and collector J. P. Morgan. Ninety years later it was acquired by the Devonshire family and hung in their stately home, Chatsworth, in July 1994.[3]

The case has a number of intriguing characteristics. The motivation was both financial and personal, and involved very considerable skill. The value of the painting, the record sum of 10,100 guineas, had been widely publicized prior to its theft, and the canvas was cut from its frame during the burglary. The painting was retained by Adam Worth as illicitly held goods in international transit until he eventually found an anonymous route by which it could be returned. The painting remained substantially undamaged, and on its recovery in 1901 it was authenticated by reference to a remaining sliver

of canvas taken to Chicago from London by C. Morland Agnew, a member of the firm. During its travels it was carefully packed in a 'hermetically sealed box, which had been placed in the false bottom of a trunk'.[4] When it was returned, by Worth's intermediary, the *New York Times* simply reported that this was by 'An American interested in racing and gambling'.[5]

Worth may have prefigured high-value art crime in the late Victorian period, but it was the theft of the *Mona Lisa* from the Louvre in 1911 that gave audacious thefts of art their full and public recognition. The thief, Vincenzo Peruggia, was a 30-year-old Italian painter-decorator, resident in Paris and employed by the Louvre, who had previously helped fit protective glazing to some of the most valuable paintings on display. He hid himself inside the museum and early on the morning of 21 August 1911 – a Monday, a day closed to the public – slipped out from a cupboard, unhooked the work, removed the panel from the outer frame, and walked out of the Louvre with the *Mona Lisa* concealed under his workman's coat. It was assumed that the work was away being photographed, and the alarm was not raised until the following day. The press and public outcry was prodigious and continued for some weeks, not least because the police had almost no clues and no leads. The Director of the Musées Nationaux, Théophile Homolle, was forced to resign. Peruggia himself had been arrested for minor offences in 1908 and 1909, and had been finger-printed using the new criminal detection system developed by Alphonse Bertillon. But when all employees were checked there was no match – because his left thumb mark had been recorded instead of his right. And when the Louvre was reopened (following the first week of intense police activity), visitors paid little attention to other paintings. A contemporary newspaper account claimed: 'They contemplated at length the dusty space where the divine *Mona Lisa* had smiled only a week before. And feverishly they took notes. It was even more interesting for them than if the Giaconda had been in its place.'[6]

Speculation abounded as to the motivation behind the theft (including a presumed German conspiracy and a brief confusion with Guillaume Apollinaire, who returned two Phoenician statuettes stolen by a friend) and the identity of the thief; 'although they considered the possibility of a Louvre employee or a madman, it was

widely believed that this must have been the work of a millionaire. Not just someone with brains, but someone with money.'[7] When in November 1913 an advertisement was placed by the Milan-based Italian art dealer Alfredo Geri, seeking works to be included in his forthcoming commercial exhibition, Peruggia responded by offering a painting, the *Mona Lisa*, for which he asked 500,000 lire. Despite suspicion of a confidence trick, he was enticed to Milan and easily entrapped. The real masterpiece had resurfaced (after many false leads and claims), but in the hands of a thief, Vincenzo Peruggia, who did not satisfy the public's expectation of the appropriate style of criminal. At his trial he claimed that he had stolen the work in order, patriotically, to return it to Italy (assuming, wrongly, that it had been looted by Napoleon). The work was exhibited in Florence, Rome and Milan, before returning triumphantly to Paris on 31 December for a brief – ticketed – display at the Ecole des Beaux-Arts, and then to the Louvre in January 1914. With the ability of early twentieth-century national newspapers (against a backdrop of greatly increased levels of literacy across Europe) to act as broadcasters across the country – and also as the testers of popular opinion – no theft of this type would now remain either unnoticed or un-commented upon. But the motivation for theft of such prominent works becomes even harder to understand as international communication has accelerated and the means of disposal or exchange more complicated.

Such early examples of high-profile theft and recovery can be clearly differentiated from the pillage and removal of works under circumstances of war or national crisis. Whether in the early nineteenth century under the imperial rule of Napoleon or more than a century later in Adolf Hitler's Nazi Germany, whatever the claimed political justification for such massive, determined and international criminality, looting and mass theft were state-sanctioned, large-scale and ruthless in logistical terms. The Adam Worth type of theft can also be distinguished from looting that has emerged as an ongoing and complex set of activities involving illicit desecration of graves, irresponsible spoiling of archaeological sites and transmission of precious cultural goods from religious and other sites in developing countries, whether in Latin America, Asia or the Middle East. In

recent years museums have done considerably more to check their holdings and offer to return works if they were illegally exported from their country of origin. The consequences of both forms of illegal activity cause problems for the proper management and integrity of museum collections.

The motivation for high-value, high-risk thefts (such as that of the Turners) can also be distinguished from the regrettable but more frequent thefts of less valuable works of art – say up to £100,000 – whether from country or metropolitan houses, or from arts and antiques fairs or dealers' galleries. These involve planned onward transmission to an illicit market, where a middleman (or fence) will discover ways to pass on the works. Petty criminals simply attack private houses and businesses in order to take what they believe to be valuable and to sell it on the black market.

The motivation for high-value, high-risk art theft is the greatest puzzle. It involves the removal of generally well-guarded and protected works of art, such as the *Mona Lisa* and Edvard Munch's *The Scream*, which have the primary characteristic of being very well known and therefore unmistakably marked out if stolen. However, they have the principal caché of being worth a huge amount of money, value that can be realized only if the work can be exchanged for cash or goods in *some* form. There is as much risk in the disposal of the stolen work of art as there is in the actual theft.

Changing Value: The 1960s

The growth and apparent success of art crime since the 1960s have made it increasingly prominent. In the 1970s Bonnie Burnham, later President of the World Monuments Fund, identified this as a problem exacerbated by an increasingly affluent society. Three decades on from the privations of the Second World War, she saw Western states vulnerable to crimes nurtured by the proliferation of excessive wealth. She also identified difficulties in a society that no longer preserved art within a privileged social setting.

Thefts and pillage, smuggling and speculation, overcrowded museums and inflated prices in the sale room: one or another

of these phenomenon touches everyone who is interested in art, and each is part of a general malaise which constitutes a real threat to the spiritual enrichment we expect from works of art. This malaise, the result of the current confusion between the material and spiritual value of artworks, can easily be recognized as the force behind the illicit art market and the destruction it causes.[8]

Whether or not the so-called spiritual nature of art was under threat, many commentators referred to a 'plague' of theft that followed hard on the heels of the sharp rise in prices for art from the late 1950s. As values increased, more frequent, more determined and more regularly reported thefts shocked the art world, not least by the bold and self-assured character of the robberies (a similar chutzpah was evident in the Great Train Robbery of August 1963). In the early 1960s a series of art thefts in the South of France was particularly disturbing for their openness – one involving a well-known restaurant, another the collection of a single artist – as well as the inability of the police to prevent them or, in several cases, to catch the perpetrators.[9] Ransom became an additional worry since insurance agents sometimes found it easier to offer a smaller sum to thieves than the full insurance value to owners. And in one case, after the outrageous theft of eight Paul Cézanne paintings from an important monographic exhibition at the Pavillon de Vendôme in Aix on 13 August 1961, it was André Malraux, as Minister of Cultural Affairs, who demanded that everything be done to get them back. As one commentator expressed it later,

> thieves have a ready form of blackmail at their disposal: pressure on the insurance companies or the owner by suggesting that the canvases themselves will be destroyed, and pressure on governments to recover works of national importance and prestige . . . The emphasis deliberately placed by the legitimate market and critics on the significance to art history of certain paintings thus makes them vulnerable in an entirely novel way.[10]

The characteristic of highly valued fine art includes its identification with a specific artist as creator, as well as low intrinsic material value (unlike gold or jewels), and therefore its inability to be used like a currency. Yet there is a clear relationship between greatly enlarged values for art (including for modern art, which had been modest in its rise in value in the inter-war period) and the interest of criminals. Valuable works appeared now to be stolen less in the hope of an onward, black market sale, and more for use as collateral in other criminal activities, such as drug-dealing, or in the hope of financial exchange with an insurance company in a buy-back arrangement. This might not always be ransom, but in the 1960s it looked disturbingly as though criminals had found a new way of making money, with highly valued art as the means. If Bonnie Burnham was right that art was becoming valued for the wrong reasons and that financial value was becoming more prominent than cultural or 'spiritual' value in Western society, this might be of the greatest specific concern for the management of historic houses as well as museums.

Beit Collection, Russborough House, Ireland, 1974, 1986, 2001 and 2002

The four occasions on which the Palladian mansion in County Wicklow belonging to Sir Alfred and Lady Beit was targeted for art theft were very different, but each illustrates a common theme of criminal bravado.[11] Referred to in understated terms as a 'saga' in the IFAR *Journal*, the 43 paintings that have been stolen, including Vermeer's *Lady Writing a Letter with her Maid*, have, bar two, been recovered.[12] The first attack on 26 April 1974 was, at the time, the biggest art robbery in the British Isles, when nineteen paintings including the Vermeer and works by Velásquez, Rubens, Goya and Gainsborough worth at least £8 million, were taken by Dr Rose Bridget Dugdale, with IRA accomplices. They tied up Sir Alfred and Lady Beit (referring to them as 'capitalist pigs'), and hoped to extract a ransom from the British Government for the paintings.[13] The Beit paintings, however, were recovered and Dugdale was sentenced to nine years imprisonment, of which she served six.[14]

The second attack, on 21 May 1986, was the work of Martin Cahill, a notorious Dublin criminal known, because of the meticulous planning of his crimes, as *The General* – the name of a 1995 book and a 1998 film about him.[15] Cahill, described as 'bizarre, crude, somewhat deranged and terrifyingly vicious', was murdered on 18 August 1994, a death claimed by the IRA for his alleged support to the Ulster Volunteer Force.[16] The gang deliberately set off the alarm at the house and then hid while the police came to investigate. The police departed, having found no intrusion. But, with the alarm assumed to be faulty and not reactivated, the gang returned and stole eighteen paintings, abandoning seven nearby and hiding eleven in a bunker in the hills prepared earlier that year.

Sir Alfred Beit, away at the time, commented: 'I cannot think other than that one of these sort of revolutionary movements are behind the theft and are seeking a ransom which they won't get. It's not me that has been robbed this time – it is the Irish people, since the collection is now in trust to the state.'[17] Russborough and most of the paintings had been formed into a charitable collection in 1976, with paintings transferring to the National Gallery of Ireland in 1987.

Cahill did not seek a ransom, but did try to sell or exchange some of the paintings abroad. After extensive investigations involving insurance investigator Peter Gwynne, and Dick Ellis and Charley Hill of the Metropolitan Police Art and Antiques Squad – starting with a complex operation in 1987 that failed – the first painting, a Gabriel Metsu, was recovered in Istanbul in February 1990. After the Isabella Stewart Gardner theft, many believed there was an 'Irish connection' that might link to the earlier Russborough theft, although this was never substantiated. After much undercover investigative work, contact was made with a diamond dealer in Amsterdam who had advanced Cahill $1 million. In a complicated international operation, with a sting led by Charley Hill, the Vermeer and most of the other paintings were recovered on 2 September 1993. A Rubens *Head of a Man* was recovered in August 2002; two Francesco Guardi landscapes remain missing.[18]

Cahill's motivation appears to have been principally connected to money laundering and the use of art as collateral, but also to his image

as a criminal. As Matthew Hart puts it, 'The task of money launder-
ing is the conversion of illicit cash into legitimate assets, which can
later be sold for clean cash . . . Moreover, art would confer status on
the criminal owner, as it did in the parallel world of legitimate col-
lecting.'[19] Although he sought to enhance his criminal reputation
with the boldness of the theft and his engagement with high-value
art, Cahill may not have realized quite what difficulties he would
encounter in passing on these works. He certainly exploited the image
of an outlaw hero, 'the clever slum lad who had robbed the foreign
billionaire and, while, he was at it, thumbed his nose at the Garda'.[20]

The two subsequent thefts at the house were suffered by Lady
Beit after Sir Alfred had died and with many of the most valuable
works transferred to the National Gallery in Dublin. Both involved
daytime attacks with vehicles rammed into the front door and a win-
dow.[21] On 26 June 2001 Gainsborough's *Madame Bacelli* and Bernado
Belloto's *View of Florence* were stolen.[22] Both were later recovered in
a house in Dublin on 23 September 2002. Three days later, on the
26th, five paintings were taken, including two by Rubens and a Ruis-
dael, later recovered in Dublin on 20 December the same year. Was
the house jinxed, or simply close to Dublin and offering a tempting
target to criminals? The administrator for Russborough House
commented: 'What can you do? You go on having more and more
sophisticated alarms, but they don't seem to deter them.'

Neue Nationalgalerie, Berlin, 1988

Through examining the high-value art thefts of recent years, it may
be possible to establish a variety of motives for criminals and also
the patterns of pursuit. Some thefts, however, produce strange ambi-
guities. Referring to the theft on 27 May 1988 of Lucian Freud's
exquisite painted portrait of *Francis Bacon* (1952), on loan from the
Tate, from the Neue Nationalgalerie in Berlin, Anthony Haden-
Guest wrote:

'Lucian called me in a state of botheration', Robert Hughes
told me. 'At the end I said "Lucian, you can at least take it
as a compliment that someone out there really loves your

work". Lucian said, "Do you really think so? I don't think so. I think somebody out there really loves Francis". Hughes chuckled, but added more somberly, "They'll probably never get it back'".[23]

Despite a high-profile campaign in 2001, involving a reward and the distribution throughout Berlin of 'WANTED' posters designed by Freud himself, there has been no trace of the painting. As a daytime theft and perhaps with the exhibition less than adequately guarded, it appears to have been an exceptional, unplanned and opportunistic theft.[24]

Isabella Stewart Gardner Museum, Boston, 1990

If you want a work of art badly enough, I don't care if it is the Hope Diamond, you can get it . . . If you work energetically at getting inside information, if you learn to deactivate the alarm system, and if you do your own surveillance, there is no work of art that cannot be taken.[25]
– Myles Connor

This boast by Boston 'ex-thief' Myles Connor was made one year ahead of the sensational robbery of the Isabella Stewart Gardner Museum just after midnight on 18 March 1990. The assault on the collection remains one of the most distressing thefts from a major museum collection. It was startling in its audacity, and agonizing for staff and trustees in the string of serious leads that have not yet produced the recovery of any of the stolen works.

Five paintings, including Vermeer's *The Concert* and outstanding works by Rembrandt and Manet, five Degas works on paper, a Rembrandt self-portrait etching, Govaert Flinck's *Landscape with an Obelisk*, a Chang Dynasty bronze beaker and the Eagle finial from a Napoleonic flagstaff were taken from the museum created in 1899 by the Boston arts patron and collector Isabella Stewart Gardner. The museum evokes a Venetian Renaissance palace with galleries arranged around a central courtyard. In her will she dictated that nothing in her galleries should ever be permanently changed – the display was to remain as she left it. To keep the loss of the art in the public eye the

museum has left the empty frames on the walls, and they remain a poignant testament to the outrage that took place twenty years ago.

In the aftermath of St Patrick's Day celebrations, two thieves, disguised in Boston police uniforms and false moustaches, presented themselves at the staff entrance and gained entry using a simple form of deception. They said there was a commotion nearby and they wanted to check that everything was in order at the museum. Once inside, they tied up the two night guards (themselves college students), and had the run of the museum for 90 minutes.[26] They cut the paintings from their frames, and seized the objects. Titian's *Rape of Europa*, larger, though worth much more than any of the others, they ignored.[27]

Although under-insured (with limited funds for full premiums in a rising market), the museum was able to offer an initial reward of $1 million for information leading to the recovery of the works. Speculation was rife that this crime was connected with the Irish underworld of Boston, but, despite many leads, nothing substantial emerged in the following years. In 1997, not long after the reward was raised to $5 million, contact was made by a *Boston Globe* reporter, Tom Mashberg, with a petty criminal, William Youngworth, and his more serious criminal associate and friend, Myles Connor. This led to the proposition that Connor (although himself in jail at the time of the theft) had masterminded the operation and then given the two actual thieves (supposedly both minor criminals who had died in the intervening years) charge of what was stolen, which then passed to the care of Youngworth. Mashberg claimed to have been taken to see one of the works – Rembrandt's *Storm on the Sea of Galilee* – and was then entwined in negotiations with both criminals to engineer the return of the paintings.[28] Despite Connor's previous boastful claims, the negotiations were unsuccessful and it never became clear whether he or Youngworth had actually been involved, or whether it had simply suited them to claim that they were.[29]

Alternative suspects have included Brian M. McDevitt, known as a con man who had tried to undertake a similar theft, but denied involvement with this one; Joe Murray, an underworld figure with Irish connections named by Youngworth; and 'Whitey' Bulger, a senior Irish-connected gangster, now retired from crime and on

Empty frames in the Isabella Stewart Gardner Museum, photographed in 1999.

the run from the Federal Bureau of Investigation.[30] It has been alleged that Bulger is a gangster with such a command of criminal and underworld life in Boston that the robbery could not have taken place without his knowledge – and the alleged protection of an FBI agent – given that it emerged that he had also worked as a senior informer.[31] The claim that, if located, Bulger might reveal the secret of where the stolen works now are, or that his death might allow an investigative breakthrough, has so far come to nothing. More recently, the writer Ulrich Boser, re-examining the whole case, has concluded that the most likely culprits were George Reissfelder and David Turner.[32] Anne Hawley, who became Director only weeks before the theft, remains optimistic, but admits that 'It's like a death in the family. There's such sorrow.'[33]

The case, regarded as the most valuable art theft in history, has spawned much comment, many investigators and even a feature-length documentary by director Rebecca Dreyfus, *Stolen*, of 2005. The film follows the obsessive pursuit by an actual retired specialist investigator, Howard J. Smith, distinguished by his bowler hat, eye-patch and prosthetic nose covering the effects of a long battle with cancer. His fifteen-year search ended with his death in February 2005. The case has also produced a change in the law, since the Isabella Stewart Gardner Museum, together with Senator Edward M. Kennedy of Massachusetts, persuaded the Federal bureaucracy to add a provision to the 1994 crime bill that made art theft a Federal felony. Thus, the theft of works of art worth more than $100,000, or worth at least $5,000 that are more than 100 years old, became a Federal crime, making pursuit across state boundaries in the US much more effective.[34]

The art critic Robert Hughes, writing soon after the theft, offered scathing comment about the exaggerated claims for the importance of the works stolen and pointed his finger at failures in security and a hugely inflated art market, and a rapidly escalating black market in which, so he claimed,

> around 90% of stolen art is never found . . . Is there a
> moral to this event? Only the obvious one: that we owe it
> to the sanctimonious, inflated racket that the art industry

has become. The theft is the blue-collar side of the glittering system whereby art, through the '80s, was promoted into crass totems of excess capital. Sotheby's and Christie's tacitly recognized this last week when, after conferring with the museum board and the FBI, they volunteered the $1 million reward money for the Gardner – a touching PR gesture, like a cigarette company giving money to a cancer ward.[35]

Although Hughes's comments are misguided, his focus on the connection between rising values in the art market and the interests of criminals is instructive. It is quite possible that the works from the Gardner Museum have survived, and will eventually be back in their frames.

The National Gallery, Oslo, 1994, and the Munch Museum, 2004

Edvard Munch's two versions of *The Scream* (1893) have both been stolen in recent decades. Like the Turner theft, both were bold, contemptuous and high-profile robberies – crimes that were previously thought inconceivable – with motives connecting to other criminal activities, with thieves hoping for some kind of pay-off, whether through exchange or ransom.

A postcard left after the first theft offered the message in Norwegian: 'Thanks for the poor security'. It was left by one of the two thieves who, in the early morning of Saturday, 12 February 1994, had climbed a ladder to the first floor of the National Gallery in Oslo, broken a glass window and removed *The Scream*, manoeuvring the framed painting back down the ladder. The theft was well planned. Although a sensor had been triggered, linked to the museum's control centre, the night guard was slow to raise the alarm and thieves had completed their work in less than a minute.[36]

The day of the theft was the opening of the Winter Olympics at Lillehammer, and offered both maximum publicity and maximum embarrassment for the Norwegian government. As with works in British national collections, the work was not insured, so the National Gallery was only able to come up with a reward equivalent

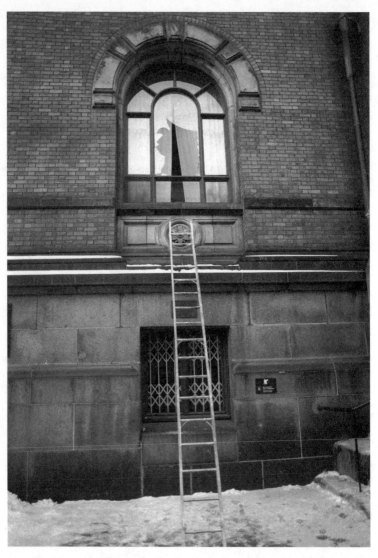

National Gallery, Oslo, 12 February 1994. Escape route used by the thieves of Munch's *Scream*.

to $25,000, although the painting was valued at a minimum of $70 million. The search for the stolen painting was intensive, and given an extra dimension by the knowledge that the work was physically vulnerable, since it had been painted on cardboard. Given that it was one of the world's most instantly recognizable modern images,

complications were likely. Within days a theory emerged that this was the work of two ex-priests seeking publicity for their anti-abortion campaign, and although the story was taken up by the newspapers, it was rightly dismissed by the investigating police.

After several weeks in which no rumours emerged of the painting's whereabouts, the Norwegian police were contacted by a British criminal who had served time in Norway for narcotics offences and claimed to have relevant information. This was enough of a link to allow the Scotland Yard Art and Antiques Squad, led by its head, John Butler, and managed by senior detective Dick Ellis, to form a joint initiative with the Norwegian police squad led by Leif Lier. In this now-famous operation, detective Charley Hill was established as an employee of the Getty Museum, Malibu, and employment and other records were falsified to verify his identity as Christopher Charles Roberts (the same pseudonym he had used five months previously in the recovery of the Russborough paintings in Amsterdam). Hill is an ebullient character, and this is work that he relished. At the end of April leads began to emerge and part of the frame was recovered. An art dealer, Einar-Tore Ulving, made contact with the Chairman of the National Gallery Board, and brought forward a man claiming to be able to return *The Scream*, Tor Johnsen.

Through Ulving, Johnsen was given the chance to meet Charley Hill who was playing Chris Roberts, the man from the Getty (accompanied by an undercover British police agent, referred to in Edward Dolnick's book with the pseudonym, Sid Walker). His story line involved wanting to engineer the display of the Munch painting in an exhibition next to the Getty's own great painting of *Christ's Entry into Brussels in 1889* by James Ensor, and being prepared to pay up to half a million pounds to return it to the Norwegians with an agreement that it would then be offered on temporary loan to the Getty. After much confusion (some of it caused by heavy-handed Norwegian surveillance), on 7 May 1994 Charley Hill was driven by Ulving to his summer house in Åsgårdstrand – as it happened a location that featured in Munch's paintings. *The Scream* had been stored in the cellar since the previous night, and Hill was now meant to ring Sid Walker to authorize the handover of the £350,000 cash that Johnsen had been shown the day before. Instead of which, he

phoned John Butler back in Oslo, who set in train the process of capturing Johnsen and his colleague Bjorn Grytdal. It was a brilliant sting: an almost perfectly executed recovery operation.

Charley Hill stayed to stand guard over the painting in a nearby hotel until the police arrived, savouring the pleasure of having recovered another masterpiece. As he had recounted after recovering the Russborough Vermeer: 'Whenever you hold a genuine masterpiece, you see immediately that it's a stunning picture. It tells you it's a stunning picture. The quality just jumps out at you.'[37]

In the aftermath of the recovery, after a celebration at the National Gallery (with new security precautions in place), a number of criminals were charged. Although the art dealer, Ulving, avoided charges, Pål Enger, a soccer player turned criminal who had planned the theft in the presumption that he could sell the painting on, and had undertaken the break-in with an eighteen-year-old, William Aasheim, was charged with the theft. Grytdal and Tor Johnsen were charged with handling stolen property. In January 1996 they were found guilty after Charley Hill and Sid Walker, who could not reveal their identities, gave evidence in a part of the trial conducted in London to circumvent a Norwegian law that forbids anonymous testimony. On appeal, however, the convictions of three of the four were overturned because 'Hill and Walker had entered Norway using false identities, their testimony about what they had seen there was inadmissible'.[38]

The face in *The Scream* is 'that of a modern city dweller cut off from the life-giving forces of nature, cut off from belief or hope or love, cut off from other people, and able to perceive the life force only as a terrifying, destructive storm'.[39] In meditating on the reasons why this supremely powerful image should have become more famous than its maker, art critic Jonathan Jones suggests that the endless reproduction of the two versions, turned into artefacts around the world, has led to its huge and powerful symbolic value. In reflecting on the first theft, columnist Bernard Levin had referred to it as 'surely Norway's most famous [picture]'.[40]

The effrontery of the theft of 1994 did not make the daylight and armed robbery of the Munch Museum on Sunday, 22 August 2004, any less shocking.

Two men rushed into the museum but crashed into the glass doors first of all . . . They pointed pistols at the guards. They pulled *The Scream* and another important work by Munch, *The Madonna*, off the wall . . . no shots were fired but people were very scared. We are still shocked. It is a terrible thing to happen. *The Scream* is painted on cardboard and very fragile.

Jorunn Christoffersen's account as the museum's spokesperson was augmented by a German tourist, Marc Michl: 'I heard screaming and ran up the stairs. I saw a man carrying a black gun and wearing a black mask. Another man was running away with two pictures under his arms.'[41]

The brutish and threateningly violent nature of the theft (one of the first prominent art thefts involving firearms) was matched by much speculation as to why the paintings were stolen. The *Guardian* reporters, like Bernard Levin nine years earlier, dismissed the idea of a secret collector: 'The belief that masterpieces are stolen to order for wealthy private collectors is no longer widely credited.' A ransom demand was expected, but the investigation eventually found a link with a vicious armed robbery in Stavanger in April 2004 in which a senior police officer had been gunned down.[42] It seemed that the art robbery was an attempt to distract police attention from pursuit of the Stavanger criminals. David Toska, however, was arrested in April 2005 for leading the brutal Stavanger attack, and in May 2006 three Norwegians were found guilty of the theft. After further investigation led by Detective Iver Stensrud, the paintings were recovered on 31 August 2006. Sadly, both paintings had sustained some damage from mishandling, although full conservation has now been carried out.[43] With 'airport-style' security measures in place, the Munch Museum reopened on 18 June 2005.

The Stéphane Breitwieser Case, Alsace, France, 2001

Stéphane Breitwieser is an exception that proves the rule: a thief who fitted the widely accepted myth of the secretive collector-thief, with very different motivations from the thieves of the Turner

paintings (see chapter Eight). Operating on the border between northern France and Switzerland, he accumulated a hoard of medieval and post-medieval art and antiquities plucked from smaller museums, entirely for his own pleasure. His interest in collecting had gone badly wrong and turned into a magpie conceit with the connivance of his girlfriend and the tacit knowledge of his mother, with whom he shared an increasingly art-filled house. He was not a gentleman thief of the Raffles kind or a sophisticated Thomas Crown, but like a twisted connoisseur he did believe that he cared more about the art than museum curators and could look after it better than they could. And so he stole it and took it home. '[He] wanted to be a little marquis, a lord of the manor, and his bedroom was his château.'[44]

Whereas the two thefts of *The Scream* were perpetrated by those involved in other criminal activities, the most unusual aspect of 33-year-old Stéphane Breitwieser's case was its simple and direct motivation of covetousness. Breitwieser, a waiter living in France but working in Switzerland, was arrested on 20 November 2001 at the Richard Wagner Museum on the shores of Lake Lucerne. He had stolen a valuable sixteenth-century hunting horn from the museum two days previously, but it emerged later in court that he had – over only six years – stolen 232 items from 139 European collections.[45] His endeavours were helped by his girlfriend, a nurse, Anne-Catherine Kleinklauss, who would frequently stand guard in museums or country-house collections across Switzerland, France, Germany and Belgium while he extracted objects from cases or cut paintings from their frames. Although much of his illicit 'collection', mostly of sixteenth- and seventeenth-century works, was of less valuable items, it included *Cheat Profiting from his Master* by Pieter Breughal, the *Princess of Cleves* by Lucas Cranach and *Mary, Queen of Scots* by Corneille de Lyon. After his arrest, Kleinklauss alerted Breitwieser's mother, who then set about destroying the evidence – she cut up and trashed paintings, and threw silver and other precious objects into the Rhine–Rhône canal. In February 2003, at the time of Breitwieser's first trial in Switzerland (he was subsequently tried in France in February 2005), two-thirds of the stolen works were unaccounted for.

Breitwieser described himself as a self-taught art lover. His father had collected antique firearms, but had abandoned the family home

after abusing his wife. Breitwieser, who began stealing in his twenties, told the police that he always stole 'in broad daylight, without break-ins, during visiting hours'.[46] In the trial of 2003 a psychiatric report quoted him as saying: 'I need these objects and they need me. I was nearly a slave.'[47] He blamed his parents' separation for the start of his compulsive behaviour, and maintained that he took the works merely for 'safekeeping', apologizing for his mother's destruction of so many fine objects. At his first trial his lawyer attempted to reduce the severity of the crimes by admitting to the lesser charge of 'fraudulent removal' of the works. Apparently, he had astonished detectives with his recall: 'He was able to tell them not only about everything that he had stolen but also the place to which he had assigned each item in his mother's home.'[48]

Breitwieser's kleptomania was complemented by a genuine inter-est in the art – he restored and re-framed the stolen paintings, 'adding descriptive plaques in gold-leaf himself'.[49] In his defence at his second trial (in France) his lawyer claimed: 'There was no desire for cupidity, no desire for lucre . . . he never resold or sought to resell a work of art . . . This was truly passion in its purest form.'[50] There was something reparative in his motivation, a twisted and criminal form of curatorship led by a belief that he had the 'right' to appropriate the works that he stole.

Kunsthistorisches Museum, Vienna, 2003

At 4 a.m. on Sunday, 11 May 2003, a thief climbed a temporary scaf-fold, broke a second-floor window, cut through blinds, and – in less than a minute – smashed the protective case over one of the world's most valuable sculptures, Benvenuto Cellini's *Saliera*. This extraordi-nary 25-cm-high (10-in.-high) saltcellar was made for banquets, and his only work in gold, created in Florence between 1540 and 1543 for François I. It is a Renaissance masterpiece apparently now valued at $60 million.[51] The removal of the work triggered an alarm at the museum, but given a number of recent false alarms the night guards did not check the room at the crucial moment after the intrusion (as in the theft of *The Scream* in 1994). The alarm was reset, but the loss was only discovered by a cleaner some four hours later.[52]

Amidst the furore and calls for the director Wilfried Seipel to resign, there was a presumption that the work was stolen either as part of a drugs scam or in order to extort money through a ransom demand. Because, unusually, such a work of fine art did have a very significant value as raw material, there were fears that the impossibility of passing on such a famous work, even on the black market, would lead to its being melted down. But ransom proved to be the motive when Robert Mang, a 50-year-old security alarm expert, emerged as the thief. The chief of the local criminal police, Ernst Geiger, explained that: 'The alarm went off, but as an alarms expert, he knew he had time to get out.'[53] For more than two years he kept the work under his bed, but in October 2005 he contacted the insurance company (which had previously offered a reward of 70,000 euros for information leading to recovery), sending the only detachable part of the work, Neptune's trident, and demanding a sum of 10 million euros for its safe return. A planned exchange of the work for money led to a fruitless chase and the thief broke off contact. But the police traced his mobile phone calls to the store were he had bought a handset, and then obtained a security camera image of Mang, and in January 2006 they released that image to the public. On Friday, 20 January, Mang entered a police station to 'clear his name', but fairly quickly admitted that he knew where the Saliera was, and led police to a forest outside his home town of Zwettl, 88 km (55 m) north of Vienna, where he had buried the work in an aluminium box.[54]

Remarkably, the sculpture only had scratches to the surface and the loss of some enamel, and went back on display on 29 January 2006. It is not entirely clear to what degree the theft was planned, because Mang claimed in court: 'It was an impulse after I had had a bit to drink. I wanted to see whether it could be done.' He conceded that he had visited the museum previously, but apparently not to plan a theft but only to follow a group of attractive Italian schoolgirls. 'It wasn't difficult', he told the court. 'Every one of us here would be able to do it. There were these movement monitors inside, the likes of which we were removing from clients' homes already 15 years ago. They look like old speakers.'[55]

Mang's motive appeared to be financial, although it may have been in his professional interest to demonstrate how inadequate the

security was at the Kunsthistorisches Museum. By the time of his court appearance, however, he was perceived by some as a latter-day Robin Hood, with 'bronzed good looks and smooth playboy manners', with fan websites springing up, and allegedly, while awaiting trial, letters from more than a thousand women. He was sentenced to only four years imprisonment, although the State Prosecutor declared that she would appeal for a longer sentence.

Drumlanrig Castle, 2003

On Wednesday, 27 August 2003, two men joined a tour of visitors to Drumlanrig Castle, south of Glasgow near Dumfries, the ancestral home of the Duke of Buccleuch and Queensbury. Soon after 11 a.m. they overpowered the female guide, one of them holding her at knife-point while the other detached Leonardo da Vinci's *Madonna of the Yarnwinder* from the staircase wall. To the horror of the other visitors, they calmly walked from the house, with the £30 million oil on panel under one arm, to join two accomplices in a waiting Volkswagen Golf GTi. The car was later abandoned about two miles from the castle.

This was a cavalier, aggressive, daytime robbery. The thieves planned carefully and clearly had no regard for security cameras or alarms, or any concern about being seen by staff or other visitors. Despite differences of view from experts as to how much of the work is actually painted by Leonardo, it was the most valuable work on display (valued above a Holbein and a Rembrandt also in the collection). The duke's son reported that his father was 'distressed and disgusted' by the theft. 'He cares passionately about this particular picture. He has very strong feelings about wanting other people to view and enjoy it.'[56] The insurers offered £1 million as a reward, but for several years there was no information about the whereabouts of the stolen painting. As in the Turner case, the work was far too well known and the theft so publicized that it was hard to imagine how thieves could offload the picture. Nevertheless, expert and writer Peter Watson dismissed the idea of the Leonardo being stolen for a 'Captain Nemo'-like figure:

I do not believe such individuals exist. The truth about art theft is nowhere near as romantic as people like to think . . . a ransom demand or a demand for a finder's fee may surface before long. More likely the thieves will find that what they have on their hands is just too hot to handle . . . The great majority of stolen paintings go nowhere and are eventually offered back to their rightful owners for a fee.[57]

The return of the Leonardo was of enormous importance to the duke, the family having owned the painting for 200 years, but sadly he died at the age of 83 just one month before it was recovered in good condition on 4 October 2007.[58] One obituary referred to his regular arrangement of transferring the Leonardo with him to each of the three houses he and his wife occupied during the year.[59] Four men were arrested in Glasgow at the time of the recovery of the painting, following an operation involving the police together with the Scottish Organized Crime Agency and the Scottish Drugs Enforcement Agency. Three solicitors and two private investigators were put on trial in March 2010, although they pleaded that they had been trying to return the painting in exchange for the appropriate reward. The prosecution, however, claimed that they were involved in a plot to extort money from the duke.

On 21 April the five men were acquitted, the cases against Marshall Ronald, lawyer, Robert Graham and John Doyle, investigators, being found 'not proven'; while solicitors Calum Jones and David Boyce were found not guilty. None of these men had been involved with the original theft; Marshall Ronald had obtained it apparently from a 'shadowy gang linked to Liverpool's underworld'.[60] The complex eight-week trial in the High Court in Edinburgh turned on the question of what was or was not legitimate negotiation for those holding the painting to have with the police or private investigators working with the authorities. In this sense – and there are clear parallels with the return of the two Turner paintings – the collapse of the case meant that no more definitive view has yet been offered within the UK.[61] It remains an important matter to discourage theft for the purpose of extortion and to prevent inappropriate negotiations with those handling stolen goods.

Musée d'Art Moderne, Paris, May 2010

On the night of 19 May 2010 a thief smashed a window, broke a padlock and, avoiding security cameras, was able to steal five important paintings by Braque, Léger, Matisse, Modigliani and Picasso, worth between them at least an estimated $123 million. Frames were discarded and found in the morning on the pavement opposite the museum. Christophe Girard, deputy culture secretary for the City of Paris, whose collection this is, referred to the break-in as 'a serious crime to the heritage of humanity'.[62] It soon emerged, however, that the security system was partially out of order, with spare parts awaited. At the time of writing there is no news on the missing paintings, although speculation has been rife as to whether inside information was available to criminal organizers. The lapse in security has brought negative comments, including from Tom Cremers, founder of the Museum Security Network: 'Security is a core business for museums, and it is not acceptable that a core business should be out of order for several months.'[63]

Networks

We would also emphasize the increasingly global nature and capacity of illegal entrepreneurialism, which defies attempts to draw neat boundaries between licit and illicit behaviours: a good example is the facilitation of money laundering by the international banking system … 'Crime as work' is not just a metaphor, but an apt description of the activities being conducted in parts of the late-modern city, where individuals seize legal and illegal opportunities intermittently.[64]

– Vincenzo Ruggiero and Nigel South, 1997

A crucial analytical approach to art theft is the Routine Activities Theory, developed by criminologists in the late 1970s and early 1980s to explain patterns in particular kinds of crime. It proposes (with fairly predictable logic) that crime is more likely to occur when three factors are present: *a suitable target, a motivated offender* and weakness in *the degree of guardianship*.[65] Fine art 'targets' are clearly well advertised as part of public museum collections, but the work of some artists will

at times appear especially prominent or attractive with the reporting of exceptional art prices in the media triggering greater interest from criminals. The 'degree of guardianship' clearly varies in different circumstances, with weaknesses ranging from the young night guards at the Isabella Stewart Gardner Museum to the weakness of upper-floor security in the National Gallery, Oslo; the use of scaffolding on a building next door to the Ashmolean Museum, Oxford, to steal a landscape painting by Paul Cézanne in the early hours of 1 January 2000; entry from the roof of the Van Gogh Museum, Amsterdam, when two paintings were stolen in December 2002; or the exploitation of temporary scaffolding and outdated alarm systems at the Kunsthistorisches Museum, Vienna; to the lack of preparedness for armed robbery at the Munch Museum and Drumlanrig Castle. Withstanding determined and armed thieves is not generally within the capabilities of even the most secure museums. Good security defences are nevertheless crucial in preventing art theft, and it is a reasonable assumption that there are many interrupted, foiled or unsuccessful art thefts about which little or nothing is known.[66]

In a significant number of cases there is a connection with the expanding networks of those trading in illegal narcotics (which escalated rapidly in Britain and Europe in the 1980s), providing an additional motivation for career criminals to attempt high-risk raids on high-value works of art. The basis of their calculations may be that an 8–10 per cent exchange value out of the huge prices on paintings still makes the risks in the theft worthwhile, although whether in the art market or the underworld, exchange values still have to be agreed by both parties. In a paper of 2005, criminologist Simon Mackenzie argues that 'Most thieves are not specialists in one particular crime, rather they are opportunists', and he goes on to comment on the 'commissioned' element of art theft: 'the thieves themselves will be profit-motivated and the theft will bear the hallmarks of professionalism and violence that characterizes these operations'.[67] As former Head of the Met's Art Squad, Detective Sergeant Vernon Rapley observed:

> For very high level art theft the purpose of the theft is almost always to sell it back on some future occasion, but historically it has been used for trading, as collateral. A criminal gang can

trade that work or swap it with another criminal gang for twenty kilos of cocaine, because that criminal gang will have the assurance that at the end of that, if they don't get their money back, they can hand the painting in for the reward. So the reward gives the painting its value within the criminal underworld.[68]

In writing about the growth of the drugs trade, sociologists Vincenzo Ruggiero and Nigel South explain: 'In describing urban patterns of drug use, trafficking and related criminal activity we adopt an image of the city as a market-place – selling everything from the mundane to the spectacular, meeting demands of need and necessity, pleasure and diversion.'[69] Certainly, items of fine art, which are prominent and stolen, could fit into that wider 'market'. Typical examples of such a network include Myles Connor, who pleaded guilty in Boston to stealing two Dutch Old Master paintings in 1990 from Amherst College in order to finance a cocaine deal. The detective Charley Hill was explicit in commenting on the Russborough House theft of 1986: 'Cahill wanted to become a major drugs distributor throughout the British Isles. The stolen works of art were to raise money for that venture.'[70] His colleague, Dick Ellis, produced a flow diagram at this time to illustrate the links across Europe between stolen art and the drugs trade.[71]

Janet Ulph, an expert in money laundering, is pessimistic about the changing international context in which art theft is placed:

> New technology and easy global travel have created the perfect seed-bed for international crime in general, including drug-trafficking and terrorism . . . the owner's stolen art [often] figures at a later stage in a particular chain of events . . . a criminal may be involved in pornography, car theft or prostitution. As part of the money laundering process, such goods as gold or works of art may be purchased as this is the usual method of disguising the money's origins.[72]

Such connectivity and networking was confirmed by the art dealer and middleman Michel van Rijn. Referring to Colonel Michael

Bogdanos, New York City Assistant District Attorney and US Marine, he wrote: 'While Bogdanos agrees that counter terrorism, narcotics, street crime and human trafficking are rightly the four main priorities for police forces around the world, his experience shows that art crime is often intricately linked with the above and should be included on the list, "right after the other four"'.[73] Vernon Rapley took a similar view in 2003:

> It's a very good commodity for criminals. If they steal a major painting, we do them the great favour of publicizing it and showing the image in the newspapers, together with its value, which means they can go to their fellow criminals and use it as collateral, as a down payment on drugs and firearms. The provenance is provided by the newspaper report that says that the painting is worth so many millions of dollars.[74]

Misha Glenny's epic study of the growth of organized crime and the shadow economy, *McMafia* (2008), sets out the wider framework within which this trafficking in stolen art is likely to take place. As the market economy of the world has become increasingly transnational and multi-dimensional, so too has the 'other side', the criminal underworld. But Glenny clarifies: 'It is not globalization in itself that has

1986–1993 A Cautionary Tale. Diagram of the link between the drugs trade and art theft produced by Dick Ellis.

spurred the spectacular growth of organized crime in recent years, but global markets that are either insufficiently regulated, especially in the financial sector, or too closely regulated, as in the labour and agricultural sectors.'[75] High-value, high-risk art theft has emerged as a particular genre of crime based both on the exceptionally visible and high prices of art and on the networks of drug dealing into which some exchange as form of collateral – for otherwise unsaleable stolen works of art – has become possible and profitable.

eight

Fiction

Crime itself . . . is like a virus. It is not seen and it is difficult to treat but its effects blight the lives of all too many of our fellow citizens. The language that we use to deal with it is powerful. Words like 'punishment', 'victim', 'murder' and 'arrest' stir deep emotions and powerful feelings in all of us.[1]
 – Michael Jack (Minister of State, Home Office, UK), 5 March 1993

This is an elegant crime, done by an elegant person. It's not about the money.
 – Catherine Banning, insurance investigator, *The Thomas Crown Affair*,
August 1999

This motion picture was in no way authorized, sponsored or endorsed by any museum, nor was any portion of the motion picture filmed inside a museum. The events, characters and other entities (including the museum) depicted in this motion picture are fictions, and any similarity to actual persons, events or entities is purely coincidental.
 – Disclaimer Notice, *The Thomas Crown Affair*, Metro Goldwyn Meyer,
August 1999

The Scene of the Crime: The *Mona Lisa*

William Nicholson's *La Retour de la Joconde* shows a crowded picture gallery in a gloomy light: the Salon Carré at the Louvre. A single figure, perhaps the artist himself, is facing towards us. His attention, looking out of the canvas, is towards us as viewers, and focused on a particular

William Nicholson, *La Retour de la Joconde*, 1914.

work as if above our heads and pointedly away from the painting that holds the interest of a huddled throng. The crowd renders it invisible – it is the *Mona Lisa*, back on display on 4 January 1914 following its sensational theft two and a half years earlier by a workman, Vincenzo Peruggia. Sanford Schwartz, in his study of Nicholson, suggests that the painting is about 'the act of scrutinizing' and proposes an underlying theme of '*not* looking at the masterpiece'. If the calculated indifference displayed in the painting is that of the artist (aged 42 and working in Paris in the early months of 1914), it is a contradiction that reinforces the importance of the occasion.[2] At this time France, and much of Europe, was still obsessed with the theft and its ramifications. This was a crime scene in which order had only partly been settled, since various hypotheses, fictions and stories relating to this famous theft spread out for many years. With the *Mona Lisa* restored to the museum, Nicholson's painting also demonstrates something of the critical relationship between crime and publicity in a modern world of rapidly accelerating communication. This is about the *perception* of the art of theft as much as about the theft of art. And it is an arena for fiction and myth-making that has grown over the following century.

The 'scene of the crime', as the starting point for criminal investigation, is a powerful concept within our culture.

> These images are usually of empty rooms or desolate stretches of highway. There may be glimpsed a corpse, covered with a sheet. There may be signs of struggle: upturned chairs or broken glass . . . There is a sense of 'having been', of departure and the departed, of vacancy – all that remains is an image of the aftermath of the crime.[3]

Peter Wollen describes this as a freezing of time, and criminologist Alison Young suggests how the recording and publication of such images fuels the intrigue: 'As spectators – whether forensic or aesthetic – we are forced to approach the scene only in order to construct a retrospection, to narrate an event that exists in a past tense. The crime scene image thus functions as a record, an archive, a collection of traces which depends upon the viewer's deductive acumen in explicating its meaning.'[4]

With art theft there is no 'body' left behind. The residue of the crime is a blank space, a pronounced break with the missing, now un-viewable work of art (intended otherwise to be scrutinized and admired). The search for clues follows – for traces left by the thieves – and the unravelling of questions of motive, access and methodology. A theft is reported to the police and an insurance company, and both detectives and loss adjuster will soon be on the scene. Each will want leads that give links to the thieves as well as the stolen art.[5] Various strands of detective work commence from the scene of the crime – each of them trying to differentiate facts from suggestive fictions. Control of information as well as its discovery is important as an investigation unfolds.[6]

Unimaginable: The Myths of the *Mona Lisa*

Leonardo da Vinci's masterpiece was painted between 1503 and 1506 on a poplar wood panel, and acquired by François I of France after Da Vinci had been invited by him to work near Amboise towards the end of his life. It is generally accepted to depict Lisa Gherardini, wife of

the Florentine merchant Francesco del Giocondo. Although it is now widely regarded as the most famous painting in the world, this was not the case until the late nineteenth century. Indeed, the theft of 1911 may have been instrumental in crystallizing its wider public appreciation. The complexity of the changing understanding of the Mona Lisa was tested by the philosopher George Boas in a noted article of 1940. He pointed out that 'works of art are not the locus of one value, known as "beauty" or something similar, but are rather multivalent, that certain of their values are experienced by some persons, others by others, and that there is no *a priori* method – except that of fiat – of determining which of many values are properly "aesthetic"'.[7] In charting the different approaches to the Mona Lisa from contemporary commentators to nineteenth-century critics, particularly Théophile Gautier and Walter Pater, and to the Freudian and the Marxian writers, Boas emphasizes that the 'enigmatic' is an invented concept as much as any other, and what may have drawn huge public attention to this painting in the late nineteenth and early twentieth centuries has driven others away: 'Mr Paul Valéry is probably right in saying that the association of "mystery" with the picture has had more influence than any other one thing in disgusting people with it.'[8]

While the Renaissance critic Giorgio Vasari had praised the portrait as 'true to life', it was the nineteenth-century critics who focused attention on the portrait's romantic 'enigmatic' expression and in particular on the subject's smile, an attribute not previously commented on. The smile is summarized by Darian Leader (analyst of the symbolism and effect of the painting) as something that came to be seen as 'sinister, dangerous, unfathomable, opaque and lethally beautiful'.[9] As Ernst Gombrich aptly remarked, 'descriptions can be adhesive. Once we have read and remembered them, we cannot help finding the picture subtly changed.'[10]

In the twentieth century, while the painting has been caricatured, appropriated and reworked, popular interest has soared with millions of copies and reproductions available worldwide. Scholarly interest has been more muted. Historian Donald Sassoon judged in 2001 that:

Twentieth-century art historians, in spite of the continuing popular interest in the matter, left the business of the Mona Lisa's smile to amateurs and concentrated on the pose, which produces the idea of movement; on the technique, which produces a sense of depth; on the history of the painting; and in particular, the identity of the sitter. The smile, though the most remarked and famous feature of the Mona Lisa, is never seriously discussed by art historians today.[11]

Nevertheless, it was writers who had given the *Mona Lisa* her special status ('She was not just enigmatic, she had become a *symbol* of the enigmatic').[12]

After the recovery of the painting, the thief, Vincenzo Peruggia, declared among many self-serving statements that:

> I shall never forget the evening after I had carried the picture home. I locked myself in my room in Paris and took the picture from a drawer. I stood bewitched before La Giaconda. I fell victim to her smile and feasted my eyes on my treasure every evening, discovering each time new beauty and perversity in her. I fell in love with her.[13]

Peruggia's comments follow Gauthier and Pater directly in believing in the power of the portrait, both beautiful and perverse. Although the illusion that a portrait actually 'looks' at its viewer is easily dismissed, the slippage between person and painting is still there when Darian Leader remarks that, 'none the less, the lifeless, dead eyes have a disquieting effect'.

With continuing speculation surrounding the theft of 1911 (about the authenticity of the recovered painting, and the misfit between the actual thief and a more debonair image of the assumed perpetrator), several stories were elaborated. The most intriguing appeared in America in the *Saturday Evening Post* in June 1932, and was referred to by the *Los Angeles Times* as a 'romantic tale which ought to be true if it isn't'.[14] Journalist Karl Decker gave an account of the work of the Marquis de Valfierno, a Latin American confidence trickster who had made Decker wait until after his death to reveal how he

had commissioned six perfect copies, transported each of them to the Americas, and then set the workman, Peruggia, to undertake the theft. Following the worldwide publicity, Valfierno would be able to sell each of the fakes as the real work, and once this was completed he had no need to keep the original.

Seymour Reit adopted Decker's story in *The Day they Stole the Mona Lisa*, published in 1981. In the foreword, he claimed: 'The narrative may read like detective fiction, but it decidedly isn't. Everything described in these pages happened: the people are real people; so too are the names, places, dates, times and events . . . never has a major art crime caused so much turmoil when it happened, and been so widely neglected afterwards.'[15] Fiction and reality were further entwined with Robert Noah's novel *The Man Who Stole the Mona Lisa* (1998), which centred on the supposed de Valfierno's work and that of his forger, Yves Chaudron.[16] Responding to questions from readers, Noah admitted: 'we don't really know that this story is true! It was told to a well respected, credentialed reporter . . . but it was told by a con artist . . . The danger with con artists is that they don't always tell the truth.'[17] Other novels and films have elaborated on the concept of a hidden, controlling force behind the theft, but despite the strong desire for a more charismatic thief no convincing evidence has emerged to displace the direct account (assuming a mix of financial and nationalistic motivation) given by the opportunistic workman, Peruggia.

The special status of the *Mona Lisa* was confirmed with important diplomatic outings – to the USA in the 1960s, and to Japan and Russia in the 1970s – for short-run exhibitions that were exceptionally popular. As a commentator noted, 'Authenticity is the key concept of tourism. It means that one waits for hours to "experience" the *real* thing.'[18] The theft of 1911 and the surrounding furore did not, alone, cause this painting to become the most famous work of art in the world, but they enhanced its position in the popular imagination. The stories that followed the theft, however, set the terms for the intertwining of myth and reality surrounding subsequent major art thefts. The *Mona Lisa* advanced the understanding that theft from museums is both a reality and a matter of detective fiction. Darian Leader notes: 'The fact that a painting wasn't there

had made people look at things in a different way. Everything that was once invisible became the object of a look, a fact that makes the theft of the Mona Lisa a work of art in itself.'[19]

The Imaginary Collector-Thief

A belief in the secretive and hoarding collector – assumed to be the case for the *Mona Lisa* and speculated over for the stolen Turners – is pervasive and sports a considerable literary pedigree. Such an individual might flourish in an invented world, set apart. Captain Nemo, of the submarine *Nautilus*, exemplifies the concept in Jules Verne's novel *Twenty Thousand Leagues under the Sea* (1870). Having declared that the world's laws no longer apply underwater, he accumulates in his salon a great picture collection (within the physical limits of his submarine). Joseph Conrad's Kurtz, in his novel *Heart of Darkness* (1902), as encountered by Charles Marlow, is not a collector but trades in the treasure of ivory, demonstrating the same theme in the control of his own, sinister jungle world. The Czech/Austrian artist Alfred Kubin wrote and illustrated *Die andere Seite* (*The Other Side*; 1909), in which the narrator explores a Dream Kingdom, created by his former schoolfriend Claus Patera. It is a dystopia in which the power-mad Patera has acquired many old and antique objects and buildings from around the world as part of his bizarre and ultimately disintegrating realm. Kubin referred to himself as a 'dream artist', and was published as Sigmund Freud's analysis of dreams was being debated as a potential route to the unconscious – by which human behaviour and motivation might be understood better. The overriding concepts here are of the expression of power through the accumulation of great works of art, and a special detached world, beyond the reach of the law, which occasionally connects or overlaps with our own.

The idea of the hidden collector has been reworked in several fiction and film narratives. In *Dr No*, the first of the Ian Fleming James Bond novels to be produced as a film in 1962, the evil scientist's underwater lair at Crab Key in Jamaica provides the setting for an unexpected encounter. Sean Connery, as Bond, pauses as he walks through the drawing room created by set designer Ken Adams and admires a portrait on an easel – it is Goya's *The Duke of Wellington*

METROPOLITAN POLICE

£5,000 REWARD

STOLEN

from

THE NATIONAL GALLERY

on 21st August, 1961

Portrait of

THE DUKE OF WELLINGTON

by Francisco de GOYA

The above reward of £5,000 will be paid by the Trustees of the National Gallery to the first person giving information which will result in the apprehension and the conviction of the thief or thieves, or receiver, and the recovery of this famous picture, the property of the Nation.

Information should be given at the Metropolitan Police Office, New Scotland Yard, London, S.W.1, or at any Police Station.

Printed by the Receiver for the Metropolitan Police District, New Scotland Yard, S.W.1. 62358/8,700

(1812–14), stolen (in reality) the previous year from the National Gallery in London.[20] The actual painting was still missing, removed through a toilet window on the night of the fiftieth anniversary of the *Mona Lisa* theft. But it was stolen not at the behest of a criminal scientist with world domination in mind, but by Kempton Bunton, a 61-year-old unemployed truck driver from Newcastle upon Tyne. The work and its high value had been publicized in 1961 when it was acquired for £140,000 by the National Gallery, with support from the Wolfson Foundation and a special Treasury grant to 'save' it from purchase and export by the New York collector Charles Wrightsman.[21] Outrage at the theft reflected the prominence of the work, as well as the fact that there had been nothing stolen in the National Gallery's 138-year history. Philip Hendy's offer to resign his directorship was not accepted by the Trustees, but a government inquiry of the following

Sean Connery with Goya's portrait of the Duke of Wellington in *Dr No* (1962).

year made a number of important recommendations, including the creation of a security adviser post for the national museums.

Bunton, however, had a mission: 'The act is an attempt to pick the pockets of those who love art more than charity . . . the picture is not, and will not be for sale – it is for ransom – £140,000 – to be given to charity.' As he later explained in his various anonymous communications to the newspapers: 'My sole object in all this was to set up a charity to buy television licences for old and poor people who seem to be neglected in our affluent society.'[22] The work was recovered in May 1965, without the frame, and Bunton confessed to the crime. In court he was defended by Jeremy Hutchinson QC.[23] Subsequently, because he claimed to have 'borrowed' the work as a protest – with no intention to sell or keep it – Bunton was found guilty only of theft of the frame but acquitted of stealing the actual painting.[24]

Whatever the contrast between the figure of the protesting Kempton Bunton and that of the lugubrious Dr No, the collector-thief stereotype was much employed following the virulent spate of art thefts in the South of France in 1961 and 1962. Writing in 1966, Robert Wraight described how the media promoted variations of the image: 'the Daily Express team went to town [with a] concocted description of a Mr Gloat . . . to be caught by Inspector Maigret . . .

"An old cobwebby cellar, flickering tallow candles spluttering their grease on the suit of a man with a magnifying glass and greed on his face as he looks at the dusty frames".'[25] The question remains as to whether such hidden collectors are simply a powerful idea linked to the concept of the 'gentleman thief', or have actually been responsible for a strand of art theft in recent decades, as a part of contemporary gangster activity and an extended black market. Views differ greatly, but part of what a myth does is to allow a fictional character to stand out in an increasingly regimented and bureaucratic society.[26]

Senior insurance expert Robert Hiscox adopts one stance:

> Because I love art to the extent that I would steal it if I were a criminal, I believe that people do have it stolen for them. The immense thrill for a villain of having a Turner in his house would probably be enhanced if he knew it had been stolen. Everybody else takes a different view, but why do you occasionally find thieves with incredible hoards? We've never found a Mr Big with real Titians and such-like, and I do realise that the majority of thefts are done because the thieves know there is incredible value in art not realising the impossible problem of turning them into cash, but I bet that many of the great paintings stolen over the years are hanging in pride of place in an immoral art-lovers mansion.[27]

Although not a view shared by most commentators, retired art detective Thomas McShane believes that: 'he, and she, does exist alright. From Riyadh to Beverly Hills, they're out there gazing up at their special prizes each and every day, proving once again that "stolen apples taste the sweetest". They're just extremely difficult to catch.'[28]

The existence of criminal hoarding collectors is impossible to prove one way or the other, although the most experienced of specialist detectives, such as Charley Hill, dispute the existence of secret collectors. Some legitimate collectors are very secretive, but there is a huge difference between those who buy legitimate works for personal pleasure and those who knowingly acquire stolen art, or would commission a theft.[29] Mark Dalrymple takes the same view: 'I get very tired of this continuous journalistic drivel about Mr Big and the

art world . . . Criminals, unless they are deranged, steal art for money. Sometimes a bit of fame as well. But it is essentially money.'[30] Edward Dolnick in his book on the 1994 theft and recovery of *The Scream*, led by Hill, considers the possibility of their existence: 'Is the stolen-to-order theory true? Brandy and smoking jackets aside, it certainly seems compelling. We know that masterpieces can never find legitimate buyers. We know that masterpieces are stolen regularly nevertheless. We know that many disappear forever.'[31] It is easy to see how such a myth arises and is perpetuated in literature and films.

The special trophy element may play an important (and perhaps an increasing) part in actual art crime – with certain collectors, certain receivers and fences, and equally with certain thieves – and there is evidence that this can be a factor in criminal circles. As Dalrymple puts it, 'there has been a trend among certain types to do it for the hell of it, to do it because they *can* do it'.[32] Dolnick also refers to the telling connection between fiction and reality: if the thieves *believe* in the idea of the hidden collector, then this gives them an added incentive and 'masterpieces will continue to disappear'.[33] The concept of hidden collectors is more fiction than fact – myth outweighing reality. As an idea it remains powerful and widespread.[34]

The Aura of the Gentleman Thief

> The week before I met you, I nailed two crooked real estate agents and a guy who was beating his kids to death. So if some Houdini wants to snatch a couple of swirls of paint that are really only important to some very silly rich people, I don't give a damn.[35]
>
> – Police Detective Michael McCann, played by Denis Leary in
> *The Thomas Crown Affair*, 1999

Edward Moat, a self-proclaimed thief, boasted in a 1970s memoir that he used post-war Europe as his hunting ground for antiquities and works of art to steal and sell on – mixing skill and panache – with himself as a latter-day Robin Hood (though without any community-minded motives). Homework, meticulous research and a connoisseur's approach were the keys to success:

It's one thing to make a boggle-de-botch at an auction or be duped by a dealer if you are a connoisseur or a director of a gallery. It is quite another thing if you go and remove a painting supposedly by a well-known name and you pass it on for a suitably large remuneration to the next owner whom you may have chosen or who may have chosen you to carry out the commission for him. Should he find that all he has is some old copy worth a mere fraction . . . the world would very soon shrink as he or his came after me.[36]

Moat's self-admiring assessment trades on the idea, like Adam Worth in the previous century, that as an art thief he was an intelligent and 'civilized' criminal, perpetrating an almost victimless crime against a tiny minority of wealthy people. Worth has been seen as the model for the arch-criminal Professor Moriarty in the Sherlock Holmes stories, in which his 'respectable' life as an American 'gentleman about town' in Paris and London runs in parallel with his work as a criminal, deeply embroiled in theft, forgery and extortion.[37] He might not abide by the law or have proper morals, but he has some scruples and considerable integrity. He avoids violence, is polite and even gracious, loyal and fair with those he employs, and targets rich private individuals and commercial institutions rather than public bodies.

A. J. (Arthur) Raffles was a similar fictional and anti-heroic character created in the 1890s by E. W. Hornung – perhaps as a complement to the generally virtuous Sherlock Holmes character created by his brother-in-law, Arthur Conan Doyle. The Raffles stories have a strong class dimension, since he is known as the 'amateur cracksman' and distinguishes himself as a thief from more professional but working-class 'colleagues' by being a gentleman, a patriot and a royalist. While the Sherlock Holmes books focus on how a crime can be solved, the Raffles stories revolve around how a crime might best be perpetrated, not least with the central character as a 'master of disguise'. Raffles is also a fine spin bowler, and this parallels the competitiveness and doggedness of sport (without the virtues of fair play and adherence to rules). Conan Doyle was concerned that while his brother-in-law had dedicated his first collection of stories to him

('To ACD. This form of flattery'), the stories were 'rather dangerous in their suggestion'. He added that 'you must not make the criminal a hero'.[38] Flying in the face of this advice, the Raffles stories have been much extended, translated into film and television, and however much they read as of their period they have strengthened a proto-type of a 'gentleman thief' that has grown in the public imagination.

Two memorable post-war European films, both directed by Jules Dassin, *Du rififi chez les hommes* (1955) and *Topkapi* (1964), contributed significantly to the perceived heroics of stealing and the sympathetic portrayal of thieves.[39] While greatly different in style and ambience – only the first offers a singular prominent anti-hero in Jean Servais' portrayal of Tony le Stéphanois – they both elaborate on a central, intriguing and complex theft. Intricate and creative planning (but nerve-racking risks) will be greatly rewarded if the 'heist' can be pulled off and the jewels (in both films) dispersed for sale away from the scene of the crime. Weapons are deliberately not carried: 'It means life.'[40] The viewer is given only partial information in the planning phase of each robbery. (A succinct summary of all 'heist-movie' plots is Act I planning, Act II theft, and Act III disagreement or disarray.)[41] There is a double suspense, about *how* the thieves will accomplish their criminal goal and *whether* they will avoid being caught. Specializ-ation and dynamics within the team are highlighted (heightened by a relentless beat-the-clock element). The pride with which the theft is undertaken (through ingenuity and skill) is critical to the viewer's sympathy, together with the implicit proposition that despite the allure of the 'priceless' jewels (with scenes of team bonding with the stolen material), there are ultimately things more valuable in life. In *Rififi* this is given dramatic and moralizing form with the kidnap of Le Stéphanois' godson: the child has a value that cannot be given a price.

Topkapi, based on an Eric Ambler novel with an added comic dimension, includes a further reversal of roles between good and bad. The Turkish security forces understandably wish to foil what they believe (wrongly) might be a threatened terrorist attack. But they are portrayed as incompetent and sinister, with a neo-Nazi styling to their behaviour and dress. In the 'elite' group of criminals making up the gang, the comedic figure of Robert Morley replaces an expe-rienced muscular criminal whose hands have been inadvertently

injured. One notable idea adapted in later films is the concept of shifting space or time, creating a gap between the security system interfered with by the criminals and the expectation of the authorities. In *Topkapi* this involves slowing down the normal rotation of a lighthouse beam, which in the darkness protects the thieves from detection, and in the later film, *Entrapment* (1999), a moment of change-over at the millennium, as the computers of the clearing banks are checked worldwide to prevent system failure.

More than any other film *The Thomas Crown Affair* reanimates and amplifies many of these ideas. Based on a story by Alan R. Trustman, it was first made into a film by Norman Jewison in 1968, starring Faye Dunaway as an insurance investigator on the trail of Thomas Crown, a wealthy businessman. Crown, played by Steve McQueen, is rich but appears to have perpetrated an outrageous bank robbery. For the more successful re-make in 1999, director John McTiernan was hired by producers Beau St Clair and Pierce Brosnan, together with scriptwriter Leslie Dixon and production designer Bruno Rubeo, and the story was altered to focus on the theft of art. In both versions the pursuit of the thief is intertwined with romantic interest, with Rene Russo playing investigator Catherine Banning alongside Brosnan's Crown (wanting to invert his James Bond image to become a bad rather than a good hero). Dunaway reappears in a cameo role as his psychoanalyst: 'Mr Crown, you have yet to talk about women' – 'I enjoy women' – 'Enjoyment isn't intimacy' – 'Intimacy isn't necessarily enjoyment.'[42]

The re-make script is complicated by Crown stealing a painting from a museum but also (to prove a point, and somewhat Robin Hood-like) deciding to return it secretly to the same place. Although very similar to the Metropolitan Museum in New York, the interior was shot in the New York Public Library with complex interiors created by Bruno Rubeo. The Met was offered the chance to be the location, but the management 'were afraid to suggest that someone could actually steal a painting from there – from their museum'.[43] The imaginary stolen work, a Claude Monet, is disguised by having another picture painted on top of it in watercolours – revealed in a later sequence when water-sprinklers are triggered by smoke detectors and wash off its outer coat.

Thomas Crown is a property dealer who seemingly has every-thing. As a rich and debonair connoisseur he owns works of art that he can enjoy in private at his leisure – the René Magritte painting of the bowler-hatted man, *The Son of Man* – a leitmotif in the imagery of the film – and now a stolen Monet, *San Maggiore at Dusk*. The repro-ductions used for filming were created by the Troubetzkoy Gallery, a specialist 'art reproduction gallery'. The president of the firm, Christopher Warner Moore, puts it boldly: 'I sell fantasy; what is that worth? . . . the paintings represent more than just quarry to the art-loving thief'.[44] Whether acquired legitimately or illegitimately, Crown's collection substantiates his quip that 'Anything is obtain-able'. As a collector and thief, however, Crown has more trouble 'obtaining' Catherine Banning, until it suits her (as part of her inves-tigation) to have an affair with him. His intertwined admiration for the beauty of works of art and women is a blatantly stereotypical central theme – both involve the enactment of power.

The film appeared a year after Martin Boorman's *The General* (1998), based on the real life of Irish gangster Martin Cahill, perpe-trator of the major art theft from Russborough House outside Dublin. However, there is a closer connection with *Entrapment*, also released in 1999, and directed by John Amiel. Another collector-thief, Robert 'Mac' MacDougal, played by Sean Connery (the first James Bond), is confronted by another insurance investigator, Virginia 'Gin' Baker, played by Catherine Zeta-Jones. The plot involves 'Gin' convincing the legendary art thief 'Mac' that she is a thief herself, thus entrap-ping him. Unbeknown to Baker's employers, however, she *actually* is a top-class thief (she steals a Rembrandt at the start of the film), who in a double bluff wants to enlist MacDougal's help in pulling off the 'Crime of the Millennium'. MacDougal denies entrapping Baker through a joint project (telling her: 'No, actually it's called *blackmail*; *entrapment* is what cops do to thieves'), and he demonstrates a similar motivation to Thomas Crown – desire. When Gin asks about paintings hidden away in his Scottish castle (including a Fran-cis Bacon) – 'Is all this paid for?' – Mac replies: 'With blood'. When pressed with 'Isn't it sad not to share it with anyone?' he responds: 'Most people buy art just to show it off – I collect art just for me.'[45] Like Edward Moat or Stéphane Breitwieser, the implication is that

the collector-thief is the *true* lover of art, prepared to take great risks to fulfil his passion.

Art theft films belong to a much broader genre of adventure and 'heist' films that includes movies such as *The Italian Job* (1969) and the *Ocean's Eleven* series from 2003, where teamwork and disagreements are both prominent. Several common elements, however, run though the art theft films that reinforce a fictional view of the art thief figure: bravery having a renewed place in the world; the love of art or jewels as comparable to the love for a woman; a desire to have what cannot be valued; the use of extreme cunning against technological devices and stopping or slowing down time to aid a robbery; the 'competition' or sport between the art thief and investigator (though clearly they may get too close); the hidden collection that the thief or commissioner holds which is worth maintaining, although no one else may see it. Thieves are men, and they do not always get captured. Like Raffles, the supposedly high level of scruples (no guns combined with glamour and heroism) helps them avoid censure as criminals, to survive as (anti-)heroes. All this is a very long way from the reality of art theft in recent years.

Alison Young points to the importance of how criminal behaviour may be influenced by stereotypes produced in the media – a kind of feedback loop. 'In the case of the hit TV series, *The Sopranos*, the US police report listening in on discussions in New Jersey criminal circles about particular characters and the authenticity of the broadcast dialogue. And the *Godfather* novel and films seem likely to have had a wider effect.'[46] We cannot know the degree of such influence, but it is fair to assume that it reinforces the determination of thieves to challenge the law, to see themselves in a particular light and to undertake dangerous and sometimes dramatic thefts. It does not legitimize them but it may offer credentials in the criminal world.

The Detective and the Investigator: Skill and Style

That's why I learned very early on that in the art sleuth dodge, it's all about recovering masterpieces. The thieves are just the chaff.[47]
– Thomas McShane, art detective, 2006

Whatever the professional skills and motivations of real art investigators, the dominant image of the detective is informed by popular crime fiction, with criminals (as anti-heroes) being pursued and eventually caught by those in authority (as real heroes), however rebellious their personalities. This image of the sleuth – the brilliant, singular detective – was developed most completely in the persona of Sherlock Holmes. Despite changes in style, the strongest characteristic for such a detective, whether male or female, is a combination of physical strength and mental determination, reassuring the reader that individual and collective threats will be overcome. As Alison Young puts it: 'The detective guides the reader through the world of criminality; as such she must be more than the reader or the client, who has been unable to solve the puzzle on her own.'[48] She quotes Raymond Chandler on the heroic nature of the detective: 'Down these mean streets a man must go who is not himself mean, who is neither tarnished or afraid. The detective in this kind of story must be such a man. He is the hero, he is everything.'[49]

Young goes further in elaborating the way detective fiction operates: 'The crimino-legal convention has always been to impose the general over the particular (thus, law is applied to the facts, or rules to the evidence). What is captivating to the reader of detective fiction, however, is more the particularity of the scene portrayed, than the general depiction of crime as a "timeless" phenomenon'.[50] And so within the story there are crucial characters required to pursue the narrative drive:

> The text [of the detective story] requires a person who is uniquely able to decode the puzzle through varying means: rationality, forensic science, re-enactment, intuition; a moment of revelation in which the enigma is explained (to the reader, who has been unable to solve the puzzle, and to

the other characters in the story); a sense of denouement or adjustment in which the moral order resumes its correct functioning.[51]

Within that fiction, however, for the detective, 'each admirable trait is mirrored by a flaw which impinges in some way on the narrative . . . pomposity, bad temper, recklessness, antagonism to authority . . . sarcasm . . . (Holmes takes cocaine to alleviate the boredom engendered by his superior intelligence) . . . The existence of a character flaw is crucial to the narratives.'[52]

In reality, when pursuing actual high-value works of art, the police detective frequently works in close concert with an investigator acting for an insurance company.[53] In Britain such a person is a loss adjuster, like Mark Dalrymple.[54] More specifically, the loss adjuster attempts to find and recover stolen works of art, rather than focusing primarily on the thief. Dalrymple is clear about the need for the closest possible coordination with police detective work:

Staying within the law is the constraint . . . I am a patient person and that in the past has proved to be a successful approach. One of the difficulties that many people suffer from, especially in this game, is that they need a 'recovery' to live . . . I don't, because I have a lot of business and work. If I need to spend time and money on something, and it is very important, then the underwriters will pay me to do so. Otherwise I will do it because I am going to do it anyway, because it is a matter of pride.[55]

The work of detectives as portrayed in literature feeds into the working experience and self-image of detectives pursuing art cases. Detectives and robbers in fiction are no longer all male, but stereotypical presumptions are still influential. This was the case with the Head of the Metropolitan Police's Art and Antiques Squad, Detective Inspector Jill McTigue, who, when offered promotion in 2005, was compared in the press to the fictional character of DCI Jane Tennison from the series *Prime Suspect*. Tennison is admired because, while aware of being perceived as good-looking, she is just as tough

or even tougher than her male colleagues. The actor Helen Mirren had made the role famous in the UK; McTigue was herself a senior professional who had headed the Murder Squad in the early 1990s.[56] While possibly flattering, the media response demonstrated the powerful influence of popular fiction on public opinion, where changing gender roles are only slowly being acknowledged. When a BBC programme about the Squad appeared in 1995, Jill McTigue herself commented that art theft might be a masculine interest but was not a gentlemanly business: 'Just because art is nice doesn't mean the people who steal it are.'[57]

As the more benign and old-fashioned image of cops chasing robbers is discarded so the masculine association with police work – particularly of being physically tough – is discarded in favour of detection work being identified as more 'feminine', with attributes of intuition, guile and negotiation. If the thief is established as a fictional anti-hero, then what is the particular image of the detective specializing in art crime?

Memoirs of art detectives offer clues, including a self-image of much dedication and a certain selflessness, combined with an anti-institutional attitude. The very idea of a specialist police unit is relatively new (pioneered in Britain and Italy in the late 1960s) and 'Art Cop' Robert Volpe, working in New York in the 1970s, described himself as both artist and detective.

> He has been aware of the dual nature of his personality. One is the artistic and creative nature, which rebels against certain established life procedures. That is Volpe the painter. The other more traditional Volpe is the Volpe who believes so strongly in 'law and order' that its pursuit actually became his profession. That is Volpe the policeman.[58]

For a period, his companion officer was Marie Cirile, drafted into the art team and referred to 'as something of a rebel . . . Slim and attractive, with brown hair, and a youthful figure, she wore a costume similar to his own: dungarees, a plain sweater, and dirty sneakers'.[59] Photographs of Cirile (looking much like early Cindy Sherman images) show her ready to circulate as if incognito in the art world.

Marie Cirile in disguise in New York in the early 1970s.

She describes how her working partner, Volpe, hoping for the same acceptance with dealers and artists,

> looked like a little kid dressed up for graduation, with his chocolate brown slacks and shirt and brown-and-white sport jacket . . . his light brown wavy hair was cut long, styled around his face and down to the collar. The most outstanding feature . . . was a bold, prospering handle-bar moustache, its turned-up ends lovingly touched with a bit of moustache wax . . . I could see that there was a lot more here than met the eye.[60]

Working in the art world and amongst artists produced these versions of dressing up.

Both detectives testify to their effectiveness in this arena: catching criminals working in the art world and making the New York dealers and museums more aware of how to prevent art-related crimes, particularly forgery and theft. The greater frustration was internal, for which Marie Cirile blames a lack of imagination within New York police management. 'In fact we were actually harassed and hampered . . . Every day we'd hear "Hey, Volpe, I want you to get a haircut, and that moustache has to come off. You can't come here dressed like that. You look like a goddamned hippie".'[61] These detectives were rebels within the police force, even though a prerequisite

for detection work is to change appearance as required. Tackling art crime depends on the social landscape of its operations and an undercover officer needs to understand that. As Metropolitan senior officer Dick Ellis said later of Rocky, '[he] does not come across as a well-educated, aesthetic, well-to-do person . . . Rocky is your rough-and-tumble black market dealer, and he's *very* good at it'.[62]

Despite difficulties, the New York team developed under Captain Kissane, and later Don Mason, and Thomas McShane gives an account of his own work there in the later 1970s, including playing the role of the 'shady art dealer Thomas Bishop' for the purpose of catching thieves with stolen works through stings. McShane emphasized the blend of skills required, including performance and presentation skills in addition to investigative analysis. At the end of describing one set-up, capturing a criminal who was part of a forgery case, he said: 'it was necessary to make him believe we were legit. Nobody buys everything. And nobody sells everything, even when they claim they have. The more you haggle over the money and details, the more real the deal appears.'[63]

Like the self-conscious Boston investigator Harold Smith, or London-based art detective Charley Hill, a mix of doggedness, chutzpah, advanced negotiating skills, an ability to inhabit roles, and probably an exuberant personality, are requirements of undercover investigation, heightened in the case of seeking out stolen art. It can be an intoxicating brew. As Hill put it,

> Thieves and gangsters all hate each other, they screw each other, they betray each other . . . if you suddenly appear in it and agree to everything they say and do everything they want, then you're just not credible. If you act agreeable, it's not a sign you're close to a deal. It's a sign they should push harder. They'll take you for some complete asshole.[64]

After pursuing *The Scream* and other important works, Charley Hill admitted his motivations were mixed: '[the] zeal for recovering stolen paintings spoke more to adrenaline hunger than to spirituality'. Much of the long search for the stolen Turners involved complex administrative negotiations, but as the paintings appeared to get closer

so the investigation had a strong element of a 'chase'. Hill added: 'It's a big thing recovering an important painting . . . and obviously I get a buzz out of it.'[65] At the end of a complex recovery operation in up-state open country the same feeling is described in somewhat pious terms by American investigator Thomas McShane:

> This was, when it came down to it, all about the beauty and magnificence of great art, about freeing two kidnapped masterpieces from their dark cellars and allowing them to wow the public with their majesty again. I was certain that masters Rubens and Ter Borch, wherever they were, had to approve of the exchange playing out across this breathtaking landscape.[66]

Between Culture and Myth

> Another border lies between crime as experience . . . and crime as phantasm, between the fear of crime and the pleasure of crime . . . Detective fiction's mass readership suggests some perverse attachment to criminality; perverse in the sense that the reader turns away from crime's representation as dread nightmare towards its textual frisson.[67]
> – Alison Young, *Imagining Crime: Textual Outlaws and Criminal Conversations*, 1996

In Noah Charney's novel *The Art Thief* (2007), a principal character is the insurance investigator Dr Gabriel Coffin.[68] We see him hot on the trail of a Caravaggio painting stolen from its setting, the central part of a church altarpiece in Rome. And we also hear him speaking on art crime at a conference taking place at the Villa i Tatti outside Florence (famous for its former owner, the art historian Bernard Berenson). The fictional conference, however, is staged in honour of Colonel Giovanni Pastore, the actual Director of the Carabinieri Unit for Safeguarding Cultural Protection in Italy. Fiction and reality are woven together as Coffin offers the conference attendees his own views on how through a particular kind of profiling the Isabella Stewart Gardner Museum case in Boston might be better investigated. The mix of reality and fiction is also evident in Guy Wilson's

earlier novel, *The Art Thieves* (1995), which includes a reference – by coincidence – to the famous Cellini *Saliera* being stolen, in this case while on loan to Rome (and then luckily being miraculously returned), some eight years before the gold sculpture was *actually* stolen in Vienna.[69]

The arena of high-value art theft may, through its apparent glamour and audacity, be plagued with fictions, confusing stereotypes, myths and constant media interest. Exaggerated reporting is clearly unhelpful, and as Dick Ellis has put it, 'Inflating the value of stolen art in the pursuit of good copy can also act to encourage further thefts as the criminals perceive the theft of art, antiquities and cultural property as being a fast track to wealth and riches.'[70] But over the past hundred years, since the theft of the *Mona Lisa*, myth-making has increased in intensity such that it confuses more rational approaches to understand this kind of theft, and, worse, undermines attempts to counter art theft and related crime more effectively. The entertainment-orientated world of film and fiction is inadvertently a barrier to a more concerted approach.

Just a year after the theft of *The Scream* from the Munch Museum in August 2004 – but well before the recovery of the painting in 2006 – a board game was produced by the respectable Norwegian publishers Aschehoug & Co. Written by Bjørn Sortlands, it was titled 'Skrik-mysteriet' (The Mystery of The Scream); designed for children 'over the age of six', it features 36 well-known works of art and players choose to be either robbers or detectives. Before bowing to pressure that forced the game to be removed from their shelves, the Munch Museum's Head of Marketing, Jorunn Christoffersen, explained to a Norwegian radio interviewer: 'It is pure fiction, so it is fun.'[71]

> Villains. Ruthless, reckless, heartless, heartless, careless villains. Cruel and unkind. It must seem at times as if shade and darkness will always triumph over light and colour.[72]
> – Nancy Banks-Smith, *Guardian*, 1995

Future

Virtuoso art theft, and the routine embarrassment of museum and gallery officials, are a recurrent entertainment ... The ingenuity of the art thief continues to enthral ... Every major art theft (particularly of a work too famous to be saleable) attracts frantic conjecture as to the motive. The public are no less fascinated by tales of purloined art than in Raffles's day and victims are no less distressed.[1]
 – Norman Palmer, *The Recovery of Stolen Art*, 1998

Hollywood has painted a picture of the art thief as glamorous, besuited Thomas Crowns, pilfering art for the thrill and challenge of it. But in the real world, it's a much less charming affair. Art crooks don't wear black jumpsuits; they don't stage elaborate robberies. In fact, most museum crooks are second-rate thugs that steal art because it packs so much value into such a compact and portable package.[2]
 – Ulrich Boser, 'This is No "Thomas Crown" Affair', 2010

In his novel *Open Doors* (2008), Ian Rankin weaves together elements taken both from recent art crimes and from commonly held ideas about them. He creates a complex narrative that includes the compulsive desire to possess works of art, the use of art as collateral in drug deals, the fooling of experts in making forged copies of paintings, the rivalry between detectives and the notion of liberating art from its apparently neglected status in the stores of public collections.[3] The story is packed with trickery, double-crossing, gangsterism and the interplay between a well-regarded professor of art, a bored self-made millionaire, a restless bank executive, a violent gang leader

and an impoverished art student. The book cleverly explores what the value of art might be to the different participants – how much it is worth to a connoisseur or to a drug-dealing gang leader. It acknowledges the filmic quality of a well-planned heist, making references to *The Lavender Hill Mob* (1951), *The Thomas Crown Affair* (1968 and 1999) and the *Ocean's Eleven* series, while also mentioning the attack in 2008 on the E.G. Bührle Collection in Switzerland. The plot assumes a close connection between what is fictional and what is real.

Although most of the story is credible, the lack of sufficient security at a national museum's storage facility is unconvincing, as also is the willingness of two businessmen to be inveigled into the heist plot such that they become primary perpetrators. But as the novel progresses the level of discomfort suffered by protagonists through the possession of stolen art pieces becomes more intriguing for the reader. Rankin's novel suggests that living with 'hot' paintings is highly problematic, countering the popular conception of hidden collectors commissioning the theft of art for their private enjoyment. Overall, the book touches on many of the questions that have emerged from actual art crimes in recent decades.

When the two recovered Turners were put back on display – on 7 January 2003 at Tate Britain – various puzzles remained.[4] The Turner case had particular complications because part of the insurance monies had been used as a fee for information leading to the recovery of the paintings. More information was made available when the Charity Commission decided in 2007 that the Tate could use the remaining insurance monies (some £15 million, after re-purchasing the title to the paintings from the insurers in 1998) for purposes related to the Collection as a whole, rather than exclusively to the Turner Bequest. This book now offers considerably more detail, although several questions remain unanswered. Could the robbery have been avoided, and with it eight and a half years of investigative work? Would closer regulation of works of art in circulation, and the more widespread use of a single database for stolen works, such as an extended version of the Art Loss Register, reduce the incentive for thieves to steal? Should there be tighter and more widely accepted limits on the use of rewards and fees for information in the recovery of stolen art? While there is little slowdown in the rising prices paid for the most

valuable works of art, and museums wish to make their collections ever more accessible, can art theft actually be prevented? Is David Lee, editor of *The Jackdaw*, correct in his pessimistic view that: 'The very practice of putting great masterpieces where people get close enough to see them means we must accept the inevitability of major thefts'?[5]

Since the Turner theft in 1994 there have been a number of shocking high-value thefts, some described in this book. Criminals are targeting very expensive works by well-known artists, through threatening violence, as in the spate of thefts in Switzerland in February 2008, or through the occasional exploitation of apparent lapses in security, as in the Musée d'Art Moderne robbery of May 2010 in Paris. In the same period attendance at art museums has grown, and loan exhibitions of contemporary and historic art have enjoyed increasing media interest and success. Art museums have become more open, more welcoming to families and children, and more enterprising in their shops, cafés and restaurants. This has provoked criticism from some – that museums have lost interest in scholarship and are neglecting the central purpose of caring for their collections. Such debates are a necessary part of the discussion of institutional purposes and priorities, yet it is already clear that to combat art crime museums and heritage sites will need to pay more attention, not less, to security, as well as, crucially, being willing to work with others and share sensitive information about criminal threats. And in a period of considerable pressure on all public institutions, there may be difficulties in keeping up levels of security staffing. If market prices for art remain at astronomic levels, however, the basic criminal incentive will remain strong.

As Julian Radcliffe, founder of the Art Loss Register, put it:

> If you go to a bank and try and steal $50 million that is very, very difficult because the security is so good. So where can you see $50 million on the wall and have a chance of removing it? Answer: in the art world, in museums or private galleries. For criminals (and there is a macho element amongst them) that is a very tempting target, even if they know that the realizable benefit to them may only be $250,000, below 10 percent, but still a good night's haul.

The controlling minds are criminal businessmen. As it has become more difficult to steal money, because of bank security, and more difficult to move money around the world, because of money laundering regulations, so art and diamonds have become more attractive.[6]

However many new technologies (including more close-circuit TV cameras, motion sensors and such like) are used in addition to physical security, tension exists between the guarding of a collection and trying to make it more accessible. Despite the greater use of computer databases to track down stolen items, stolen art and antiquities have become an underworld commodity. There may be different levels at which criminals focus on art theft, but Vernon Rapley, ex-Head of the Art and Antiques Squad in London, comments on the changing interests in London:

> These criminals who are utilising art as a commodity are involved in drugs and all kinds of crime as well . . . This has developed at a low level with criminals watching 'The Antiques Roadshow' over the past twenty years and thinking 'Why am I breaking into a house and stealing the video recorder, when I could steal the Georgian candlesticks – they are not identifiable and I can sell them for ten times as much'.[7]

It is clear that whatever the different levels of value, this is a serious and continuing criminal business and needs concerted, shared and continuing efforts to combat it. Ex-Metropolitan police investigator Dick Ellis points to the double incentive for criminal organizers, handlers and thieves:

> They have shown that they can commit a sophisticated crime in a professional way and they know what they are going to do with the item once they have got it. This puts them in a very professional league. Anybody can do drugs, anybody can do armed robberies . . . but start trading in high-value art and it sets you apart a bit.[8]

A contentious and unresolved issue in the pursuit of stolen art relates to the use of payments for information and the offer of a reward in the process of recovering works. The trial in Scotland in 2010 of those lawyers and investigators who had sought a reward payment for the Leonardo da Vinci painting stolen from Drumlanrig Castle in 2003 (which they had not stolen, but obtained from intermediaries) demonstrated the uncertain line to be drawn between seeking a fair recognition for a public service in returning a great work of art and potentially extorting money from the owner by refusing to return it until a sum is agreed as a reward. Those charged alleged that they were simply negotiating in the process of legitimately claiming the reward. This was challenged by the prosecution, but the jury concluded that the accusations against the men were 'not proven'.[9]

Offering rewards or paying for information leading to recovery, like the use of registered informers, is part of police practice and distinct from an individual or institution simply offering to buy back a stolen work. Rewards, however, need great care as to the conditions under which they should be paid to ensure that they do not benefit criminals involved in a robbery. For Dick Ellis extreme caution is required:

> If you offer a reward, you will encourage information; that has been shown to be the case time and time again. But you have to understand the motivation of the person giving the information. Criminals will use that offer of a reward to try and sell the stolen property back . . . However, if you can be certain enough that that person wasn't directly involved in the commissioning of the crime or dishonest handling, then arguably it is safe to pay them a reward.[10]

Many take a hard line and argue that any kind of payment is bad in principle, and comparable to human hostage cases where any payment is seen as wrong, since it encourages more hostage taking. Vernon Rapley sees certain payments as a potential obstruction to combating art theft:

We should not negotiate with these people. That is the only way to go forward. Because the great majority of these offences are committed for exactly that reason ... On an international basis we have to declare that the buying back or the payment for the return of stolen goods must be stopped. A reward, which is subject to proper conditions, and leads to a successful conviction, still has a place – but that is the practice in this country, whereas in some countries they are willing to pay for the return of stolen property with very few further questions being asked. And it is continually tried here.[11]

Julian Radcliffe firmly condemns payments and is particularly conscious of the parallels with hostage negotiations since he set up a specialist international company, Control Risks, to deal with hostage taking before developing the Art Loss Register. As in hostage work, Radcliffe takes the view that additional legislation is not required, but he is keen to develop a wider public policy framework through which a common accepted standard for the processes and means of pursuing high-value works can be agreed. 'I am utterly opposed to large sums of money being put on the table. However, to say that a reward may be paid, but without mentioning a sum and emphasizing that it will only be after recovery and/or conviction is an important part of public policy principles.'[12]

In recent years the greater use of databases in the recovery of stolen art has been enabled through new technologies as well as increased international coordination. In a trans-national field, thieves and handlers should be prevented from trading in any kind of black market. Questions, however, remain as to whether databases really deter criminals: could a single database covering all kinds of art and antiquities be established, and would there be international agreement for its use and support? Currently, databases are split between information held in the public sector, such as the Metropolitan Police, Europol and Interpol databases, and those offered on a commercial basis, such as the Art Loss Register.[13]

Julian Radcliffe sees the Art Loss Register as potentially the centre of a public–private sector partnership that could give it wider

spread and greater use.[14] He argues that the development of databases has had a positive impact across the art market as a whole:

> By my estimate stolen art is only 2–3% of the art trade in turnover, but may be about 15% of the total profits. When we started [in 1991] one in 7 to 9,000 lots might be stolen material and consigned by someone probably close to the thief. Now the number has dropped. Even though our database is infinitely bigger and is now steady at around 250,000 items – then we only had 20,000 items on the database – things are now different. Firstly because procedures have tightened up, and secondly because the things that are getting to auction houses such as Sotheby's or Christie's are later in the life of the item, so traders are getting a higher price lower down and they are almost always being consigned by good faith purchasers. We are also doing more work before something comes to a sale; so our searching [to check for stolen works] is permeating down the transaction chain.[15]

Others, like Vernon Rapley, are more sceptical and also look to wider institutional cooperation.

> A really good database won't deter high level crimes. But it would deter the mid-level art thefts. The Art Loss Register has a £5,000 threshold – which is about right. Trying to deal with things below that level is too difficult. It would definitely reduce the saleability of those objects between £5,000 and half a million and could make a difference. Anything over a million is stolen for a different purpose.
>
> There is not enough cooperation and intelligence sharing between police forces. In the UK you still have this ridiculous situation where forces do not speak to each other enough, as well as needing to talk more to Customs. Internationally there is a huge amount of intelligence which should be fed to Interpol and then fed out to various member states, and we are as guilty in Britain as anyone else.[16]

A related question is whether works of art, like cars, could have registration documents – the equivalent of a passport that would be required for all transactions and international loans of works above a certain value – or whether this would impose too heavy a burden on the art market and the museums sector. As head of a large insurance company, Robert Hiscox sees the need to have a working system that is more comprehensive:

> At the moment we have about three loss registers, and each of them is not quite good enough. We ought to have one really comprehensive, international, online register of lost or stolen art. I have argued that we should also have a positive register. Every work of art sold should have a certificate, like the log book of a car, which certifies that it is that work. I proposed a scheme about 35 years ago but the art trade hated it . . . The dealers like the 'fluidity' of provenance and the ability to 'alter' paintings. The art market is the last great unregulated market where huge values are traded with no controls.[17]

The argument that Interpol should be the central agency to oversee a single more complete database is very strong.[18] If there was to be a public–private sector partnership then Julian Radcliffe regards Interpol's work as a framework for future international cooperation:

> We attend the Interpol Annual Meeting, and the Art Loss Register gives a lot of very good intelligence to the police in many different countries through Interpol. The art trade wants to go to one place, as saying to a dealer you have to check eleven different databases is impossible . . . I always say that the Art Loss Register is not necessarily sufficient but it is necessary.[19]

Future Perfect

The theft of the Turners in Frankfurt, and equally the theft of the five modern paintings from the Musée d'Art Moderne in Paris, were possible because of apparent lapses in security that allowed criminals

to take advantage. Physical security, surveillance systems, sufficient and trustworthy staff – day and night – all play a part in keeping high-value works secure in public museums and galleries. It may be harder to have comprehensive systems in country houses or in commercial galleries, but the risk may necessitate the expenditure. But compared to the amount of high-value art that is transported and displayed in public exhibitions worldwide, the losses, however distressing, are relatively few. That does not make any of them acceptable. Robert Hiscox takes the view that: 'The overall record of museums of maintaining, looking after, and holding works of art is actually incredibly good. The occasional thefts from museums are very small in relation to the immense value of so much art within reach of so many people.' He worries, however, for the future:

> In insurance underwriting you have to balance your books and there is no way we are getting in enough overall premium income to cover what will one day be an enormous loss when an aeroplane full of valuable art crashes, let alone if it lands on MOMA. There is a huge catastrophe waiting to happen. So we really do it for the love and to enable exhibitions to happen. The only way to get museum premiums down is by not having Tate-type [in Frankfurt] thefts ... But basically the premiums are extraordinarily cheap and the exposure we all face is huge.[20]

In addition to its role in promoting an international database, Interpol has set out a number of uncontentious but demanding propositions on their website. If they could all be implemented then their combined effect would be to raise standards and shift institutional thinking. Much is based on circulating information and encouraging the sharing of skills and knowledge; other elements demand considerable resources.

Interpol proposes that at the national level, countries should:

- Bring in laws to protect cultural heritage and regulate the art market
- Become party to international conventions, with reference to the 1970 UNESCO and 1995 UNIDROIT Conventions

- Prepare inventories of public collections using standards that make it possible to circulate information in the event of theft
- Develop a computerized database along the lines of those currently in use, to avoid duplication of effort
- Circulate information on thefts as rapidly as possible
- Raise public awareness with regard to the cultural heritage both in the country and abroad
- Set up specialized police units to tackle this type of crime
- Hold training courses for the police, other law-enforcement services and customs, with the support of cultural institutions

That owners of cultural property should:
- Compile inventories of collections using common standards with photographs and exact descriptions of each object
- Make objects easily identifiable (by marking by the owner or by a specialist company)
- Protect the premises where the collections are held
- Report thefts immediately to the police or other law-enforcement authorities and provide them with a full list of stolen items together with photographs

That those in the art and antique trade should:
- Take extreme care when purchasing items and use all available means to satisfy themselves as to their origin
- Refuse to buy objects without adequate documentation as to their origin[21]

Given that it is not likely that all these proposals will be implemented, what are the critical elements that would create a breakthrough in preventing both general and high-value art theft? For the general level, Radcliffe focuses on two crucial areas:

First, if the whole of the art trade searched as diligently as second-hand motor dealers did, the recovery rate for stolen art would go up from what is at best 15% of stolen items recovered after 20 years, to perhaps 60–70% recovered after just 10 years. We could never recover the last 20% as these works are probably destroyed, damaged, hidden or lost. But if you really want to stop the theft of art the way to tackle it

is to prevent its resale, and you could prevent its resale for anything except tiddlywinks money if the whole art trade checked their goods properly. In other trades they do this happily and routinely, while we only have the top of the art trade searching, not the whole art trade.

Secondly, all losses must be reported to the police. Many losses are not reported to the police because of tax and family disputes: a lot of stuff goes on below the radar. All losses have to be reported to the police and have to be reported to a central database by the insurers, by the police, by whoever. If we had complete searching and a complete database then the incidence of losses would drop dramatically.[22]

Dick Ellis, however, regrets that organizational development and cost cutting in the police service have had unintended effects, which now have to be overcome in the UK to achieve proper coordination:

It is tragic what has happened. When the national crime intelligence service was formed, which grew to become the national crime squad, and is now superseded by the serious and organised crime agency, they just looked at the top ten target criminal interests: terrorism, people trafficking and such like, the most serious crimes committed by the most serious people. And if you are not on their target list they are not looking at you. Nobody was watching the people committing burglaries and art theft of a very organised nature. They were given free rein because they weren't serious enough to be dealt with at a national level, and yet they were too serious for individual constabularies, who were getting key performance indicators all about reducing 'bulk' crime within their constabulary. They were not going to spend huge resources focusing on one or two burglaries, even if they were very high value ones, when they could be clearing up thirty crimes on a council estate by arresting teenagers.[23]

Alongside the questions of communal responsibility, Mark Dalrymple has emphasized the sense of communal loss: 'The sad thing

is that criminals are stealing from all of us, for their own financial greed. They are taking things away from us, especially if it is from a museum within the public domain. The Turners were part of our heritage, and I felt this enormously.'[24]

* * *

Whatever the practical considerations of preventing art theft for both general and high-value items, there are wider considerations of what makes up the field of investigation. The fictions that surround art theft are evidently hard to displace. Certain clichés, such as the dashingly debonair art thief and the secret criminal collector, appear to be endlessly renewed in the popular imagination through films, television and detective fiction. They are part of the surrounding culture within which thieves operate, even though in reality their work is not glamorous. Status has some place in criminal motivation but the desire is predominantly financial, linked to the high and rising market values for the rarest antique objects and the most sought-after works of art. A conundrum remains that for 'priceless' paintings and sculptures, revered for their apparently timeless qualities, there is a price at which they can be exchanged, involving stupendous amounts of money. Such works have a market position but, if stolen, will have an alternative value when used as collateral or exchanged as a commodity among criminals. Art is then an underworld currency.

It is necessary to recognize both the unhelpful myths and the brutal realities of high-risk thefts as they are undertaken. The response from museums should be set within an appropriate ethical framework, working in close cooperation with the police authorities and international cultural agencies with the intention of sharing experience between museums and galleries. In constrained times, resources will always be limited. Policy guidelines are needed that can reinforce higher standards for the processes of recovering stolen art and antiquities, combined with a single international database and specialist police squads in individual countries. If this agenda is promoted with greater energy and determination and with a broad sharing of knowledge and skills, then the story of high-value art theft could end with a better result. Artists create great works of art as

a proposition for a better world, and the passion of those running public galleries is to further that creativity. In the future, thwarting criminal activities may need to be a more prominent part of this work. Light and colour must overcome shade and darkness.

References

Introduction

1 William Shakespeare, *Much Ado About Nothing*, Act IV, Scene I, Line 220.
2 Few inventory reviews are quite as devastating as the losses at the Hermitage Museum in St Petersburg; see www.aolnews.com/2010/09/19/russia-admits-staggering-losses-of-museum-items/ (accessed 7 January 2011); see also Dario Gamboni, *The Destruction of Art: Iconoclasm and Vandalism since the French Revolution* (Chicago, IL, and London, 2007).
3 For estimates of this growth, see Thomas D. Bazley, *Crimes of the Art World* (Westport, CT, 2010), pp. 44–8.
4 Quoted by Deborah Gage, 'Art Thefts through History', paper contributed to the AXA Art conference, *Rogues Gallery: An Investigation into Art Theft*, British Museum, London, I November 2005. The Interpol website is itself very careful not to offer a definitive answer to this question: 'We do not possess any figures which would enable us to claim that trafficking in cultural property is the third or fourth most common form of trafficking, although this is frequently mentioned at international conferences and in the media. In fact, it is very difficult to gain an exact idea of how many items of cultural property are stolen throughout the world and it is unlikely that there will ever be any accurate statistics': www.interpol.int (accessed 22 August 2010). There is also much evidence that the bulk of this is cultural artefacts and antiquities, rather than fine art; for an attempt to assess the scale of the problem, see Bazley, *Crimes of the Art World*, chapter Six.
5 An equally bold and filmic theft involved the loss of paintings worth $163 million when they were stolen from the Emile Bührle Foundation in Zurich on II February 2008 – the largest ever robbery in Switzerland. A man burst into the entrance hall waving a handgun and instructed both visitors and staff to lie on the floor. His accomplices went into the main exhibition hall and removed four oil paintings by Cézanne, Degas, Van Gogh and Monet. Although in many ways the attack was neat and well ordered, a witness reported the car boot to be open and the paintings visible. Two of the paintings were recovered within a week; as of January 2011 the other two are still missing.

6 Roger Bayes, 'Thieves Hold £20m Paintings to Ransom', *The Times* (2 January 2001), p. 6.

7 Richard Ellis, 'Investigating Stolen Art: The Reason Why', paper contributed to the AXA Art conference *Rogues Gallery*: www.axa-art.co.uk/ sps/richard_ellis.pdf (accessed 4 February 2008).

8 Ibid.

9 See Simon Houpt and Julian Radcliffe, *The Museum of the Missing: A History of Art Theft* (New York, 2006), pp. 105–12.

10 Peter Watson, 'Stolen Art: The Unromantic Truth', *The Times* (29 August 2003).

11 See John E. Conklin, *Art Crime* (Westport, CT, 1994).

12 Michel van Rijn, *Hot Art, Cold Cash* (London, 1994); he previously ran a website, offline as of 1 September 2010: www.michelvanrijn.nl/

13 Quoted by Conklin, *Art Crime*, p. 142.

14 The *Mona Lisa* clearly achieved even greater worldwide fame after its theft in 1911 and recovery in 1913. Given that they remain in public collections, it is hard to determine whether the thefts (and recoveries) of the two versions of *The Scream* in 1994 and 2004 actually increased their financial value, but they certainly confirmed the iconic status of the paintings.

15 Particularly Bonnie Burnham, *The Art Crisis* (London, 1975), p. 13.

16 See, for instance, Burnham, *The Art Crisis*; see also *Trace*, the journal published for the Trace organization, and the Art Loss Register. For a summary of the setting up of specialist police squads, see Bazley, *Crimes of the Art World*, chapter Nine.

Chapter 1: Loss

1 Interview with Mark Dalrymple, London, 29 June 2007.

2 Evelyn Joll, Martin Butlin and Luke Herriman, eds, *The Oxford Companion to Turner* (Oxford, 2001), p. 382.

3 A. J. Finberg, *The Life of J.M.W. Turner* (Oxford, 1965), p. 440.

4 The question of loss and memory is referred to by Geoff Dyer in an essay 'Tuner and Memory', in *Working the Room* (London, 2010), p. 99; available at www.tate.org.uk/tateetc/issue16/forgetmenot.htm (accessed 27 January 2011).

5 Gerald Finley, *Angel in the Sun: Turner's Vision of History* (Montreal, 1999), p. 205.

6 Ibid., p. 200.

7 Quoted in the catalogue entry on the Tate website: www.tate.org.uk/ servlet/ViewWork?cgroupid=-1&workid=14788&searchid=25070 (accessed 14 July 2007).

8 Turner appears to have been secretive about much of his life, as exemplified by James Wilson in *The Dark Clue* (London, 2001), an historical novel principally composed of the enterprise of writing a biography of Turner.

9 Nick Powell, 'Finance and Property', in Joll, Butlin and Herriman, eds, *The Oxford Companion to Turner*, p. 107.

10 Ibid., pp. 441, 452.

11 Ibid.

12 Martin Butlin and Evelyn Joll, *The Paintings of J.M.W. Turner* (New Haven, CT, and London, 1977), p. 230.

13 Finley, *Angel in the Sun*, p. 203.

14 Peter Gillman and Leni Gillman in the *Sunday Times* magazine (26 January 2003), p. 42.

15 Interview with Mark Dalrymple, London, 29 June 2007.

16 It may seem odd that the collections are not insured, but it has long been a view of government that it is better value to protect the national collections in every possible way and to take the risk of something going missing or being damaged, rather than pay vast premiums to commercial insurers. In this sense, national collections are sometimes referred to as self-insured.

17 Brian Sewell, 'Do We Really Want the Stolen Turners Back?', *Evening Standard* (25 August 1994), p. 30.

18 Interview with Nicholas Serota, London, 1 June 2007.

19 Interview with Alex Beard, London, 13 June 2007.

Chapter 2: Pursuit

1 Interview with Mark Dalrymple, London, 29 June 2007.

2 Mark Dalrymple, summary memorandum to the Tate, 7 August 2003.

3 Sandy Nairne, memorandum, *Theft of Turner, N00531 and N0532, from Shirn Kunsthalle Frankfurt 28/7/94*, Tate Archive.

4 Interview with Jurek Rokoszynski, London, 18 June 2007.

5 Report, 'Gründei' [Reasons], 1998, from the Frankfurt Police Service, courtesy of the journalist Peter Gillman.

6 Ibid.

7 Interview with Mark Dalrymple, London, 29 June 2007.

8 Peter Woolrich, 'The Art Hunter', *Reader's Digest* (March 2006), p. 68.

9 Michael Lawrence, letter to Alex Beard, 17 January 2003, Tate Archive.

10 Mark Dalrymple, letter to Sandy Nairne, 27 January 1998, Tate Archive.

11 Lawrence, letter to Beard, pp. 4–5.

12 Tate Press Release, dated November 2000.

13 Geoffrey Robinson, 'The Strange Tale of the Serbs, the Turners and Tate Modern', in *The Unconventional Minister* (London, 2001), pp. 165–9.

14 Ibid., p. 166.

15 Interview with Robert Hiscox, London, 25 September 2007.

16 Dennis Stevenson, Chairman of Tate Gallery Trustees, 1988–98; quoted in Robinson, *The Unconventional Minister*, p. 168.

17 Notes to the Trustees' Meeting, June 1998, Tate Archive.

18 Robert Graham, fax to Alex Beard, 7 July 1998, Tate Archive.

19 Interview with Alex Beard, London, 13 June 2007.

20 The agreement expired on 28 July 1999, so Mark Dalrymple's new information arrived three days after this.

21 Interview with Robert Hiscox, London, 25 September 2007.

22 Interview with Jurek Rokoszynski, London, 18 June 2007.

23 This was confirmed in a fax to Rocky on 30 September 1999, Tate Archive.

24 Mark Dalrymple, note to Tate, 7 August 2003, Tate Archive.

25 Interview with Mark Dalrymple, London, 29 June 2007.

26 Interview with David Verey, London, 14 August 2009.

27 Richard Hartman, DCMS, to Alex Beard, 27 August 1999, Tate Archive.

28 Edgar Liebrucks to Tate, 14 October 1999, Tate Archive.

29 Metropolitan Police Service, letter to Nicholas Serota, 10 December 1999, Tate Archive: 'Were this to be a 'buy-back' the MPS could not support this proposition. However, crucially, the German prosecutor has stated that, should such a transaction go ahead, he will make every effort to recover the monies by tracing and prosecuting offenders. In other words, money is required to fund a German law enforcement operation to recover paintings. The operation, as proposed, entails a handover of money for goods and attracts a high risk that the money will not be recovered subsequently. . . . It is our belief that this represents a genuine opportunity to recover the paintings and that it is not possible further to negotiate the amount requested.' A paper for the Tate, dated 13 December, 'Payment to Recover the Tate Gallery Turner paintings' by Mark Dalrymple, gave further reassurance on the legality and appropriateness of the arrangements.

30 I was later filmed for a German documentary on the case (made by Edmund Koch and re-edited for a screening on BBC Two under the title *Underworld Art Deal*, 9 November 2005) and, while making clear that no ransom payment was made, said that 'a reward initially offered by the insurers might need to be enhanced'. This caused criticism of the Tate, through the inference that a reward *was* paid, when the authorized arrangement was simply the payment to the authorized lawyer, Edgar Liebrucks.

31 Interview with Jurek Rokoszynski, London, 18 June 2007.

32 Confusingly, in April 2000 something unexpected popped up on my computer. A character called 'Alberto G' got in direct contact with me by email and claimed to have images of the paintings. He was working with a Spanish lawyer. But despite the interest I showed, the images never materialized, nor did we manage to trace whether he was connected.

33 Roy Perry, 'Report on the Photographs of Polaroids Purported to be of the Front and Backs of J.M.W. Turner N00531 . . . and N00532', 11 April 2000, Tate Archive.

34 The order was clear about total confidentiality: '[. . .] 7 The publication of (i) this Order and (ii) what took place in Chambers before the Judge (save only for the disclosure of this Order and of what took place to the Charity Commissioners and to other such persons as may be agreed between the parties) be prohibited'.

35 The Sub-Committee had met on an occasional basis and ensured that the operational decisions that I made, under Nicholas Serota's authority as Director of Tate, were within the overall guidance and policy of the Tate Trustees.

36 Minutes of a Meeting of the Special Committee of the Board of Trustees of the Tate Gallery held at 8.30 a.m. on Thursday, 25 May 2000, Tate Archive, p. 2.

37 Edgar Liebrucks, email to Sandy Nairne, 30 June 2007.

38 Letter from Barclays Bank to J. Rokoszynski, 14 July 2000.

Chapter 3: Recovery

1 In a 'Diary' piece in the *London Review of Books*, Adam Reiss notes about police officers: 'Used to spending lots of time waiting around for things to happen, they're addicted to banter and very good at sustaining it; they're both respectful and resentful of authority; they have a strong sense of moral purpose and duty and a millenarian view of the world – for many, the barbarians are at the gate.' *London Review of Books* (18 November 2010), p. 38; or www.lrb.co.uk/v32/n22/adam-reiss/diary (accessed 9 January 2011).

2 Quotation translated from Edgar Liebrucks, letter to Sandy Nairne, 21 July 2000, Tate Archive.

3 Interview with David Verey, London, 14 January 2009.

4 Nigel Rosser, 'Closing in on the Stolen £24m Turners', *Evening Standard* (24 November 2000), p. 10.

5 Ibid.

6 News item, *Art Newspaper* (February 2001).

7 Nick Hopkins, 'Mystery of Stolen Turners Deepens as Conmen Try To Pass off "Awful" Copies', *Guardian* (23 April 2001), p. 9.

8 Ibid.

Chapter 4: Return

1 Julian Bell, *What is Painting?: Representation and Modern Art* (London and New York, 1999).

2 Dr Sabine Schulze, letter to Sir Nicholas Serota, 20 December 2002, Tate Archive.

3 The Caspar David Friedrich painting was recovered in August 2003 and now hangs again in the Kunsthalle, Hamburg. See report in the *New York Times*: www.nytimes.com/2003/09/02/arts/arts-briefing-germany-stolen-art-returned.html (accessed 28 November 2010).

4 Carol Vogel, 'A Pair of Stolen Turners Are Returned to the Tate', *New York Times* (21 December 2002).

Chapter 5: Ethics

1 Lee Bollinger, Introduction to Joseph L. Sax, *Playing Darts with a Rembrandt: Public and Private Rights in Cultural Treasures* (Ann Arbor, MI, 1999).

2 Gail Anderson, Introduction to *Reinventing the Museum* (Lanham, MD, 2004), p. 1.

3 Even before the Tate occasion, my partner and I offered supper in

Kentish Town to Rocky, Mick, RL, Alex, Roy and a few others – I cooked
lemon flans with my 'painted' versions of the two paintings.

4 See an important work such as Colin Renfrew, *Loot, Legitimacy and
 Ownership: The Ethical Crisis in Archaeology* (London, 2000), and a North
 American-based bibliography compiled by Dr Hugh Jarvis at the
 University of Buffalo: http://wings.buffalo.edu/anthropology/
 Documents/lootbib.shtml (accessed 28 December 2010).

5 For a view of these changes, see Martha Lufkin, 'Legal Issues for
 Museums: The Hot Topics', *Art Newspaper* (May 2010), p. 24.

6 John Cotton Dana, writer and librarian, and founding director of the
 Newark Museum in New Jersey, originally published a pamphlet, *The
 Gloom of the Museum*, as part of 'The New Museum Series'; it is reprinted
 in Anderson, *Reinventing the Museum*, p. 25.

7 This much-derided phrase was originally used as part of an ironic
 marketing campaign for the V&A in London in 1988.

8 For the Tate Affair, see John Rothenstein, *Brave Day, Hideous Night:
 Autobiography, 1939–1965* (London, 1965); and Frances Spalding, *Tate:
 A History* (London, 1998). For David Hockney's attack on the Tate's
 acquisitions policy, see *The Observer* (4 March 1979).

9 See, for instance, Michael Daley's letter to the *Daily Telegraph* of 12 November
 2005: www.telegraph.co.uk/comment/letters/3620991/The-Daily-Telegraph-
 letters.html (accessed 28 December 2010).

10 See Hans Haacke, various catalogues; and Sandy Nairne, *State of the Art*
 (London, 1987).

11 Karl E. Meyer, *The Plundered Past* (New York, 1973), p. xv.

12 First published in the *Wall Street Journal* (12 December 2002); reprinted
 in *Museum Frictions: Public Cultures/Global Transformations*, ed. Ivan Karp et al.
 (Durham, NC, and London, 2006), p. 247.

13 The contrast with the very idea of the universal museum is the position
 of the 'community museum' (of which there are many examples, such as
 the District Six Museum in South Africa and any of the network of such
 museums in Mexico), where rights and issues of citizenship, as they
 affect visitors and supporters, are more likely to be featured than con-
 cerns about any universal notion of 'world heritage'; see *Museum Frictions*,
 Part Two, 'Tactical Museologies', p. 207.

14 Meyer, *The Plundered Past*, p. 132.

15 Marion True maintained her innocence throughout the five-year
 trial, which was stopped in October 2010 through the application
 of the statute of limitations. See *Art Newspaper* (January 2011),
 pp. 8–9.

16 The Department for Culture, Media and Sport had in 2001 created a
 panel led by Lord Alan Howarth to advise it, and the changes in the case
 of the national museums were given legal authority by Section 47 of the
 Human Tissue Act of 2004.

17 As reported on the BBC News website, 18 November 2006. The Natural
 History Museum decision was announced on 17 November 2006; see
 www.nhm.ac.uk/about-us/news/2006/november/news_10019.html

(accessed 18 August 2007). The museum holds 19,950 human remains specimens, of which only 54 per cent are from the UK.

18 All UK national museums have (since 1998) participated in the Spoliation Project to check the provenance on works that could in the twentieth century have been stolen or appropriated under duress from Jewish families by the Nazis. Museums also now ensure that they check on the provenance of works that they borrow for temporary exhibitions (in order not to add legitimacy or value to works if they have a crime-linked history).

19 Richard Ellis, 'Investigating Stolen Art: The Reason Why', contributed to the AXA Art conference, *Rogues Gallery: An Investigation into Art Theft*, British Museum, London, 1 November 2005; published on AXA Art website: www.axa-art.co.uk/Content.asp?IDAREA=5&TIPO=A&IDCONTENT=361&C=1 (accessed July 2008).

20 Nigel Reynolds, 'How Tate Laid Money Trail To Recover Turners', *Daily Telegraph* (5 November 2005), p. 3; *Underworld Art Deal* (by Egmont R. Koch and Nina Svensson) was broadcast on Wednesday, 9 November 2005, at 1900 GMT on BBC Two.

21 Interview with Jurek Rokoszynski, London, 18 June 2007.

22 Interview with David Verey, London, 14 January 2009.

23 Interview with Nicholas Serota, London, 1 June 2007. He also commented on the Trustees' Sub-Committee: 'I do think that Tate was fortunate in having available for advice David [Verey] and Christopher [Mallaby], a senior banking figure and a senior diplomatic figure, both of them in different spheres but highly experienced in complex, international negotiations, which had to be conducted under highly confidential conditions, and where the nature of the transaction was "unusual". In different ways they were both of very considerable assistance.' I took the same view.

24 Nigel Reynolds, 'Tate Comes Close to £3m Ransom Confession', *Daily Telegraph* (21 December 2005), p. 9

25 Charlotte Higgins, 'Tale of Intrigue behind Tate Britain's Recovery of Stolen Turners Revealed', *Guardian* (21 December 2005), p. 9. In a later account of the case in the *Reader's Digest*, 'The Art Hunter' (March 2006), pp. 66–75, Peter Woolrich describes how Rocky watched cash for the first painting being counted in the bank and comments that 'Rocky didn't even want to know where the lawyer took it.' The point is simply that the pursuit was the responsibility not of Rocky or the Tate but of the Frankfurt authorities themselves.

26 Roger Pearce, letter to Nicholas Serota, 10 December 1999, Tate Archive; also quoted in Jack Malvern, 'Tate Paid £3.2 Million "Reward" for Art Return', *The Times* (21 December 2005), p. 13.

27 Reynolds, 'Tate Comes Close to £3m Ransom Confession', p. 9.

28 Higgins, 'Tale of Intrigue', p. 9.

29 Interview with Alex Beard, London, 13 June 2007.

30 Interview with Mark Dalrymple, London, 29 June 2007.

31 Interview with Jurek Rokoszynski, London, 18 June 2007.

32 Sonia Purnell, article in *Evening Standard: ES Magazine* (6 June 2003), p. 38.

33 Mark Dalrymple, 'Virtue Has Its Own Reward: The Law and Practice of Rewards to Recover Stolen Art', *Rogues Gallery*: www.axa-art.co.uk/ Content.asp?IDAREA=5&TIPO=A&IDCONTENT=361&C=1 (accessed July 2008).

34 Mark Dalrymple, 'Payment to Recover the Tate Gallery Turner Paintings', paper dated 13 December 1999, Tate Archive.

35 Interview with Dick (Richard) Ellis, London, 16 December 2008.

36 Interview with Vernon Rapley, London, 21 May 2010.

Chapter 6: Value

1 Steven Connor, 'The Necessity of Value', in *Principled Positions: Postmodernism and the Recovery of Value*, ed. Judith Squires (London, 1993), pp. 31–49.

2 Robert Wraight, *The Art Game* (New York, 1966), p. 14.

3 John Conklin, *Art Crime* (Westport, CT, 1994), p. 12.

4 John Fekete, *Life After Postmodernism* (New York, 1987), quoted by Connor, 'The Necessity of Value'.

5 Ibid., p. 189.

6 James Elkins, *Pictures and Tears: A History of People Who Have Cried in Front of Paintings* (London and New York, 2001), p. ix.

7 Ellen Dissanayake, *What is Art For?* (Seattle, WA, and London, 1988), p. 73.

8 See particularly the analysis by the anthropologist and philosopher Pierre Bourdieu, *The Field of Cultural Production* (London, 1993) and *Rules of Art: Genesis and Structure of the Literary Field* (Stanford, CA, 1996).

9 Text of Walter Benjamin's essay of 1936, 'The Work of Art in the Age of Mechanical Reproduction', is available at www.marxists.org/reference/ subject/philosophy/works/ge/benjamin.htm (accessed 30 December 2010); John Berger, *Ways of Seeing* (London, 1972).

10 Arthur Rosett, Attorney for the US Government, in a case involving returning a Paul Klee work stolen in California and then illegally sold to a German public museum, February 1963. Quoted by Milton Esterow in *The Art Stealers* (New York, 1966), p. 37.

11 William D. Grampp, *Pricing the Priceless: Art, Artists and Economics* (New York, 1989), p. 9.

12 Ibid., pp. 54–5.

13 Ibid., p. 38.

14 Ibid.

15 See Bourdieu, *The Field of Cultural Production* and Bourdieu, *Rules of Art*.

16 Jonathan Leake and Elizabeth Gibney, 'High Price Makes Wine Taste Better', *Sunday Times* (13 January 2008), p. 9.

17 Anna Somers Cocks, 'Why We Like Art Less When Its Price Is Going Down', *Art Newspaper* (13 March 2008); online at: www.theartnewspaper. com/article.asp?id=7645 (accessed May 2008).

18 George Dickie, *Art and Value* (Oxford, 2001), p. 107.

19 Robert Stecker, *Artworks: Definition, Meaning, Value* (Universtiy Park, PA, 1997), p. 257.

20 Barbara Herrnstein Smith, 'Contingencies of Value', in *Critical Enquiry*, X (1983), p. 11; see also 'Value Without Truth-Value', in Fekete, *Life After Postmosdernism*, pp. 1–21; Barbara Herrnstein Smith, *Contingencies of Value: Alternative Perspectives for Critical Theory* (Cambridge, MA, 1988); and Pierre Bourdieu, *Distinction: A Social Critique of the Judgement of Taste* (Cambridge, MA, 1984).

21 Herrnstein Smith, 'Contingencies of Value', p. 23.

22 Gerald Reitlinger, *The Economics of Taste* (London, 1961), p. xii.

23 Geraldine Keen, *The Sale of Works of Art* (London, 1961), p. 26.

24 The term blue chip derives from gambling in casinos, where blue is the counter of the highest value.

25 Grampp, *Pricing the Priceless*, p. 127.

26 Willi Bongard's 'Compass' was the first 'top 100' list in the art world; he also published *Kunst und Kommerz: zwischen Passion und Spekulation* (Oldenburg, Hamburg, 1967).

27 There are many sources for these examples; the conversion to present-day equivalent values is courtesy of Lawrence H. Officer and Samuel H. Williamson, *Purchasing Power of Money in the United States from 1774 to 2009*, MeasuringWorth, 2010: www.measuringworth.com/ppowerus/; see also http://en.wikipedia.org/wiki/List_of_most_expensive_paintings (both accessed 12 July 2010).

28 Judith Benhamou-Huet, *The Worth of Art: Pricing the Priceless* (New York, 2001), p. 10.

29 The economist Adam Smith remarked: 'With the greater part of rich people, the chief enjoyment of riches consists in the parade of riches, which in their eye is never so complete as when they appear to possess those marks of opulence which nobody can possess but themselves', in *An Inquiry into the Nature and Causes of the Wealth of Nations* [1776], Book One, Chapter XI (London, 1925), p. 173.

30 Charles W. Smith, *Auctions: The Social Construction of Value* (London, 1989), p. x.

31 Ibid., p. 80.

32 Ibid., p. 109.

33 Peter Wilson was consciously aiming to transform Sotheby's auctions into social events and had hired the publicists J. Walter Thompson to help with the Weinberg sale in 1957. According to Robert Lacey, an invitation was mistakenly sent to the Queen, a mistake since it was intended for *Queen* magazine. She could not attend the auction, but came to a preview because of her interest in Degas. Robert Lacey, *Sotheby's* (London, 1998), pp. 118–19.

34 'Testing the Highs', *Time* (22 October 1958): www.time.com/time/magazine/article/0,9171,937655,00.html (accessed May 2008).

35 Peter Wilson, talking to the BBC Third Programme, quoted in Wraight, *The Art Game*, p. 19.

36 James Stourton, Chairman of Sotheby's UK, commented that as the first black-tie occasion the Goldschmidt sale represented the birth of the 'event' auction and the start of international auctioneering, with

Americans selling French paintings in London, which at the time was radical. It was also the moment when Impressionists began to take over the market from Old Masters. And it represents the moment when the auctioneers took the advantage from dealers, since this oscillates between the two in the history of British collecting. Conversation with the author, London, 6 January 2011.

37 Smith, *Auctions*, p. 128.

38 Press Release, White Cube Gallery: www.whitecube.com/exhibitions/beyond_belief/ (accessed May 2008).

39 Rudi Fuchs, 'Victory over Decay', in *For the Love of God: The Making of the Diamond Skull* (London, 2007), p. 7; the book contains an analysis of the date and origin of the skull, together with an analysis of 'brilliant' diamonds and details of the craftsmen who worked on the piece.

40 Damien Hirst quoted in BBC News Online: http://news.bbc.co.uk/1/hi/entertainment/6712015.stm (accessed May 2008).

41 After display in London in 2007, it was displayed in Amsterdam in 2008, and then at the Palazzo Vecchio in Florence from November 2010 to May 2011, where it was publicized as being worth €100 million.

42 See analysis in Misha Glenny, *McMafia: Crime without Frontiers* (London, 2008).

43 Interview with Vernon Rapley, London, 21 May 2010.

44 Ibid.

Chapter 7: History

1 For a full analysis, see Thomas D. Bazley, *Crimes of the Art World* (Westport, CT, 2010).

2 For a full account of Adam Worth's life, see Ben Macintyre, *The Napoleon of Crime: The Life and Times of Adam Worth, Master Thief* (New York, 1997).

3 The painting has a long and complex history, having been lost in the late eighteenth century, re-emerging in the 1840s, having been cut down, and was then part of the Wynn Ellis collection, before being put up for sale in 1876.

4 'Stolen Gainsborough Has Been Recovered', *New York Times* (6 April 1901); see http://query.nytimes.com/mem/archive-free/pdf?res=F60811F7385414728DDDAF0894DC405B818CFID3 (accessed 7 September 2010).

5 Ibid.

6 Quoted by Darian Leader, *Stealing the Mona Lisa: What Art Stops Us from Seeing* (London, 2002), p. 66; for an overview of the theft and the stories relating to it, see also R. A. Scotti, *The Lost Mona Lisa* (London, 2009).

7 Leader, *Stealing the Mona Lisa*, p. 168.

8 Bonnie Burnham, *The Art Crisis* (London, 1975), p. 240; a similar argument had already been put forward in Robert Wraight, *The Art Game* (New York, 1966), pp. 19–28.

9 See Wraight, *The Art Game*, p. 178; Milton Esterow, *The Art Stealers* (New York, 1966); Keith Middlemas, *The Double Market: Art Theft and Art Thieves*

(Farnborough, 1975), chap. 5, p. 115; Hugh McLeave, *Rogues in the Gallery: The Modern Plague of Art Thefts* (Boston, MA, 1981), chap. 3, p. 42.

10 Middlemas, *The Double Market*, p. 98.

11 The Beits had purchased the house in 1952 and subsequently restored it.

12 'News and Updates', *IFAR Journal*, X/3 (2002), pp. 8–10. This journal, published in New York, is devoted to publicizing thefts and tracking stolen art.

13 The most complete account of the thefts is given in Matthew Hart, *The Irish Game* (London, 2004).

14 See also McLeave, *Rogues in the Gallery*, pp. 78–83.

15 See Paul Williams, *The General: Godfather of Crime* (Dublin, 1995); the film was released in 1998, directed by John Boorman. A second film, *Ordinary Decent Criminal*, starring Kevin Spacey, was released in 2000.

16 Michael Mulqueen, 'The Old Master and the Man They Called the General', *Independent on Sunday* (11 August 2002), p. 20.

17 Quoted in Hart, *The Irish Game*, p. 48.

18 David Lister, 'Rubens Stolen by Infamous Gangster Found in Dublin', *The Times* (8 August 2002).

19 Hart, *The Irish Game*, p. 135.

20 Ibid., p. 56.

21 Sir Alfred died in 1994 and Lady Beit in 2005. See 'Clementine, Lady Beit, Obituary', *The Times* (13 September 2005).

22 This theft took place on the fifth anniversary of the death of the investigative journalist Victoria Guerin, which may have been intentional.

23 Anthony Haden-Guest, *True Colors* (New York, 1998).

24 See Simon Houpt, with a foreword by Julian Radcliffe, *The Museum of the Missing: A History of Art Theft* (New York, 2006), p. 129. For a profile of the painting by critic Andrew Graham-Dixon, see: www.andrewgrahamdixon.com/archive/readArticle/99 (accessed 31 January 2010).

25 Myles Connor, quoted by Daniel Golden in 'Hot Art', *Boston Globe*, Sunday Magazine (12 February 1989).

26 John Conklin, *Art Crime* (Westport, CT, 1994), p. 129.

27 For the fullest account of the theft and the various investigations, see Ulrich Boser, *The Gardner Heist: The True Story of the World's Largest Unsolved Art Theft* (New York, 2009).

28 See Tom Mashberg, 'Stealing Beauty', *Vanity Fair* (March 1998), pp. 108–53.

29 See Myles Connor, *The Art of the Heist: Confessions of a Master Art Thief, Rock-and-Roller, and Prodigal Son* (London, 2009); his website, http://mylesconnor.com/, and http://www.youtube.com/watch?v=-W9iSSkYuDw (both accessed 7 September 2010).

30 See Ralph Blumenthal, 'Five Years and $300 million', *New York Times* (15 December 1994); Ed Butler, 'The Greatest Art Heist of Our Time', *The Independent* (7 August 2004); and Thomas McShane, 'The Heist of the Century', *The Independent* (11 April 2007): http://www.independent.co.uk/news/uk/crime/the-heist-of-the-century-444219.html (accessed 31 December 2010).

31 See Sandra Laville, 'Find Whitey', *Guardian*, Special Report (4 June 2007), pp. 10–11.

32 See Boser, *The Gardner Heist*, pp. 196–8.

33 Butler, 'The Greatest Art Heist of Our Time'.

34 Houpt, *Museum of the Missing*, pp. 125, 127, 142.

35 Robert Hughes, 'A Boston Thief Reflects', *Time* (2 April 1990).

36 This and other details are very well set out in a comprehensive account of the theft by Edward Dolnick, *Stealing the Scream: The Hunt for a Missing Masterpiece* (Cambridge, 2007).

37 Ibid., p. 224.

38 Ibid., p. 235; see also Simon Mackenzie, 'Criminal and Victim Profiles in Art Theft: Motive, Opportunity and Repeat Victimisation', paper contributed to the AXA Art conference, *Rogues Gallery: An Investigation into Art Theft*, British Museum, London, 1 November 2005, available at: www.axa-art.co.uk/sps/simon_mackenzie.pdf (accessed 14 November 2007).

39 Jonathan Jones, 'The Bigger Picture', *Guardian*, Weekend Supplement (17 February 2007), p. 37.

40 Bernard Levin, 'British Cool in the Face of a Scream', *The Times* (27 December 1995), p. 16.

41 Gwlady Fouché, Owen Bowcott and Jon Henley, 'A Blur of Balaclavas – and The Scream Was Gone Again', *Guardian* (23 August 2004), p. 3.

42 *IFAR Journal* (VII/ 2, 2004, p. 4) emphasized the unusual circumstance of such high-profile paintings being stolen with no ransom demand being made; see also Kris Hollington, 'Master Plan', *Guardian* (13 June 2005), available at http://arts.guardian.co.uk/arttheft/story/0,,1505351,00.html (accessed 14 November 2007).

43 Also reported in the *IFAR Journal*, IX/1 (2006), pp. 6–8; for a report on the conservation process, see: www.munch.museum.no/content.aspx?id=67&mid=2&lang=en (accessed 31 December 2010).

44 Picture framer Christian Meichler talking about Stéphane Breitwieser, in Ian Thomson, 'The Artful Dodger', *Sunday Times*, Colour Magazine (20 October 2002), p. 38.

45 Nathalie Ogli, 'Waiter Jailed for Art Theft Spree across Europe', *Guardian* (7 February 2003), p. 17.

46 Quoted by Alan Riding, 'Your Stolen Art? I Threw It Away, Dear', *New York Times* (17 May 2002), pp. 1 and 10.

47 Ogli, 'Waiter Jailed for Art Theft Spree'.

48 John Hooper, 'Connoisseur Turned Crook Who Plundered Europe's Galleries for the Simple Love of Art', *Guardian* (5 February 2003), p. 3.

49 Thomson, 'Artful Dodger', p. 37.

50 Defence lawyer Joseph Moser quoted in Amelia Gentleman, 'Woman Joins Art Thief Son in Dock', *Guardian* (7 January 2005), p. 15.

51 See http://en.wikipedia.org/wiki/Cellini_Salt_Cellar (accessed 8 September 2010).

52 See Ian Traynor, 'The World's Dearest Pinch of Salt Taken in 54 Seconds', *Guardian* (16 May 2003), p. 15. In retrospect, Breitweiser's motives look

less clear when it emerged in April 2011, following his previous prison sentence, that he was accused once again of stealing from museums.

53 Quoted in Houpt, *Museum of the Missing*, p. 82

54 Imre Karacs, 'Art Thief Leads Police to Buried £37m Salt Cellar', *Sunday Times* (22 January 2006), p. 23.

55 Roger Boyes and Bojan Pancevski, '£40m Salt Cellar Thief Is Caught by a Cocky Text', *The Times* (8 September 2006), and 'Happy Ending for Cellini's Saltcellar', *IFAR Journal*, VIII/2 (2005–6), p. 2.

56 Richard, then Earl of Dalkeith, is now the duke; see Michael Horsnell and Dalya Alberge, '£1m Reward for Return of Stolen Madonna', *The Times* (29 August 2003); see also 'Thieves Posing as Tourists Grab £60m Leonardo', *The Times* (28 August 2003).

57 See Godfrey Barker, 'Rich Pickings', *Sunday Times* (31 August 2003), p. 19.

58 Severin Carrell, 'Stolen Work by Leonardo Recovered after Four-year Hunt', *Guardian* (5 October 2007), p. 7.

59 *Daily Telegraph* (6 September 2007).

60 Severin Carrell, 'Five Not Guilty over Theft of £30m Da Vinci', *Guardian* (22 April 2010), p. 22. See also Severin Carrell, 'Pay £4m or the Leonardo Gets It: Lawyer Accused of Extortion over Stolen Painting', *Guardian* (2 March 2010), p. 3; Charlene Sweeney, 'Tour Guide Tells of Terrifying Man with Axe Stole Leonardo Painting', *The Times* (2 March 2010); and Lucy Bannerman and Charlene Sweeney, 'Private Investigators Cleared of Leonardo Extortion Plot Demand: "Where's Our Reward?"', *The Times* (22 April 2010).

61 See Arifa Akba, 'How Search for da Vinci Work Led Police to Solicitors' Office', *The Independent* (6 October 2007).

62 Quoted by the BBC: www.bbc.co.uk/news/10130840 (accessed 6 July 2010).

63 As quoted in Claudia Barbieri, 'Who Dunnit? Paris Museum's Security Blamed', *Art Newspaper* (June 2010), p. 16.

64 Vincenzo Ruggiero and Nigel South, 'The Late-Modern City as a Bazaar: Drug Markets, Illegal Enterprise and the "Barricades"', *British Journal of Sociology*, XLVIII/1 (March 1997), p. 61.

65 See Conklin, *Art Crime*, p. 9; and also Mackenzie, 'Criminal and Victim Profiles in Art Theft'.

66 An unusual Robin Hood character working in Venice emerged with the publication in 2010 of a memoir by Vicenzo Pipino, who claimed always to have returned the works of art that he had stolen; see report in the *Sunday Times* (15 August 2010), p. 26; Vicenzo Pipino, *Rubare ai ricchi non è peccato* (Pordenone, 2010).

67 Mackenzie, 'Criminal and Victim Profiles in Art Theft', p. 5

68 Interview with Vernon Rapley, London, 21 May 2010.

69 Ruggiero and South, 'The Late-Modern City as a Bazaar', p. 54; see also William Sherman, 'The Drug Cartel, Fences, Informers and Stolen Art', *ARTnews* (March 1991), pp. 123–7; and Conklin, *Art Crime*, p. 184.

70 Martin Bailey, 'The Art Theft–Drug Smuggling Link Exposed', *Art Newspaper* (January 1997), p. 1.

71 See ibid., and Hart, *The Irish Game*, p. 145.

72 Janet Ulph, 'Tracing or Recovering Stolen Art or the Proceds of Sale', in *The Recovery of Stolen Art: A Collection of Essays*, ed. Norman Palmer (London, 1998), p. 101.

73 Taken from Michel van Rijn's website, July 2007.

74 Interview with Vernon Rapley, London, 21 May 2010.

75 Misha Glenny, *McMafia: Crime without Frontiers* (London, 2008), p. 394.

Chapter 8: Fiction

1 Quoted from House of Commons speech in Alison Young, *Imagining Crime: Textual Outlaws and Criminal Conversations* (London, 1996), p. 3.

2 Sanford Schwartz, *William Nicholson* (London and New Haven, CT, 2004), p. 156; Schwartz makes a very convincing case that the central and partially silhouetted figure is the artist himself, pp. 153–6.

3 Peter Wollen, in *The Scene of the Crime*, ed. Ralph Rugoff, exh. cat., Armand Hammer Museum, Los Angeles (Cambridge, MA, 1997); quoted in Alison Young, *Judging the Image: Art, Value, Law* (London and New York, 2005), p. 99.

4 Young, *Imagining Crime*, p. 99.

5 Former US informer Paul 'Turbocharger' Hendry describes how you 'work backwards from the crime scene to the thieves via the under-world', *Independent Lens* (accessed 31 December 2007); website entry on Rebecca Dreyfus's film *Stolen*: www.pbs.org/independentlens/stolen/turbocharger.html (accessed 10 September 2010).

6 Loss adjuster Mark Dalrymple stresses: 'I work pretty much on a confidential, one-to-one basis because information is crucially important . . . where we decide what the press should know or shouldn't know'; interview, London, 29 June 2007.

7 George Boas, 'The Mona Lisa in the History of Taste', *Journal of the History of Ideas*, I/2 (1940), p. 207.

8 Ibid., p. 223.

9 Darian Leader, *Stealing the Mona Lisa: What Art Stops Us from Seeing* (London, 2002), p. 155.

10 Ernst Gombrich, 'Portrait of the Artist as a Paradox', *New York Review of Books* (20 January 2000), p. 8; quoted in Donald Sassoon's fascinating and exhaustive study, *Becoming Mona Lisa: The Making of a Global Icon* (New York, San Diego, CA, and London, 2001), p. 14.

11 Ibid., p. 15.

12 Leader, *Stealing the Mona Lisa*, p. 155.

13 Quoted in Milton Esterow, *The Art Stealers* (New York, 1966).

14 'The Mona Lisa Romance', *Los Angeles Times* (24 June 1932), p. 4; Karl Decker in *Saturday Evening Post* (25 June 1932).

15 Quoted in Sassoon, *Becoming Mona Lisa*, p. 202.

16 Robert Noah, *The Man Who Stole the Mona Lisa* (New York, 1998).

17 Robert Noah interviewed on 9 June 1998, *Boxtop*, Liveworld transcript: www.liveworld.com/transcripts/Boxtop/6-09-1998.1-1.html (accessed 1 January 2008).

18 Sassoon, *Becoming Mona Lisa*, p. 243.

19 Leader, *Stealing the Mona Lisa*, p. 164.

20 Some information from The Internet Movie Database, www.imdb.com (accessed 1 January 2008); the film was not released in the US until spring 1963 because of a concern over a perceived link between the plot and the Cuban missile crisis in October 1962.

21 Between 1930 and 1949 it had been lent by its former owner, the Duke of Leeds, to the adjacent National Portrait Gallery.

22 Kempton Bunton, quoted in Esterow, *The Art Stealers*, pp. 8–10.

23 Jeremy Hutchinson, Baron Hutchinson of Lullington QC, was later Chairman of the Trustees of the Tate Gallery.

24 This led to one of the new provisions in the UK Theft Act of 1968, making it illegal to 'remove without authority any object displayed or kept for display to the public in a building to which the public have access'. Quoted in Esterow, *The Art Stealers*, p. 11; the author refers to the notion of the hidden collector, dismissing the MAL, Mad Art Lover, idea as 'nonsense'. It is possible that someone else committed the theft; in 1969 a confession was made to the police by a man who claimed to have undertaken the actual theft and then handed the painting over to Bunton, who then started his campaign. The same man said he had also handed the painting in to the left luggage office at Birmingham New Street Station in 1965. See *The Observer* (22 June 1969). Bunton weighed 17 stone and would have found clambering in and out of a toilet window difficult; this is discussed on the Museum Security Network, where the suggestion is made that the thief might have been Bunton's son John; see: www.museum-security.org/?p=4408 (accessed 15 August 2010).

25 Robert Wraight, *The Art Game* (New York, 1966), p. 177.

26 It was Roland Barthes in his essays originally written in the 1950s who provided an important way of analysing the significance of many everyday objects; see Roland Barthes, *Mythologies* (Paris, 1970).

27 Interview with Robert Hiscox, Chairman, Robert Hiscox Insurance, London, 25 September 2007.

28 Thomas McShane and Dary Matera, *Loot: Inside the World of Stolen Art* (Dunshaughlin, 2007), p. 62.

29 The comparison between legitimate but secretive collectors of expensive paintings and the figure of 'the criminal art connoisseur' is made by Ben Macintyre in *The Times* (13 July 2002).

30 Interview with Mark Dalrymple, London, 29 June 2007. Charley Hill's opinion is similar: 'The media's constant invoking of hideaways lined with old masters infuriates . . . because it invests "scumbags" with glamour . . . The assumption that stolen masterpieces are destined for the secret galleries of untouchable criminals as . . . [provides] the police with a perfect excuse for giving up on art crime. Why spend time and money in a doomed search for paintings that are locked away for ever? It is, after all, only art.' Edward Dolnick, *Stealing the Scream: The Hunt for a Missing Masterpiece* (Cambridge, 2007), p. 138.

31 Ibid., p. 134.

32 Interview with Mark Dalrymple, 29 June 2007.

33 Dolnick, *Stealing the Scream*, p. 138.

34 Roland Barthes' analysis of myth might lead one to the idea that the hidden collector is an example of an imaginary solution to an inescapable social conflict around the way that much highly valuable art is possessed by individuals.

35 Michael McCann character in *Thomas Crown Affair*, quoted in Simon Houpt, *The Museum of the Missing: A History of Art Theft* (New York, 2006), p. 144.

36 Edward Moat, *Memoirs of an Art Thief* (London, 1976), p. 86; it is an uncorroborated account.

37 See Ben Macintyre, *The Napoleon of Crime: The Life and Times of Adam Worth, Master Thief* (New York, 1997).

38 Quoted in entry on A. J. Raffles in *An International Catalogue of Superheroes* website: www.internationalhero.co.uk/r/raffles.htm (accessed 4 January 2008).

39 William Wyler's comedy *How to Steal a Million* (1966) adds fakery to art theft for good measure.

40 Tony le Stéphanois to Jo le Suedois, meaning 'life imprisonment' in *Du refifi chez les hommes*, 1955; *Refifi* became the single title used in the US, and has the colloquial meaning of 'trouble', with an implication of fighting.

41 See Wikipedia entry for 'Heist film': http://en.wikipedia.org/wiki/Heist_film (accessed 4 January 2008).

42 Dialogue between the psychiatrist and Thomas Crown, *The Thomas Crown Affair*, United Artists, August 1999; further replay twists and connections are to be expected when *The Thomas Crown Affair II* appears, originally slated for 2008, and also known as *The Topkapi Affair*.

43 John McTiernan, commentary, DVD edition, *The Thomas Crown Affair*, United Artists, 1999.

44 In Patrick Pacheco, 'Art of the Con', *Los Angeles Times* (1 August 1999); available at http://pbfiles.t35.com/tca/articles1.html (accessed 4 January 2008).

45 Virginia Baker and Robert MacDougal in dialogue, *Entrapment*, Fountainbridge Films, April 1999.

46 Interview with Alison Young, Melbourne, 2 December 2008.

47 McShane and Matera, *Loot*, p. 217.

48 Young, *Imagining Crime*, pp. 103–4.

49 Raymond Chandler, 'The Simple Art of Murder', in *Pearls Are a Nuisance* (London, 1964), p. 198; quoted in Young, *Imagining Crime*, p. 103.

50 Ibid., pp. 81–2.

51 Ibid., p. 81.

52 Ibid., pp. 103–4.

53 In two particular films the narrative is driven by rivalry between detectives and loss adjusters, as portrayed by Catherine Banning in *The Thomas Crown Affair* and Virginia Baker in *Entrapment*.

54 'An impartial claims specialist responsible for investigating claims on behalf of insurance companies. The role involves examining the causes of loss or damage, confirming that they are covered by the insurance policy,

and assessing the validity of the claim'. *Loss Adjuster, Chartered*: Prospects.ac.uk website (accessed 12 January 2008).

55 Interview with Dalrymple, 29 June 2007.

56 McTigue was in charge of the Art and Antiques Squad in 1994 when the Turner paintings were stolen in Germany; see chapter One.

57 Celia Dodd, 'The Art Detectives', Inside Story Feature, *Radio Times* (June 1995); in a review of the programme, Nancy Banks-Smith comments on Jill McTigue: 'Very pretty, slightly posh, I can't think why TV hadn't turned her into a drama series', in 'All Cut Up at the Vic', *Guardian* (23 June 1995).

58 Laurie Adams, *Art Cop: Robert Volpe, Art Crime Detective* (New York, 1974), p. 14.

59 Ibid., p. 25.

60 Marie Cirile, *Detective Marie Cirile: Memoirs of a Police Officer* (New York, 1975), p. 191.

61 Ibid., p. 197.

62 Dick (Richard) Ellis, quoted in Dolnick, *Stealing the Scream*, p. 176.

63 McShane and Matera, *Loot*, p. 167.

64 Dolnick, *Stealing the Scream*, p. 199.

65 Ibid., p. 215.

66 McShane and Matera, *Loot*, p. 51.

67 Young, *Imagining Crime*, p. 13.

68 Noah Charney, *The Art Thief: A Novel* (New York, 2007); see also Tom Mueller, 'To Catch a Thief', *New York Times*, Magazine (17 December 2006).

69 Guy Wilson, *The Art Thieves* (Norwich, 1995).

70 Richard Ellis, 'Investigating Stolen Art: The Reason Why', paper contributed to the AXA Art conference, *Rogues Gallery: An Investigation into Art Theft*, British Museum, London, 1 November 2005.

71 The game, 'Skrik-mysteriet', is still available for sale on the Aschehoug & Co. website; report from blog www.artstealer.com (accessed 10 July 2007).

72 Nancy Banks-Smith, review of 'The Art Detectives', which included Art and Antiques Squad pursuit of Mr Rothstein, 'All Cut Up at the Vic'; see chapter One.

Chapter 9: Future

1 Norman Palmer, 'Statutory, Forensic and Ethical Initiatives in the Recovery of Stolen Art and Antiquities', in *The Recovery of Stolen Art*, ed. Norman Palmer (London, 1998), p. 6.

2 Ulrich Boser, 'This is No "Thomas Crown" Affair', *Wall Street Journal* (26 May 2010).

3 Ian Rankin, *Open Doors* (London, 2008).

4 The painting by Caspar David Friedrich, stolen with the Turners from the Frankfurt Kunsthalle in July 1994, was eventually recovered and

returned to its owner, the Kunsthalle, Hamburg, in 2003, with Edgar
Liebrucks as the intermediary.

5 David Lee, 'It's a Steal: Why Art Remains a Favourite among Thieves', *The Times* (22 May 2010).

6 Interview with Julian Radcliffe, London, 4 June 2010.

7 Interview with Vernon Rapley, London, 21 May 2010.

8 Interview with Dick Ellis, London, 16 December 2008.

9 Not proven as opposed to guilty or not guilty is a third choice available in Scottish courts. See Severin Carrell, 'Five Not Guilty over Theft of £30m Da Vinci', *Guardian* (22 April 2010), p. 22; and Lucy Bannerman and Charlene Sweeney, 'Private Investigators Cleared of Leonardo Extortion Plot Demand: "Where's Our Reward?"', *The Times* (22 April 2010).

10 Interview with Ellis, 16 December 2008.

11 Interview with Rapley, 21 May 2010.

12 Interview with Radcliffe, 4 June 2010.

13 For a discussion and list of art crime databases, see Thomas D. Bazley, *Crimes of the Art World* (Westport, CT, 2010), p. 191.

14 Julian Radcliffe describes how the Art Loss Register came about: 'IFAR [International Foundation for Art Research] started it with a broader remit of authentication, but also educational work in the arts and raising ethical standards. The founder, Bonnie Burnham, should get the credit for discovering that people, not only in the art trade but museum curators, were not telling anyone about their losses: not telling the police, their trustees, or anyone, because they were ashamed. They thought it would affect their funding, and the ethics of that were deplorable. She decided to start a database . . . However, I said I could raise more money but we would have to put it onto a proper operational basis. So we set up a new company and took over the database from IFAR.'

15 Ibid.

16 Interview with Rapley, London, 21 May 2010.

17 Interview with Robert Hiscox, London, 25 September 2007.

18 The discovery in a New York saleroom in November 2010 of a painting by Degas, stolen 37 years previously in France, raised the question of the efficacy of existing databases; see *Independent on Sunday* (23 January 2011), p. 38.

19 Interview with Radcliffe, 4 June 2010.

20 Interview with Hiscox, London, 25 September 2007.

21 Interpol website: www.interpol.int/Public/WorkOfArt/Default.asp (accessed 19 September 2010).

22 Interview with Radcliffe, 4 June 2010.

23 Interview with Ellis, 16 December 2008.

24 Dalrymple also commented: 'Such thefts drove me to create COPAT (The Council for the Prevention of Art Theft) and we tried to offer better advice in this country'. Interview with Mark Dalrymple, London, 29 June 2007.

Select Bibliography

Adams, Laurie, *Art Cop: Robert Volpe, Art Crime Detective* (New York, 1974)

Agnew, Geoffrey, *Agnew's, 1817–1967* (London, 1967)

Anderson, Gail, ed., *Reinventing the Museum* (Lanham, MD, 2004)

Bazley, Thomas D., *Crimes of the Art World* (Westport, CT, 2010)

Bell, Julian, *What Is Painting? Representation and Modern Art* (London and New York, 1999)

Benhamou-Huet, Judith, *The Worth of Art: Pricing the Priceless* (New York, 2001)

Boas, George, 'The Mona Lisa in the History of Taste', *Journal of the History of Ideas*, 1/2 (1940), pp. 207–24

Boser, Ulrich, *The Gardner Heist: The True Story of the World's Largest Unsolved Art Theft* (New York, 2009)

—, 'This Is No "Thomas Crown" Affair', *Wall Street Journal* (26 May 2010)

Bourdieu, Pierre, *Distinction: A Social Critique of the Judgement of Taste* (Cambridge, MA, 1984)

Burnham, Bonnie, *The Art Crisis* (London, 1975)

Butlin, Martin, and Evelyn Joll, *The Paintings of J.M.W. Turner* (New Haven, CT, and London, 1977)

Chandler, Raymond, 'The Simple Art of Murder', in *Pearls Are a Nuisance* (London, 1964)

Charney, Noah, *The Art Thief: A Novel* (New York, 2007)

—, ed., *Art and Crime: Exploring the Dark Side of the Art World* (Santa Barbara, CA, 2009)

Cirile, Marie, *Detective Marie Cirile: Memoirs of a Police Officer* (New York, 1975)

Conklin, John E., *Art Crime* (Westport, CT, 1994)

Connor, Myles, *The Art of the Heist: Confessions of a Master Art Thief, Rock-and-Roller, and Prodigal Son* (London, 2009)

Dalrymple, Mark, paper at AXA Art conference, *Rogues Gallery: An Investigation into Art Theft*, British Museum, London (1 November 2005) (see also papers by Richard Ellis and Deborah Gage)

Dickie, George, *Art and Value* (Oxford, 2001)

Dissanayake, Ellen, *What is Art For?* (Seattle, WA, and London, 1988)

Dolnick, Edward, *Stealing the Scream: The Hunt for a Missing Masterpiece* (Cambridge, 2007)

Elkins, James, *Pictures and Tears: A History of People Who Have Cried in Front of Paintings* (London and New York, 2001)

Esterow, Milton, *The Art Stealers* (New York, 1966)

Fekete, John, *Life After Postmodernism: Essays on Value and Culture* (New York, 1987)

Finberg, A. J., *The Life of J.M.W. Turner* (Oxford, 1965)

Finley, Gerald, *Angel in the Sun: Turner's Vision of History* (Montreal, 1999)

Fuchs, Rudi, 'Victory Over Decay', in *For the Love of God: The Making of the Diamond Skull* (London, 2007)

Gillman, Peter, and Leni Gillman, 'In 1994, Two Turner Masterpieces Were Stolen from this Wall', *Sunday Times Magazine* (26 January 2003)

Glenny, Misha, *McMafia: Crime without Frontiers* (London, 2008)

Gombrich, Ernst, 'Portrait of the Artist as a Paradox', *New York Review of Books* (20 January 2000)

Grampp, William D., *Pricing the Priceless: Art, Artists and Economics* (New York, 1989)

Haden-Guest, Anthony, *True Colors: The Real Life of the Art World* (New York, 1998)

Hart, Matthew, *The Irish Game* (London, 2004)

Houpt, Simon, and Julian Radcliffe, *The Museum of the Missing: A History of Art Theft* (New York, 2006)

Joll, Evelyn, Martin Butlin and Luke Herriman, eds, *The Oxford Companion to Turner* (Oxford, 2001)

Karp, Ivan et al., eds, *Museum Frictions: Public Cultures/Global Transformations* (Durham, NC, and London, 2006)

Keen, Geraldine, *The Sale of Works of Art: A Study Based on the Times-Sotheby Index* (London, 1961)

Lacey, Robert, *Sotheby's: Bidding for Class* (London, 1998)

Leader, Darian, *Stealing the Mona Lisa: What Art Stops Us from Seeing* (London, 2002)

Macintyre, Ben, *The Napoleon of Crime: The Life and Times of Adam Worth, Master Thief* (New York, 1998)

McLeave, Hugh, *Rogues in the Gallery: The Modern Plague of Art Thefts* (Boston, MA, 1981)

McShane, Thomas, and Dary Matera, *Loot: Inside the World of Stolen Art* (Dunshaughlin, 2007)

Meyer, Karl E., *The Plundered Past* (New York, 1973)

Middlemas, Keith, *The Double Market: Art Theft and Art Thieves* (Farnborough, 1975)

Moat, Edward, *Memoirs of an Art Thief* (London, 1976)

Mould, Philip, *The Art Detective: Fakes, Frauds and Finds and the Search for Lost Treasures* (London, 2010)

Nairne, Sandy, *State of the Art: Ideas and Images in the 1980s* (London, 1987)

Noah, Robert, *The Man Who Stole the Mona Lisa* (New York, 1998)

Palmer, Norman, ed., *The Recovery of Stolen Art: A Collection of Essays* (London, 1998)

Pipino, Vincenzo, *Rubare ai ricchi non è peccato* (Pordenone, 2010)

Radcliffe, Julian, Introduction in Jonathan Webb, *Stolen: The Gallery of Missing Masterpieces* (Toronto, 2009)

Rankin, Ian, *Doors Open* (London, 2008)

Reitlinger, Gerald, *The Economics of Taste* (London, 1961–70)

Robinson, Geoffrey, *The Unconventional Minister* (London, 2001)

Rothenstein, John, *Brave Day, Hideous Night: Autobiography, 1939–1965* (London, 1965)

Ruggiero, Vincenzo, and Nigel South, 'The Late-Modern City as a Bazaar: Drug Markets, Illegal Enterprise and the "Barricades"', *British Journal of Sociology*, XLVIII/I (1997) pp. 54–7

Rugoff, Ralph, ed., *The Scene of the Crime*, exh. cat., Armand Hammer Museum, Los Angeles (Cambridge, MA, 1997)

Sassoon, Donald, *Becoming Mona Lisa: The Making of a Global Icon* (New York, San Diego, CA, and London, 2001)

Sax, Joseph L., *Playing Darts with a Rembrandt: Public and Private Rights in Cultural Treasures* (Ann Arbor, MI, 1999)

Schwartz, Sanford, *William Nicholson* (London and New Haven, CT, 2004)

Scotti, R. A., *The Lost Mona Lisa* (London, 2009)

Smith, Barbara Herrnstein, *Contingencies of Value: Alternative Perspectives for Critical Theory* (Cambridge, MA, 1988)

Smith, Charles W., *Auctions: The Social Construction of Value* (London, 1989)

Spalding, Frances, *Tate: A History* (London, 1998)

Squires, Judith, ed., *Principled Positions: Postmodernism and the Recovery of Value* (London, 1993)

Stecker, Robert, *Artworks: Definition, Meaning, Value* (University Park, PA, 1997)

Van Rijn, Michel, *Hot Art, Cold Cash* (London, 1994)

Whittman, Robert K., *Priceless, How I Went Undercover to Rescue the World's Stolen Treasures* (New York, 2010)

Williams, Paul, *The General: Godfather of Crime* (Dublin, 1995)

Wilson, Guy, *The Art Thieves* (Norwich, 1995)

Wilson, James, *The Dark Clue* (London, 2001)

Woolrich, Peter, 'The Art Hunter', *Reader's Digest* (March 2006)

Wraight, Robert, *The Art Game* (New York, 1966)

Young, Alison, *Imagining Crime: Textual Outlaws and Criminal Conversations* (London, 1996)

——, *Judging the Image: Art, Value, Law* (London and New York, 2005)

Selected Websites (all accessed January 2011)

ARCA (Association for Research into Crimes against Art): www.artcrime.info

Art Hostage [blog]: http://arthostage.blogspot.com/

Art Loss Register: www.artloss.com

Art Theft Central: http://arttheftcentral.blogspot.com

IFAR (International Foundation for Art Research): www.ifar.org

Interpol – Stolen Works of Art: www.interpol.int/Public/WorkOfArt/ Default.asp

Los Angeles Police Department – The Art Detail: www.lapdonline.org/art_ theft_detail

Metropolitan Police – Art and Antiques: www.met.police.uk/artandantiques

Museum Security Network: www.museum-security.org

Acknowledgements

I should first like to acknowledge the generous support and encouragement of my former colleagues at Tate, most particularly Nicholas Serota and Alex Beard, and including Laura Down, Anna Jobson, Suzanne Freeman, Sharon Page, Roy Perry and Sian Williams. I am grateful to Tate Trustees who advised on the process of recovering the Turner paintings, including David Verey, Christopher Mallaby and Dennis Stevenson. I am indebted for wider advice and support to Mark Dalrymple of Tyler & Co., Robert Hiscox, Chairman of Hiscox and to members of the Art and Antiques Squad – in particular its most recent head, Vernon Rapley. However, the recovery of the Turner paintings would not have been achieved without the committed work of Jurek Rokoszynski, John Pearse and Mick Lawrence, and my thanks go to them.

In the process of researching and writing this book I have been given generous help by many people, including, in the United States, Anne Hawley, Michael Ann Holly and Sandy Schwartz; in Germany, Herr Hauschke of the Frankfurt Prosecutors Office, and, with his critical role in the story, Edgar Liebrucks; and in Australia, Alison Young. In Britain I am grateful for help received from, among others, Tim Binding, Jon Bird, Carrie Britton, Severin Carrell, Barry Curtis, Nicholas Donaldson, Dick Ellis, Leni and Peter Gillman, Charley Hill, Jeremy Hutchinson, Caroline Michel, James Nairne, Julian Radcliffe, David Scholey, Janet Williams, Adrian Wootten and John Wyver.

I should like to acknowledge the support of the Sterling and Francine Clark Art Institute, Williamstown, Massachusetts, where I was given a Visiting Fellowship in the summer of 2007, during which time I was able to work towards this book. The critical comments of Fellows on that programme were much appreciated.

National Portrait Gallery colleagues have been unstinting in their help and encouragement, most particularly Pim Baxter, Emma Cavalier, Helen Hillman and Lucy Macmillan, who undertook picture research, and especially Alexandra Finch, until recently Manager in the Director's Office, and my consistently very supportive Chairman of Trustees, David Cannadine.

I am also very grateful to Michael Leaman and colleagues at Reaktion Books for their attentive work in publishing this book.

This story began in 1994, and it would never have been possible for me to pursue the paintings, and then write this book, without continuing support at

home. I would like to thank Christopher, Eleanor (to whom I am particularly grateful for work on the final preparation of the text) and offer special and heartfelt thanks to my partner, Lisa Tickner. This book is for her.

Photo Acknowledgements

© Desmond Banks: p. 217; Courtesy Dick Ellis and Metropolitan Police: p. 214; Courtesy Doubleday, New York, 1975: p. 235; © epa/Katja Lenz: p. 19; Courtesy *Evening Standard*, 2011: pp. 102–3; © Getty Images: p. 181; Courtesy Metropolitan Police: p. 223; Courtesy MGM, 1962: p. 224; Prudence Cuming Associates Ltd 2007, © Hirst Holdings Limited and Damien Hirst. All rights reserved, DACS 2010: p. 183; © Jurek Rokoszynski: pp. 95, 141; © Scanpix Norway/Press Association: p. 202; Courtesy Isabella Stewart Gardner Museum, Boston, 2011: pp. 198–9; © Tate, London 2011: pp. 24–5; Courtesy Tate, 2011: p. 135; © *TV Times*, 1995: p. 35.

Index